The Conspiracy

of Art

SEMIOTEXT(E) FOREIGN AGENTS SERIES

The publication of this book was supported by the French Ministry of Foreign Affairs through the Cultural Services of the French Embassy, New York.

Published by Semiotext(e)
501 Philosophy Hall, Columbia University, New York, NY 10027
2571 W. Fifth Street, Los Angeles, CA 90057
www.semiotexte.com

Special thanks to Giancarlo Ambrosino, Jon Brilliant, Justin Cavin, Diego Cortez and Mike Taormina for copy editing.

Cover Photography: "Sainte Beuve 1987" by Jean Baudrillard
Back Cover Photography: Marine Dupuis
Design by Hedi El Kholti

ISBN: 1-58435-028-8
Distributed by The MIT Press, Cambridge, Mass. and London, England
Printed in the United States of America

10 9 8 7 6 5 4 3

The Conspiracy of Art

Jean Baudrillard

Manifestos, Interviews, Essays

Edited by Sylvère Lotringer

Translated by Ames Hodges

<e>

Table of Contents

The Piracy of Art

When Jean Baudrillard, the world-renowned French theorist, first published "The Conspiracy of Art" in 1996, he scandalized the international artistic community by declaring that contemporary art had no more reason to exist. Baudrillard was no art aficionado, but he was no stranger to art either. In 1983, after the publication in English of his ground-breaking essay, *Simulations*,[1] he was adopted by the New York art world and put on the mast of *Artforum*, the influential international art magazine. The book instantly became a must-read for any self-respecting artist—they suddenly were becoming legions—and it was quoted everywhere, even included in several artist installations. Eventually it made its way—full-frame—into the cult Hollywood SciFi film *The Matrix*. (Baudrillard is Neo). The prestigious lecture he gave on Andy Warhol at the Whitney Museum of American Art in 1987 was booked months in advance. For a while artists fought around his name, jockeying for recognition. So it isn't surprising that his sudden outburst against art would have raised such an uproar. There was a widespread sense of betrayal among art practitioners, as if he had broken an implicit contract. "The denunciation came as a slap in the face,"[2] a Canadian critic wrote, adding that it was "a radical delegitimization of his own position as

a cultural critic." Baudrillard, of course, never claimed to be one. Like the Situationists, he has a healthy disrespect for "culture."

True, he didn't mince his words. Art was "confiscating banality, waste and mediocrity to turn them into values and ideologies," he wrote, adding that contemporary art wasn't just insignificant, but *null*. Null isn't exactly a term of endearment—obsolete, worthless, without merit or effect, the dictionary says. Baudrillard seemed to have gone out of his way to provoke the art world, and he certainly got what he asked. It was all the more remarkable that another violent libel he published the following year, "A Conjuration of Imbeciles" (the French political establishment, which let Le Pen hijack the democratic system) elicited no reaction. Politicians apparently are used to this kind of treatment. So there is something special about the art world after all—it could do with a lot more abuse.

But could abuse really make a difference? Some critics or curators in the marches of Empire took the attack at face value and crossed him from their list, but people in the know simply basked in the frisson of a well-publicized "scandal." It doesn't matter what is said about art as long one pays attention to it. No sooner had Baudrillard's column been published in the French leftist newspaper *Libération* in May 1996, and instantly beamed all over the place through the internet, Baudrillard was deluged with invitations for art events, lectures, catalogue essays. It was obvious that visibility and fame, not contents, were the real engine of the New Art Order. Its power and glamour managed to entice, subdue and integrate any potential threat. Criticizing art, in fact, has become the royal way to an art career *and this will be no exception.*

It was exactly the point Baudrillard was making in *The Conspiracy of Art*, and this reaction confirmed what he had already

anticipated twenty-five years earlier in *The Consumer Society*[3]: critique has become a mirage of critique, a counter-discourse immanent to consumption, the way Pop Art's "cool smile" was no different from commercial complicity. Two years later, in *For a Critique of the Political Economy of the Sign*,[4] he went even further, asserting that contemporary art had an ambiguous status, half-way between a terrorist critique and a de facto cultural integration. Art, he concluded, was "the art of collusion." By now this collusion is affecting society at large and there is no more reason to consider art apart from the rest, as the composition of this book suggests. Obstacles and oppositions, in reality, are used by the system everywhere in order to bounce ahead. Art in the process has lost most of its singularity and unpredictability. There is no place anymore for accidents or unforeseen surprises, writes Chris Kraus in *Video Green*. "The life of the artist matters very little. What life?"[5] Art now offers career benefits, rewarding investments, glorified consumer products, just like any other corporation. *And everything else is becoming art*. Roland Barthes used to say that in America sex was everywhere, except in sex. Now art is everywhere, *even* in art.

In *Simulations*, Baudrillard suggested that Disneyland's only function was to conceal the fact that the entire country was a huge theme park. Similarly art has become a front, a showcase, a deterrence machine meant to hide the fact that the whole society is transaestheticized. Art has definitely lost its privilege. By the same token it can be found everywhere. The end of the aesthetic principle signaled not its disappearance, but its perfusion throughout the social body. It is well-known that Surrealism eventually spread his slippery games thin through fashion, advertisement and the media, eventually turning the consumer's unconscious into kitsch. Now art is free as well to morph everywhere, into politics (the aestheti-

cization of politics isn't a sign of fascism anymore, nor is the politicization of aesthetics a sign of radicalism for that matter), into the economy, into the media. All the more reason for art to claim a dubious privilege in the face of its absolute commodification. Art is enclosing itself in a big bubble, ostensibly protected from consumer contagion. But consumption has spread inside, like a disease, and you can tell by everybody's rosy cheeks and febrile gestures. The bubble is quickly growing out of proportion. Soon it will reach its limit, achieving the perfection of its form—and burst with a pop like bubble-gum, or the 90s stock market.

A self-taught sociologist in the 60s, Baudrillard remained intellectually close to the French Situationists and shared their unconditional distrust of "culture." Ironically, on its way to complete surrender in the late 80s and 90s, the art world made a huge effort to reclaim its virginity by enlisting the Situationists' radicalism to its cause. It was a curious intellectual exercise, and I saw it unfolding at the time with some glee: the art world reappropriating avant-gardism long *after* proclaiming the "end of the avant-garde." The way it was done was even more interesting: showcasing the Situationists' involvement with architecture and their ideological critique the better to evacuate their unequivocal condemnation of art and art criticism. "Nothing is more exhilarating than to see an entire generation of repentant politicians and intellectuals," Baudrillard wrote, "becoming fully paid-up members of the conspiracy of imbeciles."[6] Art isn't even the only one to conspire.

"Get out, art critics, partial imbeciles, critics of bit parts, you have nothing more to say," the Situationists threw at "the art of the spectacle." They also violently expelled from their midst any artist tempted to participate in the bourgeois comedy of creation. By this account, Guy Debord and his acolytes would have to fire *everybody*

in the present art world, whatever their professed ideology. Granted, it is difficult to be more paranoiac than Debord was. And yet he was absolutely right. There *was* a conspiracy of art, even if he had to hallucinate it. Now duplicity is transparent. Who today could boast having *any* integrity? Debord was ahead of his time and we would actually benefit from having him among us today, *but not emasculated.* Actually we would be incapable of recognizing him if he did. Was Baudrillard's exasperated outburst so different from what the Situationists themselves would have done? Art, he wrote, "is mediocrity squared. It claims to be bad—'I am bad! I am bad!'—*and it truly is bad.*" Baudrillard was wrong in one count. It is worse.

The Conspiracy of Art signaled the "return of the repressed" among the art world. It was displaced, of course, but symptoms always are. And it was unmistakable. Yet no one—especially those heavily invested in Freud—recognized it for what it was: Baudrillard was simply repaying the art world in its own coin. The real scandal was not that he would have attacked art, *but that art would have found this attack scandalous.* Unlike the Situationists, Baudrillard never believed it possible to maintain a distance within the society of spectacle. But his provocation was perfect pitch and totally in keeping with the Situationists' attempt to reclaim their subjectivity through calculated drifts. Except that Baudrillard's solitary drift into provocation was neither deliberate, nor existential. It was just a purge.

Baudrillard always had a knack for bringing out the most revealing features in a volatile situation. The year 1987 happened to be a real turning point for the New York art world, throngs of young artists flooding the art market desperately seeking Cesar, a "master thinker," a guru, anything really to peg their career on.

They took *Simulations* for an aesthetic statement (it was an anthropological diagnostic) and rushed to make it a template for their still inform art. Baudrillard protested, nonplussed by their sudden adulation. "Simulation," for him, is not a thing. It is nothing in itself. It only means that there isn't any more original in contemporary culture, only replicas of replicas. "Simulation," he retorted, "couldn't be represented or serve as a model for an artwork." If anything, it is a challenge to art. The rush turned into a rout, everybody scattering around with their tails between their legs. Ten years later, Baudrillard did it again. *The Conspiracy of Art* took on not just the commercialization of art fueled by the return to painting and the real-estate boom, but its global projection through neo-liberal deregulation and the delirious speculations of a stock-market just about to go bust. It wasn't the naivety of art anymore that Baudrillard blasted, but the cynical exploitation of "art" for non-artistic purposes.

Returning from a brief pilgrimage to the Venice Biennale, Baudrillard exploded. Too much art was too much! Immediately upping the ante, he claimed the existence of a "conspiracy" which didn't exactly exist in the flesh, but was all the truer for that. Besides, who can resist a bit of conspiracy theory? The pamphlet was mostly an "abreaction," an acting-out meant to free *his* own system from all the bad energy. An earnest French artist took the cue and claimed in *Libération* that Baudrillard was "feeding paranoia toward contemporary art." She was absolutely right too. Who could doubt that contemporary art today is besieged by a hostile audience and badly in need of reinforcement? Aren't artists and dealers, curators, critics, collectors, sponsors, speculators, not to mention socialites, snobs, spongers, crooks, parasites of all kinds, all feeding off art crumbs, heroically sacrificing themselves to

redeem art from shoddy consumerism, just like Russian "liquidators" putting down the sarcophagus on the Chernobyl reactor at the cost of their lives? It wasn't enough that art would have become a huge business, a mammoth multinational corporation with its professional shows, channels and conventions, it still had to be treated with utter reverence, even awe. The controversy was briskly moving to pataphysical heights.

Baudrillard probably had his doubts about contemporary art even before he saw any of it, and he mostly managed to keep away from any serious involvement. To this day he prefers "strange attractors," borderline objects or projects (Sophie Calle's vacant drifts through sentiment, the strange cruelty of Michal Rovner's biological theater), art that doesn't claim to be art or mean anything, more anthropological than aesthetic in outlook. In a sense Baudrillard himself is a strange attractor (cruelty included), a borderline thinker doing to philosophy or sociology what these strange "things" do to art, all UFO's coming from different galaxies, each endowed with rigorous rules that cannot be transgressed, even by themselves. Gilles Deleuze once superbly said that he wanted to exit philosophy to engage art, literature, film, *but as a philosopher*. Unlike him, Baudrillard never had to make a huge effort to get out of philosophy. He never belonged there in the first place, or anywhere for that matter. And he entered art not as a philosopher, but as a *traitor*, in Deleuze's sense, inventing his own itinerary. He just went to the other side, becoming a practicing artist of sorts, imperturbably showing in galleries photographs that he didn't really believe in. And then becoming a traitor to art *again* by refusing to own up to it.

Baudrillard's rejection of art was all the more unexpected, and appeared all the more outrageous for that to those who believed

he had crossed over. And yet he didn't seem to notice the contradiction. The episode of the "simulationist school" (and of the "anti-simulationist" controversy) may have had something to do with it. In 1987 Baudrillard didn't yet know much about the American art world and didn't quite realize what was happening around his name. At best, he told me later, he sensed that "there was something fishy there" [*Je me suis méfié*] with a sound peasant-like distrust of sleek city talkers. So he flatly refused to play into the artists' hands. He might as well have acceded their demand, the way he subsequently accepted the gallerists' offer to exhibit his photographs because *it would eventually have amounted to the same.* How could anything one does ever be wrong coming "after the orgy"? If art ceased to matter as art, then what prevented *anyone* from joining in? Actually that he, who admittedly had no artistic claim or pedigree, would be invited to exhibit his work, amply proved his point: there was nothing special anymore about art. Groucho Marx once said that he would never join a club that accepted him as a member. Baudrillard did worse: he joined a group whose reasons to exist he publicly denied.

"Pataphysician at twenty—situationist at thirty—utopian at forty—viral and metaleptic at sixty—the entire story," is the way Baudrillard once epitomized his own itinerary.[7] Pataphysics was founded by Alfred Jarry, creator of Ubu, the brat-king with a paunch. It is the science of imaginary solutions, and this is precisely what Baudrillard reinvented in the circumstance. A pataphysical solution *to a problem that didn't exist.* Because *he* certainly had no problem with it. Others may have, but it was their problem and it wasn't up to him to solve it. Attacking art and becoming an artist all at the same time was perfectly acceptable in his book. He hadn't asked to show his photographs, merely obliged. As far as he knew,

they may have been trying to bribe him publicly, some kind of sting operation by the art squad. *But they always implicate you one way or another*, so at least it was all above board. It was part of the "conspiracy" of art. Baudrillard didn't have to feel any qualms about it, could even enjoy the ride for what it was worth. Early on he learned from French anthropologist Marcel Mauss that "gifts" always come with a vengeance. He knew he would eventually have to reciprocate, squaring the circle. And *he did*: he wrote *The Conspiracy of Art*.

Baudrillard is a special kind of philosopher, especially in a country where ideologies come cheap and easy—what he does is no different from what he writes. He *performs* his philosophy, not just preaches it. He is a practicing artist of his own concepts. This is an art he never betrayed, his only claim to artistry. Exhibiting his photographs was part of his work as a pataphysician, as much as attacking art was part of his work as a Situationist. That people would be angered at him for these gestures simply proved that they didn't have a clue. They hadn't understood anything about his theory, or about the world we live in for that matter. For Baudrillard the actual photographs are beside the point. It is what *precedes* them that counts in his eyes—the *mental event* of taking a picture—and this could never be documented, let alone exhibited. But what could be more gratifying than having fully paid-up members of the conspiracy exhibit something that he himself doesn't consider art? The products themselves will go the way of all things artistic—in the garbage or in a gallery. The Museum of Modern Art is considering acquiring his photographs for its collection. The Whitney Museum of American Art is thinking it too, and it would be just fair. What artist today is more modern and American than Baudrillard? The desert too is real.

Proclaiming that art is *null* was not an aesthetic judgment on his part, but an anthropological problem. It was a *polemic* gesture towards culture as a whole, which now is simultaneously nothing and everything, being at once elitist and crassly materialistic, repetitive, ingenious, pretentious and inflated beyond human recognition. For Baudrillard art has nothing to do with art as it is usually understood. It remains a yet unresolved issue for post-humans to deal with—if anyone in the far-away future still cares organizing another exciting panel on the future of art.

Art doesn't come from a natural impulse, but from calculated artifice (at the dawn of modernism, Baudelaire already figured this out). So it is always possible to question its status, and even its existence. We have grown so accustomed to take art with a sense of awe that we cannot look at it anymore with dispassionate eyes, let alone question its legitimacy. This is what Baudrillard had in mind, and few people realized it at the time. First one has to *nullify* art in order to look at it for what it is. And this is precisely what Marcel Duchamp and Andy Warhol respectively did. By now art may well have outgrown this function, although everyone keeps acting as if it still mattered. Actually nothing proves that it was meant to persevere, or would persist in the forms it has given itself, except by some kind of tacit agreement *on everybody's part*. Baudrillard called it a "conspiracy," but he might as well have called Disneyland "the Conspiracy of Reality." And none of it, of course, was real, except as a conspiracy. Conspiracy too is calculated artifice. Maybe the art world is an art onto itself, possibly the only one left. Waiting to be given its final form by someone like Baudrillard. Capital, the ultimate art. We all are artists on this account.

Art is no different anymore from anything else. This doesn't prevent it from growing exponentially. The "end of art," so often

trumpeted, never happened. It was replaced instead by unrestrained proliferation and cultural overproduction. Never has art been more successful than it is today—*but is it still art?* Like material goods, art is endlessly recycling itself to meet the demands of the market. Worse yet: the less pertinent art has become *as art*, the louder it keeps claiming its "exceptionalism." Instead of bravely acknowledging its own obsolescence and questioning its own status, it is basking in its own self-importance. The only legitimate reason art would have to exist nowadays would be *to reinvent itself as art*. But this may be asking too much. It may not be capable of doing that, because it has been doing everything it could to prove that it still is art. In that sense Baudrillard may well be one of the last people who really cares about art.

Baudrillard is notoriously "cool" and it may come as a big surprise that he would have got genuinely excited after viewing a major retrospective of Andy Warhol's work.[3] Didn't Baudelaire say that a dandy should never lapse from indifference, at most keep a "latent fire"? What Baudrillard so readily embraced in Warhol, though, was not the great artist, but the machine he masterfully managed to turn himself into. Both in his art and in his frozen persona, Warhol embodied in an extreme form the only radical alternative still conceivable in the century: renouncing art altogether and turning commodity itself into an art form. It mattered little that the work eventually got re-commodified as art, and that Warhol himself somehow betrayed his own machinic impulse. Can one ever expect capital to leave anything unchallenged?

The same thing happened earlier on with the invention of the readymade. The idea of exhibiting a "fountain" (a public urinal) in a gallery was totally unprecedented and it sent reality itself reeling. Duchamp probably meant merely shaking the art institution, in dada

fashion, but it was art itself that was the casualty, precipitating the collapse of art history, including his own stunt with painting. There was no more reason to wonder if art should be realistic, expressionistic, impressionistic, futuristic, if it had to paint the light or bring out the scaffolding. It was all in the mind. Non-retinian art was an oxymoron, an explosive device. Something like Nietzsche's laughter. It was a challenge to "culture," meaning the business of art. Reality itself everywhere was up for sale, so why not in a gallery? The readymade wasn't a point of departure, but a point of no return. Once added up, art and reality amounted to a *sum zero equation*. It was *null*. Opening the floodgates of art to the decodification of capital, Duchamp left nothing behind.

Could art survive such an abrupt deterritorialization? Apparently yes, but over Duchamp's dead body. Morphing banality into art, Duchamp hadn't fathered a new artistic era, instead he left art intestate, a bachelor machine with nothing more to grind except itself. But this was enough to turn his iconoclastic gesture into a new art paradigm. One can always reterritorialize everything on nothing, This is what the "conspiracy" of art really was about, "striving for nullity when already null and void," as Baudrillard put it. This *nullity* triggered the great rush of 20th century art, stripping the bride bare, hastily throwing along the way everything that could still justify its own existence as art, gradually exhausting its own resources as a rocket exhausts its fuel to stay on orbit. Filling the gap between reality and art didn't give either of them a new boost, as everyone hoped it would, rather cancelled out any possibility for creative illusion. What was left was an endless recycling of art's own demise, deconstruction and self-reference replacing a more secret kind of alterity, or the reinvention of more inflexible rules. Andy Warhol managed to complete this anorexic cycle by

replacing art itself with mechanical reproduction, by the same token returning banality to its irremediable enigma. Anything that came after that was bound to merely retrivialize banality, eagerly affixing finality to an end already gone out of sight. Going nowhere, art came to nothing—and everything—simply staying there, grinding its teeth, losing its bite, then losing the point of it all. It is now floating in some kind of vapid, all consuming euphoria traversed by painful spurts of lucidity, sleep-walking in its sleep, not yet dead, hardly alive, but still thriving.

— Sylvère Lotringer

Provocation

1996

The Conspiracy of Art

The illusion of desire has been lost in the ambient pornography and contemporary art has lost the desire of illusion. In porn, nothing is left to desire. After the orgies and the liberation of all desires, we have moved into the *transsexual*, the transparency of sex, with signs and images erasing all its secrets and ambiguity. Transsexual, in the sense that it now has nothing to do with the illusion of desire, only with the hyperreality of the image.

The same is true for art, which has also lost the desire for illusion, and instead raises everything to aesthetic banality, becoming *transaesthetic*. For art, the orgy of modernity consisted in the heady deconstruction of the object and of representation. During that period, the aesthetic illusion remained very powerful, just as the illusion of desire was for sex. The energy of sexual difference, which moved through all the figures of desire, corresponded, in art, to the energy of dissociation from reality (cubism, abstraction, expressionism). Both, however, corresponded to the will to crack the secret of desire and the secret of the object. Up until the disappearance of these two powerful configurations—the scene of desire, the scene of illusion—in favor of the same transsexual, transaesthetic obscenity, the obscenity of visibility, the relentless transparency of all things. In reality, there is no longer any pornography, since it is virtually everywhere. The essence of pornography permeates all visual and televisual techniques.

Maybe we are just acting out the comedy of art, just as other societies acted out the comedy of ideology, just as Italian society (though it is not alone) keeps acting out the comedy of power, just as we keep acting out the comedy of porn in the obscene advertising pictures of women's bodies. Perpetual striptease, fantasies of exposed organs, sexual blackmail: if all this were true, it would indeed be unbearable. Fortunately, it is all is too obvious to be true. The transparency is too good to be true. As for art, it is too superficial to be truly null and void. There must be some underlying mystery. Like for anamorphosis: there must be an angle from which all of this useless excess of sex and signs becomes meaningful, but, for the time being, we can only experience it with ironic indifference. In this unreality of porn, in this insignificance of art, is there a negative enigma, a mysterious thread, or, who knows, an ironic form of our destiny? If everything becomes too obvious to be true, maybe there still is a chance for illusion. What lies hidden behind this falsely transparent world? Another kind of intelligence or a terminal lobotomy? (Modern) art managed to be a part of the accursed share, a kind of dramatic alternative to reality, by translating the rush of unreality in reality. But what could art possibly mean in a world that has already become hyperrealist, cool, transparent, marketable? What can porn mean in a world made pornographic beforehand? All it can do is make a final, paradoxical wink—the wink of reality laughing at itself in its most hyperrealist form, of sex laughing at itself in its most exhibitionist form, of art laughing at itself and at its own disappearance in its most artificial form, irony. In any case, the dictatorship of images is an ironic dictatorship. Yet this irony itself is no longer part of the accursed share. It now belongs to insider trading, the shameful and hidden complicity binding the artist who uses his or her aura of derision

against the bewildered and doubtful masses. Irony is also part of the conspiracy of art.

As long as art was making use of its own disappearance and the disappearance of its object, it still was a major enterprise. But art trying to recycle itself indefinitely by storming reality? The majority of contemporary art has attempted to do precisely that by confiscating banality, waste and mediocrity as values and ideologies. These countless installations and performances are merely compromising with the state of things, and with all the past forms of art history. Raising originality, banality and nullity to the level of values or even to perverse aesthetic pleasure. Of course, all of this mediocrity claims to transcend itself by moving art to a second, ironic level. But it is just as empty and insignificant on the second as the first level. The passage to the aesthetic level salvages nothing; on the contrary, it is mediocrity squared. It claims to be null— "I am null! I am null!"—*and it truly is null.*

Therein lies all the duplicity of contemporary art: asserting *nullity*, insignificance, meaninglessness, striving for nullity when already null and void. Striving for emptiness when already empty. Claiming superficiality in superficial terms. Nullity, however, is a secret quality that cannot be claimed by just anyone. Insignificance—real insignificance, the victorious challenge to meaning, the shedding of sense, the art of the disappearance of meaning—is the rare quality of a few exceptional works that never strive for it. There is an initiatory form of Nothingness, or an initiatory form of Evil. And then there are the inside traders, the counterfeiters of nullity, the snobs of nullity, of all those who prostitute Nothingness to value, who prostitute Evil for useful ends. The counterfeiters must not be allowed free reign. When Nothing surfaces in signs, when Nothingness emerges at the very heart of the sign system, that is

the fundamental event of art. The poetic operation is to make Nothingness rise from the power of signs—not banality or indifference toward reality but radical illusion. Warhol is thus truly null, in the sense that he reintroduces nothingness into the heart of the image. He turns nullity and insignificance into an event that he changes into a fatal strategy of the image.

Other artists only have a commercial strategy of nullity, one to which they give a marketable form, the sentimental form of commodity, as Baudelaire said. They hide behind their own nullity and behind the metastases of the discourse on art, which generously promotes this nullity as a value (within the art market as well, obviously). In a way, it is worse than nothing, because it means nothing and it nonetheless exists, providing itself with all the right reasons to exist. This paranoia in collusion with art means that there is no longer any possible critical judgment, and only an amiable, necessarily genial sharing of nullity. Therein lies the conspiracy of art and its primal scene, transmitted by all of the openings, hangings, exhibitions, restorations, collections, donations and speculations, and that cannot be undone in any known universe, since it has hidden itself from thought behind the mystification of images.

The flip side of this duplicity is, through the bluff on nullity, to force people *a contrario* to give it all some importance and credit under the pretext that there is no way it could be so null, that it must be hiding something. Contemporary art makes use of this uncertainty, of the impossibility of grounding aesthetic value judgments and speculates on the guilt of those who do not understand it or who have not realized that there is nothing to understand. Another case of insider trading. In the end, one might also think that these people, who are held in respect by art, really got

it since their very bewilderment betrays an intuitive intelligence. They realize that they've been made victims of an abuse of power, that they have been denied access to the rules of the game and manipulated behind their backs. In other words, art has become involved (not only from the financial point of view of the art market, but in the very management of aesthetic values) in the general process of insider trading. Art is not alone: politics, economics, the news all benefit from the same complicity and ironic resignation from their "consumers."

"Our admiration for painting results from a long process of adaptation that has taken place over centuries and for reasons that often have nothing to do with art or the mind. Painting created its receiver. It is basically a conventional relationship" (Gombrowitz to Dubuffet). The only question is: How can such a machine continue to operate in the midst of critical disillusion and commercial frenzy? And if it does, how long will this conjuring act last? One hundred, two hundred years? Will art have the right to a second, interminable existence, like the secret services that, as we know, haven't had any secrets to steal or exchange for some time but who still continue to flourish in the utter superstition of their usefulness, perpetuating their own myth.

A Conjuration of Imbeciles

Two situations, each as critical and unsolvable as the other: the nullity of contemporary art and the political impotence in the face of Le Pen. They are interchangeable and solved by transfusion: the powerlessness to present any political opposition to Le Pen shifts to the realm of culture and of the cultural Holy Alliance. And calling contemporary art into question can only come from reactionary, irrational, or even fascist thought...

What can we use against this respected conspiracy of dunces? Unfortunately, nothing can correct this mechanism of intellectual perversion, since it emerges from the bad conscience and the impotence of our "democratic" elites when they try to resolve the impasse of art as well as the political impasse of the struggle against the Front National. The simplest solution is to confuse the two problems in a single moralizing vituperation. The real question then becomes: Is there no longer any way to "open" the problem, to utter something uncommon, insolent, heterodoxical or paradoxical without being automatically branded a member of the extreme right (which is, it must be said, a way of paying tribute to the far right)? Why has everything moral, orthodox and conformist, which was traditionally associated with the right, passed to the left?

Painful revision. The right once embodied moral values and the left, in opposition, embodied a certain historical and political urgency. Today, however, stripped of its political energy, the left has become a pure moral injunction, the embodiment of universal values, the champion of the reign of Virtue and keeper of the antiquated values of the Good and the True, an injunction that calls everyone to account without having to answer to anyone. Its political illusions frozen for twenty years in the opposition, the left in power proved to be the bearer of a morality of history rather than any historical mission. A morality of Truth, Rights and good conscience: the zero degree of politics and probably the lowest point of a genealogy of morals as well. This moralization of values was a historic defeat for the left (and for thinking): that the historical truth of any event, the aesthetic quality of any work, the scientific pertinence of any hypothesis would necessarily have to be judged in terms of morals. Even reality, the reality principle, is an article of faith. Call the reality of a war into question and you are immediately called a traitor to moral law.

With the left just as drained of political life as the right, where has politics gone? Well, it has moved to the extreme right. As Bruno Latour put it so well in *Le Monde*, Le Pen is the only one with any political discourse in France today. All the other discourses are moral or pedagogical, made by school teachers and lesson givers, managers and programmers. Given over to evil and immorality, Le Pen has swept up the political pot, the remnants of everything that was left behind, or frankly repressed, by the politics of the Good and the Enlightenment. The more the moral coalition against him hardens its stance—a sign of political impotence—the more Le Pen profits from the politics of immorality, from being the only one on the side of evil. When the right passed to the side of moral values

and the established order, the left did not hesitate, in the past, to defy these moral values in the name of political values. Today, the left has fallen victim of the same shift, the same loss of control: by investing in the moral order, it can only watch the repressed political energy crystallize elsewhere and against it. And the left can only feed the Evil by embodying the reign of Virtue, which is also the greatest hypocrisy.

Le Pen would have to be invented if he didn't exist already. He delivers us from a wicked part of ourselves, from the quintessence of the worst in ourselves. Because of this, we have to curse him—but if he disappeared, have pity on us, we would be left to all our racist, sexist, nationalist viruses (our common lot), or simply to the deadly negativity of the social body. In this, Le Pen is the mirror of the political class, which exorcises its own evil in him, just as we exorcise into the political class the inherent corruption of societal functions. The same corruption, the same catharsis. The desire to extirpate this, to petrify society and moralizing public life, to liquidate whatever takes the place of evil, this desire displays a complete misunderstanding of the mechanisms of evil, and thus of the very form of politics.

Preying on unilateral denunciation and totally unaware of the reversibility of evil, the anti-Le Penists relinquished the monopoly of evil to Le Pen, who thereby enjoys an unshakeable position because of his very exclusion. The political classes that stigmatize him in the name of Virtue provide him with the most comfortable position: he has to do nothing more than grab all the symbolic charge of ambivalence, of the denial of evil and of hypocrisy that are spontaneously produced in his favor and almost at his bidding when his adversaries claim to defend legitimate rights and the good cause. Le Pen's energy comes from his enemies, and they are quick to turn

his own errors to his own advantage. They have not realized that good never comes from evicting evil—which then exacts a spectacular revenge—but from a subtle treatment of evil by evil.

All of this to say that Le Pen is the embodiment of stupidity and nullity—obviously—but the stupidity and nullity of others, those who denounce their own impotence and their own stupidity when denouncing him. At the same time, the absurdity of confronting him directly without an understanding of this diabolical game of musical chairs only feeds their own ghost, their own evil twin with this astounding lack of lucidity.

What is it that controls this perverse effect through which the left is blocked in denunciation while Le Pen maintains a monopoly on proclamations? Where one side profits from the crime while the other feels all the negative effects of recriminations? Where he revels in evil while the left is chained to its victimization?

A simple truth: by locking Le Pen in a ghetto, the democratic left is locking itself up. It establishes itself as a discriminatory power and exiles itself in its own obsession. It instantly gives the other side the privilege of being denied justice. And Le Pen has no qualms about arguing for this republican right for his own benefit. But most of all he has established himself in the illegal, imaginary, but very profound privilege of the persecuted. Now he can benefit from the advantages of both legality and illegality. Drawing on this ostracism, he can use language more freely, proffer insolent judgments, all of which the left denies itself.

Here is an example of the magical thought that has replaced political thought: Le Pen is accused of rejecting and excluding immigrants. But this is a mere drop in the bucket of the social exclusion that is taking place at every level. And we are all complicit in and victims of this complex and inextricable process of collective

responsibility. It is therefore typically magical to conjure the virus that has spread in function of our social and technological "progress," to exorcise this curse of exclusion and our powerlessness to face it by making one man, institution or group the execrable figure of a cancer that could be extracted through a surgical operation even though it has metastasized throughout the entire body. The Front National only follows the trail of the metastasis; the germs spread all the more vigorously that we think the abscess has been eliminated. And it so happens that this magical projection against the FN treats immigrants in the same way. We should be wary of the illusion of contamination that changes the positive into a negative virus and the demand for freedom into "democratic despotism" merely through the transparency of evil. Rational intelligence never suspects the existence of this reversibility, the subtle twist of evil (despite all the things modern pathology has taught us about the physical body, we pay no attention to it for the social body).

To remain in the political realm, we have to avoid ideology and see things in terms of the social physiology. Our democratic society is the stasis; Le Pen is the metastasis. Global society is dying of inertia and immune deficiency. Le Pen is the visible translation of this viral state, its spectacular projection. It's the same as in a dream: he is the burlesque, hallucinatory figure of this latent state, of the silent inertia made up of a combination of forced integration and systematic exclusion in equal doses.

With the hope of reducing inequality in this society (almost) definitively gone, one should not be surprised to see resentment turn to the inequality between races. Social failure feeds racist success (and all other forms of fatal strategies). In this sense, Le Pen is the only wild analyst of this society. The fact that he is on the extreme right is the sad consequence of the longstanding lack of

these analysts on the left or extreme left. No judges or intellectuals could be analysts, only immigrants on the opposite end of the spectrum could possibly do so, but they have already been recuperated by certain well-intentioned movements. Le Pen is the only one who has carried out a radical elimination of the left/right distinction. Elimination by default, of course, but the harsh criticism of this distinction in the 1960s and in '68 unfortunately disappeared from political life. Le Pen has taken up a de facto situation that the political class refused to confront (it even tries to do everything to erase it through elections). But one day, we will have to face its dire consequences. If political imagination, political will and political demands ever have a chance of bouncing back, it will only be through the radical abolition of this fossilized distinction that has become meaningless and disavowed over the decades and only perseveres through a complicity in corruption. The distinction has practically disappeared, but it continues to be resuscitated thanks to an incurable revisionism, making Le Pen the creator of the only new political scene. As if everyone was an accomplice in sabotaging what little remains of democracy to give the retrospective illusion that it did once exist. Many other things today manage to survive through the mise-en-scène of their disappearance, validating their own existence through an anticipation of mourning. And Le Pen leads this death-like labor by executing the "contract."

Is there any way to draw conclusions from this extreme (yet original) situation except from the hallucinatory *medium* of Le Pen, i.e. from a magical conspiracy that drains everyone's energy? How can we avoid succumbing to this viral growth of our own daemons other than by accepting responsibility, above and beyond the moral order and democratic revisionism, for the wild analysis that Le Pen and the Front National have stolen from us?

2002

In the Kingdom of the Blind...

We have just witnessed a most remarkable *opera bouffe* or comedy of political mores, and this time the elections brilliantly deserved their reputation as a con game.

Beyond all those who let themselves fall into this trap, the electoral system as a whole and therefore the "democratic" system of representation was beaten at its own game.

Everything began with the growing indifference to politics (I do not mean among professionals) and the added indifference, since indifference itself has become a reference, a culture of indifference that is not far from becoming the only true social bond.

The first attempted diversion: "People are not indifferent to politics but to its spectacle and general corruption." Wrong: the spectacle of political degeneration fascinates people, it fascinates us. They have become indifferent to politics, to the very principle of representation, and this indifference is most certainly combined with their indifference to their own lives, thus it is neither an accidental nor a superficial phenomenon. It may even be a gut reaction of apathy in the face of the general harassment aimed at making us responsible for everything.

Montesquieu once said that "the people can become so enlightened that they are no longer indifferent to anything." Well,

it seems that the people are just enlightened enough to choose to remain indifferent to certain things and to avoid the mortal danger of being concerned by anything.

By arranging to exclude the Front National from any national representation, the dominant political class has exposed itself, totally blindly (and for over twenty years), to the risk that this exclusion could become a weapon and infiltrate society like a virus. Right and left have become one and the same. There is no hint of a solution in exorcising Le Pen by denying him existence, no more than there is a chance of eradicating terrorism by exterminating the Taliban. Le Pen thrives on exclusion from the system of representation and any reinforced exclusion strengthens him, just as any censured image automatically becomes erotic.

Antidemocratic ideologies can easily be fought and disqualified, but that is not the point: the point is the general unease with representation, present even among the democrats and antifascists. By excluding the Front National, we allow it benefits from all the potential of this unease; it becomes the flash point (*abcès de fixation*) for all of this latent indifference and ends up embodying the violent political counter-transference of a society towards itself. By being off-limits, it becomes the emblem not only of everything that is not represented or representable, but also of everything that may no longer want to be represented. This forms a vast, elusive potential that can crystallize in any place and at any time; and the political class, by definition, cannot and will not take it into account. It can only submit to its electric shock from time to time, as it did in the recent elections. But this will not teach it anything, because it will continue to think that everything is due to the naïveté or the stupidity of a part of the population that should simply be democratically pushed back into the shadows.

The only intelligent strategy (politically speaking) would obviously be to integrate the Front National in the system of representation. But even this would be pointless, because Le Pen embodies something other than political ideas or the resentment of a single category—something persistent and obscure that resists political reasoning and feeds off of this very dissidence. This is obvious when we see that, with the whole world against him, Le Pen has raked in the winnings without a fight. This is what gives him his self-assurance and air of triumph: he does not have to be credible because he does not represent anything, because he is nothing. And yet, by being nothing, he embodies it perfectly while the others mournfully shoulder the burden of representation. He is at once the absolute mockery and the truth of the situation. Le Pen is a very subtle Père Ubu, since he forced the left, in a turn of ferocious irony, to vote for Chirac, reducing them to the humiliating situation of "kneeling in suspenders." By electing the right through its own opponents, Le Pen deprived it of any real legitimacy—thus making the two conflicting parties take each other hostage and mutually disqualify each other. He did not even have to try. He simply exploited the logic of representation: the left could only vote against itself in the second round and Chirac could only govern in a vacuum, since he no longer knows who he represents.

In fact, Le Pen is a real terrorist like those of September 11th. He turned the weapons of exclusion against the system of power, just as they turned Boeings into flying bombs aimed at the towers. It was a veritable attack on the twin towers of left and right. And just as the September 11th terrorists turned their deaths into an absolute weapon, Le Pen turned the virtual divide between representatives and represented, the exclusion at the heart of the

current democratic structure, into a master weapon against the entire political class. And the legislative elections will reestablish the holy alliance to erase this blow, just as the war in Afghanistan will have served to exorcise the September 11th attacks and restore world order.

All discussions of Le Pen are apotropaic. They are aimed at warding off his evil, erasing his existence, and above all, spreading the belief that he is nothing (which, as we have seen, is painfully true, because that is his force, being this spiral paunch[1] (*gidouille*), this palotin,[2] this pataphysical specter of corruption and derision.) Remember the general relief when the Front suddenly split in 1998, as if by magic: we told you so, it was nothing, we didn't have to do anything, it fell apart on its own! Too bad: now the exact opposite is true, the left and right have fallen apart, by ruining their representative credit and no longer having an imaginary enemy to comfort them in their democratic status.

It is always the same dubious analysis, the timorous evocation of objective causes (growing insecurity, poor voting by the disenfranchised, the incompetence of the political classes, irresponsible abstention, etc.) with added shame, democratic affliction. "We have the Shame!" say the same youth from the ghettos who once shouted, "We have the Hate!"

Instead of that, the entire political class should congratulate itself for undergoing the trial of truth, giving it some chance of survival—if not of resuscitation… In the meantime, it has done everything to write itself off. Worst of all is that it has succeeded in dragging the entire population into its misery and affliction, forcing that population to mechanically and sentimentally save a political class in which it no longer believes.

Controversy

Starting From Andy Warhol

Jean Baudrillard: The only things I said about art that excited me were on Warhol, Pop Art and Hyperrealism. I think Andy Warhol was the only artist at a time when art was caught up in a very important transitional movement, the only artist who was able to situate himself at the forefront, before all the changes. Maybe it's also just luck or destiny… Everything that characterizes his work—the advent of banality, the mechanized gestures and images, and especially his iconolatry—he turned all of that into an event of platitude. It's him and nobody else! Later on, others simulated it, but he was the greatest simulator, with style to match! The exhibition of his works in Venice (Summer 1990) far surpassed and outclassed everything else in the Biennial.

Andy Warhol was a big moment in the 20th century because he was the only one who had a gift for dramatization. He still managed to bring out simulation as a drama, a dramaturgy: something dramatic slipped between two phases, the passage into the image and the absolute equivalence of all images. His principle was to say, "I am a machine, I am nothing." Since then, everyone has just repeated the same mantra, only pretentiously. He, however, thought it as something radical: "I am nothing and I can function." "I am working on every level, artistic, commercial, advertising…" "I am operationality itself!"

He affirmed the world in its total evidence, the stars, the post-figurative world (it is neither figurative nor non-figurative, but mythical). His world was glamorous and everyone in it was glamorous! Warhol's act could be considered a revisitation of art after Duchamp. According to our own coordinates and temporality, it is less a work of art than an anthropological event. That's what interests me about him: the object. He is someone who, with utter cynicism and agnosticism, brought about a manipulation, a transfusion of the image into reality, into the absent referent of star-making banality.

Warhol remains for me a founder of modernity. It is somewhat paradoxical, since modernity is usually considered more of a destruction; yet there is a certain jubilation, not at all suicidal or melancholy, because, ultimately, that's the way he is: cool, and even more than cool, totally insouciant. It's mechanical snobbism and I like that kind of provocation of aesthetic morals. Warhol freed us from aesthetics and art...

Warhol went the farthest in abolishing the subject of art, of the artist, by withdrawing from the creative act. Behind this mechanical snobbery, there is in fact an escalation in the power of the object, the sign, the image, the simulacrum and value of which the best example today is the art market itself. This goes well beyond the alienation of price as a real measure of things: we are experiencing a fetishism of value that explodes the very notion of a market and, at the same time, abolishes the artwork as work of art. Andy Warhol does not belong to any avant-garde or utopia. He settles his accounts with utopia because contrary to other artists who keep comfortably deferring the idea, he enters directly into the heart of utopia, into the heart of nowhere. He identified himself with this nowhere, he was this nowhere place that is the very definition of

utopia. He managed to move through the space of the avant-garde and reach the place it was striving to occupy: nowhere. But while others still relished the detour through art and aesthetics, Warhol skipped steps and completed the cycle in a single stroke.

Françoise Gaillard: *You are talking about the Warhol phenomenon, but today his works are still considered to be artworks, the kind that are hung in museums...*

Let's talk about that! Like everyone, I had seen many reproductions. Venice was the first time I saw so many works together, and an exhibition is no small matter... When you see the *Liz Taylors*, the *Mick Jaggers* or *The Chairs*, they beat any Velazquez room in the Prado! The *Mao* portraits could hold their own with paintings by the grand masters, but that would be a bonus because in reality they are painted or serigraphed on a backdrop of radical indifference!

I like it all the more in that I have always more or less done the same thing: reaching a certain emptiness, attaining a zero-level capable of bringing out singularity and style. And be brilliant! He achieved just that by asserting that everything is brilliant, art, everyone... It's a wonderful statement!

For art people, the ones who define themselves by very elitist standards, this is obviously unacceptable. But today these standards are all the more false because they are indefensible. The moral law of art has now disappeared. There only remain rules to a game that is radically democratic. It is even more than democratic: it is indifferentiating. Warhol went that far, though without theorizing it since everything he says is wonderful in its naiveté, its false naiveté. And moreover he didn't say anything because there was nothing to get out of him. He was abused for this attitude.

You see him as someone who, at a given moment, gave "expression"—
not to use the term "aesthetic expression"—to a certain reality, a social
evidence?

Yes, an evidence of annulation.

And at the same time an aestheticization of all expressive products?

Yes, he pushed aesthetics to the limit, to the point where it no longer had any aesthetic quality and reversed into its opposite. There was a fantastic coherence to the Venice exhibition. You could see scenes of violence, car accidents for example, images that were the last photograph to be taken or found. They are not exaggerated, they are exactly, literally, literalized! And then there is no blackmail: he takes the world as it is with its stars, its violence, the world the *media* makes such a repulsive fuss about, which is what is killing us! Warhol totally loots this world.

He takes away its pathos?

He cools it down, so to speak, but he also makes it an enigma. In his works, he gives an enigmatic force back to a banality that we *seem*—and I say this emphatically!—to have completely unmasked and denounced morally. We can denounce it forever, but it will keep existing. End of story!

Other opuses existed alongside Warhol's own work—Rauchenberg,
Lichtenstein…—and touched on a little bit of everything, using
objects and comic books, but in terms of lyrical residues. As if to reach
a kind of re-aesthetization of this residue…

That's right, they re-aestheticize it. For Warhol, it is not residue, it is substance or at least non-substance.

It is both total affectation, radical snobbism and at the same time total non-affectation, absolute candor in relation to the ignorance of the world. And this world, without wanting to, knows what it is: it is no longer the natural, substantial, ideological world... It knows that it is a world of images that are no more, images without imaginary. If we could beam Warholian waves through our neurons, we might avoid such intoxication.

Your trips to the United States in the past few years have put you in contact with certain movements and artists who, explicitly or not, claim to play off Warhol's influence, and others who, like Koons, use him as a starting point and try to outmatch each other with kitsch. You have even been made the spokesman of a certain avant-garde that is now spreading in Europe.

There are those who cultivate the connection to Warhol and those who distance themselves from him because it is too dangerous. They claim that Warhol was a primitive in the art of simulation since they are the "true simulators."

This marking of distance culminated in an exhibit at the Whitney in New York, of which I became involved in spite of myself. True, some artists refer to me through my writings and my ideas on simulation. In fact, it was a strange trap that forced me to reestablish my bearings. Simulation has been all the rage in the art world in recent years. I see it as an phenomenon totally ancillary of events that preceded it, including Warhol.

How can I defend myself from a truth when I am more and more convinced that the people in art do not have the slightest idea,

the slightest thought about what is now really happening. These artists are sly and pretentious when they claim to see things twice removed, when they claim to be even more null because they are the "true simulators" of pure reappropriation, pure copying. How can one react to this mise-en-abîme in which they themselves use the terms "banality, simulation, loss of referent," the arguments of a critical analysis that are by now meaningless?

At the Whitney event, these artists tried to categorize me as a precursor without engaging in any discussion or debate with me. This has led, among other things, to the "Neo-Geo" school, a very marginalized and confused group. There is nothing to add to this nullity caused by authors, otherwise oftentimes very intelligent, incapable of putting up with their own nullity. In spite of myself, I served as an alibi and reference, and by taking what I said and wrote literally, they missed simulation.

In other words?

It's the illness of aestheticization. In simulation, there is a risk, a challenge that is not predetermined. When you say there are signs, simulation, people reply by saying, "If there is no reality, only simulacra, since we are inside, we go for the simulacrum." You can never know if it is a complete rip off or not, and at the same time, you cannot argue the point. This is a way of denying the essential since simulation, in itself, is still a metaphoric game with many things, including language, that they do not take at all into account. There may be, in simulation, a kind of short circuit between reality and its image, between reality and representation. In the end, these are the same elements that once served to constitute the reality principle; except that here they collide and cancel each other out,

somewhat like matter and anti-matter. What comes out of it, the universe of simulation, is fascinating, phantasmagorical, whereas these artists have only recovered and expressed its fastidious and boring side...

Perhaps because these artists belong to a generation that is no longer in this phase of dramatizing simulation. They no longer know what was at stake in the opposition between sign and reality!

I realized too late that in the United States they made the journey in reverse. This analysis was made in a utopian manner; it cancels out what you said and at the same time consecrates it all.

These artists were born into simulacrum, into truth because the situation is such, over there, that the simulacrum is true. Then they turn to Europe to find some vague theorizing, which leads to bastardized things. Jeff Koons' attitude is clear: it's rewriting done after and in relation to Warhol. It's a post-modern remake, not really that shitty (la Cicciolina isn't either, as a porn star!)

You mean that, in this case, the imaginary and dream-like dimension present in Warhol's star portraits is gone? The threat of death is gone and it has become completely "Saint-Sulpician"?

It's no longer an object of desire! La Cicciolina is mindless, maniacal desire. It's a wax museum! Even banalized by serigraphy, Warhol's stars were expressing something intensely about death, about destiny... Koons is not even a regression: it's just mush! You see it then forget it. Maybe it's made for that...

1996

Art between Utopia and Anticipation

Ruth Scheps: *In one of your articles, you wrote, "The entire movement of art has pulled out of the future and moved to the past".!*[1] *Does that mean that painting—and maybe art in general—has pulled out of the function it once might have had of anticipating things to come?*

Jean Baudrillard: That is in fact what it would mean literally, but saying it that way is a bit too simple. There has certainly been a movement of retraction, a halting of perspectives, in as much as the avant-garde ever truly meant something. In that case you could say that avant-garde utopias have been replaced by regressive utopias and that this rear guard is perhaps now in the pole position. That sentence develops the idea that art is going through a sort of traveling shot of its own history, a more or less authentic or artificial resurrection of all its past forms. It can surf through its history and rework it, not exactly by exploring new fields—after all, maybe the aesthetic world is finite like the physical universe—but by veering along the final and necessary curve of things. There is no exponential linearity of human progress, even less so for art, where the linear function has always been a problem. No one ever thought that art was going from one point to another, with a final destination.

Listening to you, it sounds like we are already close to the end of time! It might nevertheless be interesting to take a step back and see how the various avant-gardes of our century imposed a certain vision of the artist as a precursor...

It's true that I am somewhat obsessed with the final expiration date. But it is out of curiosity, not out of some apocalyptic spirit, that I tend to put things in the perspective of an end point to see what happens to them. At that point, art, the economy, etc. all have the same problem. So yes, it might be interesting to see if there was not something determinant, traumatic in art; for example in the rise of someone like Duchamp.

And maybe even before, if you look at how art accompanied culture as a whole starting in 1875?

It is obvious that art already changed direction with the sudden and maybe seductive break into abstraction. The passage through abstraction is a considerable event. It is the end of a system of representation, although probably not the end of art, to the contrary. I still see abstraction both as a complete renewal of things and as an aberration. It is potentially dangerous for art to the extent that the aim of abstraction (and modernity in general) is to move towards an analytical exploration of the object, in other words, shedding the mask of figuration in order to find behind appearances an analytical truth for the object and for the world.

Isn't that parallel to the scientific approach?

Indeed. It is absolutely parallel to the approach of modernity as a whole, be it social or scientific, and I wonder if one could not already find there a corruption of art by science, or at least by the spirit of objectivity.

Reaching farther towards the basic structures of the object and the world, crossing through the looking-glass of representation and reaching the other side to provide a more elementary truth of the world is grandiose if you like, but also extremely dangerous to the extent that art is nonetheless a superior illusion (at least I hope so!) and not a progress towards analytical truths. This turn is therefore already a problem. But for me, the major turn began with Duchamp (although I don't insist on sacralizing him): the event of the readymade indicates a suspension of subjectivity where the artistic act is just the transposition of an object into an art object. Art is then only an almost magic operation: the object is transferred in its banality into an aesthetics that turns the entire world into a readymade. In itself Duchamp's act is infinitesimal, but starting with him, all the banality of the world passes into aesthetics, and inversely, all aesthetics becomes banal: a commutation takes place between the two fields of banality and aesthetics, one that truly brings aesthetics in the traditional sense to an end.

And for me, the fact that the entire world becomes aesthetic signifies the end of art and aesthetics in a way. Everything that follows—including the resurgence of past forms of art—becomes readymade (a bottle, an event or its reenactment). The forms of the history of art can be taken up as such; they only need to be transferred into another dimension to make them readymades, like Martin O'Connors, for example, takes up Millet's *Angélus* in his own way. But this readymade is less pure than Duchamp's, whose act reaches a certain perfection in its bareness.

Would the precursor Duchamp be one of the last artists to anticipate?

In a certain way, he writes off all structures of representation and, in particular, expressive subjectivity, the theater of illusion: the world is a readymade and all we can do is to maintain the illusion or the superstition of art by means of a space in which objects are moved and which will necessarily become a museum. But the museum, as its name indicates, is a sarcophagus all the same.

Now all is not over. Duchamp put a scenario in place, but within this generalized aesthetics—and therefore within this inaesthetics of things—very magical events can occur! Andy Warhol is an example, another artist who introduced nothingness into the heart of the image. That is also a fantastic experience, but one that seems to me to be outside the realm of art history.

Hasn't art in the second half of our century largely renounced the pretensions it had to change life?

Personally, I find art increasingly pretentious. It wants to become life.

That is a different pretension than wanting to change it?

There was a Hegelian perspective in which one day art would be brought to an end. As for Marx it was supposed to bring an end to economics or politics, because these would no longer have any reason to exist given the transformations in life. The destiny of art is therefore effectively to go beyond itself into something else, whereas life...! This glowing perspective evidently did not materialize. What happened is that art substituted itself for life in the form of a generalized aesthetics that finally led to a "Disneyfication" of the

world: a Disney-form capable of atoning for everything by transforming it into Disneyland, takes the place of the world!

What you call the simulacrum.

Yes, but this term now covers so many things! The simulacrum was still a game with reality. Here, the world is literally taken as it is and "Disneyfied," in other words virtually sealed. And like Disney himself, who placed himself under "cryogenic seal" in liquid nitrogen, we risk cryogenization in a virtual reality.

The *Disney* company is buying up 42nd Street in New York. It might turn it into an international *Disney* attraction, where prostitutes and pimps would merely be characters in the virtual reality of the *Disney* aesthetic! This mutation is more decisive than the simulacrum or simulation I have analyzed. In any case it is something other than the *Society of Spectacle* Guy Debord spoke of (1967), which at the time was a powerful analysis but has lost its power because we are beyond it. There is no more spectacle, no more possible distance, no more alienation where you could be something other than yourself. Not any more. The same is changed into the same and in so doing, the readymade has gone global.

Duchamp's "trick" was both a fantastic act and, at the moment when it emerged, something absolutely new. And it has still become a sort of fate.

Is what art anticipates today a generalized virtualization of future society as a whole?

In any case, galleries now primarily deal with the byproducts of art. In New York, where many galleries have disappeared, the remaining

ones mainly attempt to manage the residues: waste is not only a frequent theme, but the very materials of art are dejecta, and the styles are residual. You can do anything, which also leads to virtual reality where you can enter inside the image (until recently images were exterior). With video, the image is interiorized, you penetrate into it, and there, almost at the molecular level, you can surf anywhere and effectively do anything. For me, this is the end of art and rather resembles a technological activity. It seems to have become the orientation of many artists.

Do you find this proliferation to be negative in certain ways?

Certainly not. I am not making value judgments because I am completely incapable of entering that world and seeing it from the inside. I don't even know how to use a computer. So I see it in somewhat metaphysical terms and, from that point of view, I would definitely have an almost total resistance to all that. Luckily or not, we increasingly live in real time where it is perfectly impossible to foresee what will happen in a future time that no longer exists. For future time no longer exists: this is the opposite of what we spoke of at the beginning, in other words all of the future is carried back to the past of which it is also the memory. There is a real time, an immediate accomplishment and a sort of readymade as well, an instantaneity with a slight difference, that's all.

And this instantaneity contains many quotations of past works.

Exactly. Art has become quotation, reappropriation, and gives the impression of an indefinite resuscitation of its own forms. But tangentially, everything is a quotation: everything is textualized in the

past, everything has always already existed. Yet this art of quotation, reappropriation, simultaneity, etc. is different. It plays on the fossilized irony of a culture that no longer believes in that value. In my opinion, the artistic world no longer believes deeply in a destiny of art. I remember saying to myself after the 1993 Venice Biennial that art is a conspiracy and even an "insider trading": it encompasses an initiation to nullity and, without being disdainful, you have to admit that there, everyone is working on residue, waste, nothingness. Everyone makes claims on banality, insignificance; no one claims to be an artist anymore.

Really everyone?

The two discourses exist, but the dominant reflection, "politically correct" in terms of aesthetics, is: "I speak waste, I transcribe nullity, insignificance." It is both fashionable and the mundane discourse on art, and they work in a world which in fact may have become insignificant, but they do it in an insignificant way as well, and this is annoying! But it all works very well; you can see the mechanisms being deployed, maintained by the galleries, the critics and finally by a public that has no other solution than to pretend at the very least to enter it. All of that creates a sort of "bachelor machine" that works all by itself.

A closed world?

A completely self-referential world.

This self-referentiality, you see it more as self-reverence than freedom if I understand you correctly.

Of course, it justifies itself from the inside and increasingly so. However, art in terms of aesthetic surplus value is growing every day. Its symbolic expression is the art market, which has attained complete autonomy, completely cut off from the real economy of value, and has become a sort of fantastic excrescence. This art market reflects what is happening aesthetically, in other words perfectly foreign to the so-called "real" world (but since I don't really believe in it either, it's not too serious). The art market is not really a Mafia, but something that formed according to the rules of its own game, and whose disappearance would go unnoticed. It still exists, better and better, while the foundations of value are increasingly weaker. So I call it a conspiracy, although I do recognize a few exceptional individuals.

For example?

Some of the people I like are Hopper, Bacon. Warhol is something else, I have always taken him metaphysically, like the reference copy of a script, but not as an artist (it would be a contradiction to call him an artist since he did not want that). There are therefore exceptions that confirm the rule. In other words, the world is aligned on a revolutionary act—the readymade—and forms survive on this counter-field, but all the rest, all of this mechanism has become value (aesthetic value and market value). Art has been transformed into value, and we should oppose form to value—for me, art is fundamentally form—and say that we have been caught in the trap of value and even, through the art market, into a sort of ecstasy of value, a bulimia, an infinite excrescence of value. Luckily, however, I still believe that form—in other words the illusion of the world and the possibility to invent this other scene—persists, though through a form of radical exception.

Should we turn to form and eventually imagine new forms of utopia?

Maybe so, but then again, you cannot establish the possibilities or the conditions for this process. It is only as another illusion, one that would rediscover the possibility that colors, forms, light transform into each other, which would lead painting—and language as well—to something you can see in Bacon, for instance, even if these forms can be perfectly monstrous in his work. But this is not exactly the problem: these forms can account for a monstrous world and transfigure it, like Warhol did. Warhol reckons with the nothingness of the image and its insignificance, but he does it in a magical and transfiguring way (except at the end when he also got caught in this trap). There the game is different, so perhaps we need a different type of illusionist to recreate the emptiness where the pure event of form can take place. But one can only open this perspective in a very general way: it's an idea and it's happening, that's all one can say. That is what I am trying to accomplish in my writing, but I have no control over what happens somewhere else.

And in this case it is unforeseeable?

I think that it is impossible to conceive of what the new generation will be like. As long as there was a certain history of art, even critical and contradictory, with avant-gardes, it was possible to foretell and anticipate, to invent, to create "revolutionary" micro-events, but now I think that is no longer possible. There can still be, as in other worlds, singularities on a backdrop of a virtually flat "aesthetic encephalogram." These singularities are unpredictable and could very well be ephemeral, not entering History, in short events that arise against, just as in politics the real events

today are singularities that come from beyond and take place against politics and history. There can no doubt be trans-aesthetic singularities, things that emerge from an alterity and are therefore unpredictable.

It is your vision, but is it also your hope?

It is not a question of hope. I have no illusion, no belief, except in forms—reversibility, seduction or metamorphosis—but these forms are indestructible. This is not a vague belief, it is an act of faith, without which I would not do anything myself.

Today, though, the pitfalls of all-powerful value and of the transcription into value are so strong that you can see the province of this type of form diminishing. Unfortunately, forms have no history; they probably have a destiny but not exactly a history, so it is very difficult to conclude any future from the past. And the hope that is still a virtue associated with this continuity of time also seems slight to me. I believe it is better to navigate, not with despair—I am no pessimist either—but based on an indeterminate aspect.

You cannot foresee what will happen in there at all, but we should be able to have an awareness that things have reached a certain end, an end that does not mean everything is finished. The aim of this modernity has reached its end, which is usually rather monstrous or aberrant, but where all possibilities have been exhausted or are being exhausted, everything ending in this sort of range of virtual reality that no one really knows anything about, despite the abundance of writing on the subject. At present, we are wearing the helmet, the digital gear of virtual reality. We hope that even this virtuality is virtual, in other words that we will no longer

have to deal with it, but it is now in the process of annexing all possibilities for the moment, including the possibilities of art, since with the multiplicity of artists working today, even if they are not working with computers or digital images, etc. if they redo what has been done, if they remix past forms, it amounts to the same. They don't need computers: this indefinite combination, which is no longer art per se, happens in the mind.

No Nostalgia for Old Aesthetic Values

Genevièvre Breerette: *On May 20, 1996, you published in the* Libération *newspaper a column called "The Conspiracy of Art," in which you repeatedly state that contemporary art is null, really null. What works, what exhibitions inspired your statements?*

Jean Baudrillard: The misunderstanding, which I am not trying to avoid, is that art, basically, is not my problem. I am not aiming for art or artists personally. Art interests me as an object, from an anthropological point of view: the object, before any promotion of its aesthetic value, and what happens after. We are almost lucky to live at a time when aesthetic value, like others by the way, is foundering. It's a unique situation.

I do not want to bury art. When I speak of the death of the real, it does not mean that this table here does not exist; that's foolish. But it's always understood that way. I can't help it. What happens when you no longer have a system of representation to picture this table? What happens when you no longer have a system of values suitable for judgment, for aesthetic pleasure? Art does not have the privilege of escaping this provocation, this curiosity. But it would deserve a special treatment, because it claims to escape banality the most and that it has the monopoly on a certain sublime, on tran-

scendent value. I really object to that. I say that you should be able to apply the same critique to art as to everything else.

You name no artists, other than Andy Warhol whom you happen to praise, which leads one to think that your statements are not as reactionary as has been said.

If I use Warhol as a point of reference, it is because he is outside the limits of art. I treat him differently from an almost anthropological perspective on the image. I do not return to him aesthetically. And then, I am in no position to say, "this one is bad, this one isn't."

You still take the liberty of saying that almost all contemporary art is null...

But I do not put myself in a position of truth. Everyone makes his or her own choices. If what I say is worthless, just let it drop, that's all.

The article was written a little hastily. I should not have started like that. I should have said that there is a hint of nullity in contemporary art. Is it null, or isn't it? What is nullity? My article is perfectly contradictory. On the one hand, I use nullity as null or nothing, and on the other, I say: nullity is a tremendous singularity. That is a critique that could have been made.

My text reflects a mood, an obsession with something, something more. That we have moved from art as such to a sort of trans-aestheticization of banality... It comes from Duchamp, okay. I have nothing against Duchamp, it is a fantastic and dramatic turn.

But he did set in motion a process in which everyone is now implicated, including us. What I mean is that in daily life, we have this "readymadeness" or this trans-aestheticization of everything

which means that there is no longer any illusion to speak of. This collapsing of banality into art and art into banality, or this respective game, complicit and all... Well, from complicity to conspiracy... We are all compromised. I am not denying it. I certainly have no nostalgia for old aesthetic values.

What is art for you?

Art is a form. A form is something that does not exactly have a history, but a destiny. Art had a destiny. Today, art has fallen into value, and unfortunately at a time when values have suffered. Values: aesthetic value, commercial value... values can be negotiated, bought and sold, exchanged. Forms, as forms, cannot be exchanged for something else, they can only be exchanged among themselves, and the aesthetic illusion comes at that price. For example, in abstraction, when the object is deconstructed, when the world and reality are deconstructed, there is still a way to exchange the object in itself symbolically. But abstraction later became merely a pseudo-analytical procedure for decomposing reality, not deconstructing it. Something has fallen apart, perhaps through the sole effect of repetition.

Did you see the exhibition "L'Informe" at the Centre Pompidou that deals with this problem by means of superb works?

No. Art can still have a strong power of illusion. But the great aesthetic illusion has become disillusion, concerted analytical disillusion, which can be performed brilliantly—that is not the problem, except that after a while it runs on empty. Art can become a sort of sociological, socio-historical or political witness. It then

becomes a function, a sort of mirror of what the world has in fact become, of what will become of it, including its virtual involvement. We may have reached farther into the truth of the world and of the object. Yet art, of course, has never been a question of truth but of illusion.

Don't you find that there are artists who do well despite this?

I could say they do too well...

You think this is the time to say that?

My concern is not the misery of the world. I don't want to be cynical, but we are not going to protect art. The more cultural protectionism we enact, the more waste we have, the more false successes, false promotions there are. It puts us in the marketing realm of culture...

To put it naively, the pretension of art shocks me. And it is hard to escape, it did not happen overnight. Art was turned into something pretentious with the will to transcend the world, to give an exceptional, sublime form to things. Art has become an argument for mental prowess.

The mental racket run by art and the discourse on art is considerable. I do not want anyone to make me say that art is finished, dead. That is not true. Art does not die because there is no more art, it dies because there is too much. The excess of reality disheartens me as does the excess of art when it imposes itself as reality.

La Commedia dell'Arte

Catherine Francblin: *I wanted to do this interview with you because —after the shock of reading your article, I believed it should be placed in the more global perspective of your thought. It seems to me that you are only interested in art to the extent that you find in it behaviors and functions that add to your critique of Western culture.*

Jean Baudrillard: True, art is on the periphery for me. I don't really identify with it. I would even say that I have the same negative prejudice towards art as I do towards culture in general. To that extent, art has no special privilege in relation to other systems of values. Art is still considered to be an unimaginable resource. I protest this idyllic view.

My point of view is anthropological. From this perspective, art no longer seems to have a vital function; it is afflicted by the same fate that extinguishes value, by the same loss of transcendence. Art has not escaped this tendency to effectuate everything, this drive to make everything totally visible to which the West has arrived. But hypervisibility is a way to extinguish sight. I consume this art visually, I can even take a certain pleasure in it, but it does not provide me either illusion or truth. Now that the object of painting has been called into question, then the subject of painting, it

seems to me that this third term has not received as much attention: the viewer. He or she is increasingly solicited, but held hostage. Is there a way of looking at contemporary art that wouldn't be the way the artistic milieu views itself?

Let's talk about this artistic milieu... You treat it very harshly since, alleging a "conspiracy of art," you describe those who belong to it as conspirators...

When I speak of a "conspiracy of art," I am using a metaphor, as I do when I speak of the "perfect crime." You can no more identify the instigators of this plot than you can designate the victims. This conspiracy has no author and everyone is both victim and accomplice. The same thing happens in politics: we are all duped and complicit in this kind of showcasing. A sort of non-belief, of non-investment makes it so that everyone is playing a two-faced game in a sort of infinite circularity. And this circularity seems to me to contradict the very form of art, which supposes a clear distinction between "creator" and "consumer." Everything arising from this confusion, in the name of interactivity, total participation, interfaces, and the rest, bores me...

I do not get the impression in reading your article that you consider yourself to be complicit to it... It seems to me that you want to put yourself in the place of the uninitiated, of those who are being fooled.

I play the role of the Danube peasant: someone who knows nothing but suspects something is wrong.[1] I claim the right to be "indocile." The in-docile person, in the original meaning of the word, is someone who refuses to be educated, instructed, trapped by

signs. I want to carry out a diagnostic by looking at things like an agnostic… I like being in the position of the primitive…

So you are playing naïve!

Yes, because as soon as you enter the system to denounce it, you are automatically made a part of it. There is no ideal omega point today from which hard and fast judgments can be made. You can see that those who make accusations against the political class are the same ones who replenish it. The class is fed by the accusations made against it. Even the bluntest critic is caught up in this circularity.

Aren't you maintaining the illusion that this critical position, now impossible according to you, could be occupied, on the contrary, by Mr. Everyone.

I think, actually, that the masses, although they participate in the game, and although they are held in a position of voluntary servility, are perfectly incredulous. In this sense, they offer a certain form of resistance to culture.

That reminds me of another of your articles in Libération, *and article titled "Serfs and Elites" in which you criticize the elite by saying that the so-called blind masses could in fact see very well… That may be true concerning politics, but could you say that these masses see clearly spontaneously in matters of art? In this domain, the public is mostly conformist…*

In the political domain, the opacity of the masses neutralizes the symbolic domination exercised on them. It is possible that the opacity

of the masses is not as great in the field of art and consequently diminishes their critical powers. There still is no doubt a certain appetite for culture... If culture has taken over from politics, it has also taken over in the regime of complicity. But the artistic consumerism of the masses does not imply that they follow the values taught to them. *Grosso modo*, this mass has nothing left to oppose. We are witness to a form of alignment, of general cultural mobilization.

Excuse me, but doesn't your critique of elites risk converging with extreme right-wing demagogy?

The terms left and right are indifferent for me. It is true that you cannot say the masses are dupes, because there is no manipulation, no objective exploitation. It is more of a fundamentalism (*intégrisme*) in the sense that everyone is to be finally integrated into the circuit. Any trickery occurring is in the political and intellectual class. There, yes, people are victims of their own values. And it's the almost mythomaniacal power these values hold over them that leads them to separate themselves as a class and to call on all those operating outside to come play inside.

Aren't you simply calling into question the system of democracy?

The democratic regime works less and less. It works in a statistical way, people vote, etc. But the political sphere is schizophrenic. The masses in question remain entirely outside this democracy of discourse. People don't have anything to do with it. Active participation is extremely low...

Isn't that what politicians on the right are saying?

They say it in order to benefit from the mobilization of the masses... "Come on our side!" etc. But on the level of beliefs, of the projection of self into values, the masses are neither on the left or the right.

You cannot isolate them, we are all included... What interests me is that all the efforts made for a radical mobilization of the masses are useless. Beyond taking positions and surface judgments, there is a resistance of the masses to politics as such, in the same way that there is a resistance to the system of aestheticization and culturization. This ever-growing public that was first conquered politically and that they now want to conquer and integrate culturally is definitely resisting. It resists progress, it resists the Enlightenment, education, modernity, etc.

This pleases you, doesn't it?

Certainly. To the extent that there are no more critical imperatives, I don't see any other possibility for opposition—another conspiracy, but an enigmatic, indecipherable one. All discourses are ambiguous, including my own. They are all caught up in a certain form of shameful complicity with the system itself. And the system counts on this ambiguous discourse to act as a guarantor for it. Thus judges are the guarantors of the political classes; they are the only ones interested in it. The system thrives by persecuting itself. On the other hand, on the side of the masses, there is something uncultivated and irreducible to political, social or aesthetic control... Everything now tends to be realized, and increasingly so. One day, the social will be perfectly realized, and only those excluded will remain. One day, everything will be culturalized, every object will be a so-called aesthetic object, and nothing will be an aesthetic object...

As the system perfects itself, it promotes integration and exclusion. In the computer field, for example, the more the system is perfected, the more people are left out. As Europe is being made, will be made, and as it comes to be, dissidence raises against this European voluntarism. Europe will exist, but England will not be a part of it, the regions will not be a part of it, etc.

The gap continues to grow between the formal realization of things, led by a cast of technicians, and its real implantation. Reality is not at all aligned on this willful realization at the top. The distortion is sizable. Triumphant discourses only survive in a total utopia. They maintain their belief in universality, whereas for some time it has only been achieved self-referentially. And since society has all the means to maintain a fictive event, it can last indefinitely...

You just spoke of the indifference of the public. However, in your article, you go a step farther... You say something like "the consumers are right because for the most part contemporary art is null." Can art be treated with a "for the most part"? If there is art, it is more in the part you neglect, the "lesser part."

I agree, but there is nothing to be said for singularity. I am now looking over the bulk of writing on Bacon. For me, it all adds up to zero. All of these commentaries are a form of dilution for the use of the aesthetic milieu. What can be the function of this type of object in a culture in the strongest sense of the word? We are not going to return to primitive societies, but in anthropological cultures, there is no object that escapes a global circuit of either use or interpretation... A singularity does not disseminate itself in terms of communication. Or only in such a restricted circuit that it is just a fetish. In classical societies as well, the circuit of circulation of

symbolic objects was restricted. A class shared the symbolic universe, without giving an extreme importance to it really, but without claiming to include the rest of the world. Today, we want everyone to have access to this universe, but how does it change life? What new energy does it bring? What are its implications? In the aesthetic world, the superstructure is so crushing that no one has a direct, raw relationship with objects or events. It is impossible to clear everything away. Only the value of things are shared, not their form. The object itself, in its secret form, the reason why it is this object and not another, is rarely reached.

What is this form? Something that is beyond value and that I attempt to reach using a sort of emptiness in which the object or the event has a chance to circulate with maximum intensity. What I am objecting to is aesthetics, this surplus value, this cultural exploitation through which the proper value disappears. We no longer know where the object is. Only the discourses surrounding it or the accumulated views end up by creating an artificial aura... What I observed in *The System of Objects* [1968, English translation, 1996], can now be found in the aesthetic system. In the economic realm, starting at a certain point, objects cease to exist in their finality; they only exist in relationship to each other, in such a way that what we consume is a system of signs. In aesthetics, the same is true. Bacon is officially used as a sign, even if, individually, everyone can try to pursue an operation of singularization to return to the secret of the exception they represent. But today, a good deal of effort is needed to pass through the system of education and abduction by signs! To find the point where form appears—which is also the point where all this ornamentation falls apart ... the blind spot of singularity can only be reached singularly. This is contrary to the system of culture, which is a system

of transit, transition, transparency. And I could care less about culture. Anything negative that can happen to culture is fine with me.

You told Geneviève Breerette in Le Monde *that you did not speak a discourse of truth, that no one was obliged to think like you... What did you mean exactly?*

That I do not want to make my statements on art an affair of doctrine. I put my cards on the table, now it is up to others to invent their rules just as I invented mine. In other words, what I affirm has no intrinsic value. Everything depends on the response. The art object presents itself as a fetish object, a definitive object. I totally refuse to present things categorically, outside debate.

There is an appeal, not in the mode of conciliation or compromise, but rather of alterity, of the duel. The question of form returns. The form never speaks the truth of the world; it is a game, something that projects itself...

What seemed difficult to swallow in your article is that you are known for your interest in images. You exhibit your own photographs... Some felt like they were betrayed by one of their own... What are the implications of the photos you take?

Of course, with my pictures, even if I take them for myself, as soon as I exhibit them, I am in an ambiguous position. This is an unresolved problem for me... But I truly have a direct pleasure in taking them, outside any photographic culture, or any search for objective or subjective expression. At a given moment, I capture a light, a color disconnected from the rest of the world. I myself am only an absence in them.

Capturing your absence from the world and having things appear... That my photos are judged to be beautiful or not does not interest me. The stakes are not aesthetic. It is more an anthropological arrangement that establishes a relationship with objects (I never photograph people), a glance on a fragment of the world allowing the other to come out from his or her context. It may be that the person viewing these photographs can also look aesthetically and be caught up in interpretation. It is even almost inevitable, since from the moment when these photos enter in the gallery circuit, they become objects of culture. But when I take photos, I use a language as form and not as truth.

This secret operation seems crucial to me. There are thousands of ways to express the same idea, but if you do not find the ideal compression between a form and an idea, you have nothing. This relationship with language as a form, as seduction, this *punctum*— as Roland Barthes would have said—has become harder and harder to find.

But only form can cancel out value. One excludes the other. Criticism can no longer consider itself today in a position of alterity. Only form can oppose the exchange of values. Form is unthinkable without the idea of metamorphosis. Metamorphosis moves from form to form without the intervention of value. No meaning, either ideological or aesthetic, can be drawn from it. It enters the play of illusion: a form only refers to other forms with no circulation of meaning. This is what happens in poetry, for example: the words refer to each other, creating a pure event. In the meantime, they have captured a fragment of the world, even if they have no identifiable referent from which a practical instruction can be drawn.

I no longer believe in the subversive value of words. However, I have an unwavering faith in the irreversible operation of form.

Ideas or concepts are all reversible. Good can always be turned into evil, truth into falsehood, etc. But in the materiality of language, each fragment uses up its energy, and there is nothing left save a form of intensity. It is something more radical, more primitive than aesthetics. In the 1970s, Roger Caillois wrote an article in which he called Picasso the great liquidator of all aesthetic values. He claimed that after Picasso, no one could conceive of anything more than a circulation of objects, of fetishes, independent of the circulation of functional objects. One could say, in fact, that the aesthetic world is the world of fetishizing. In the economic realm, money must circulate in any manner it can, otherwise there is no value. The same law governs aesthetic objects: there have to be more and more in order for an aesthetic universe to exist. Objects now only have this superstitious function leading to a de facto disappearance of form through an excess of formalization, in other words through an excess use of all forms. There is no worse enemy to form than the availability of all forms.

You seem nostalgic for a primitive state ... one that, in reality, certainly never existed...

Of course, and that is why I am not a conservative: I do not aspire to regress to a real object. That would mean cultivating reactionary nostalgia. I know this object does not exist, no more than truth does, I maintain the desire for it through a glance that is a sort of absolute, a divine judgment, in relationship to which all other objects appear in their insignificance.

This nostalgia is fundamental. It is lacking in all kinds of creations today. It is a form of mental strategy governing the correct use of nothingness or the void.

Too Much is Too Much

Sylvère Lotringer: The Conspiracy of Art *elicited pretty strong reactions among the art world. It was taken as a full-fledged attack on contemporary art. "Consternation is spreading through the cultural community," a critic commented, wondering whether this was "an abrupt wake-up call or simply a lack of manners."*

Jean Baudrillard: *The Conspiracy of Art* positioned me as an enemy of art. But you know that I have no vested interest in art while all these people make their living from the idea. For me art is not privileged. With writing, it is possible to critique from the inside, to do a truly *critical* critique. But it is out of the question in a world like the art world, because of the complicity of reciprocal praise. That is what I wanted to denounce: passivity and servility as a form of conspiracy. The idea of art's collusion. Its unabashed complicity with the state of things.

What's surprising really is that the art world was so shocked. What you thought of art was pretty clear from the start. In The Consumer Society *(1970) you already stated explicitly that the humor of Pop Art had nothing subversive about it, its "cool smile no different from commercial complicity. In* For a Critique of the Political Economy

of the Sign *(1972) you pointed out that art has an ambiguous status, half-way between a terrorist critique and a de facto cultural integration. You explicitly stated then that contemporary art was nothing but "the art of collusion," merely pretending to subvert an order that was in fact its own. In* The Conspiracy of Art *you simply took this judgment a bit further by addressing the art world directly, challenging it to answer in kind. And your timing was right: the global inflation of art is reaching truly pataphysical heights. Art today is in denial of its own reality.*

Some have criticized me for being "mean" with art. But artistry is growing stronger everywhere and find it intolerable. It does not even dare match political cynicism. The convivial, the interactive elements are all offered for consumption like sacrament.

Do you think it is more prevalent in art than in politics?

No, this is not only true of the art world. Politicians in France no longer know who they are, and intellectuals don't know either. There is no space between them capable of creating some tension, some intensity. So it's a drift into the void, each one trying to replace the other, to reenergize the political machine. Intellectuals are trying to save politics, but they are not playing the game, and taking it to an extreme. Le Pen does not work with representation as they do. He works with appearance, and he has all the tobacconists on his side. So politicians are right to be scared. Without realizing it, without even pushing for it, Le Pen has acknowledged the breakdown of rational democratic representation. And he has taken over its space, which is left fallow. He will have demonstrated that power is no longer representative, that it no longer has any

legitimacy. And I think they have indeed locked themselves in a senseless situation. Politicians are handed the dirty work the way handling money was delegated to the Jews. They deal with the accursed share. They do the dirty work of managing power. We entrust power to the most despicable people. And it's the same thing for artists. They have to administrate banality, the leftovers of everyday life, exorcising abjection, the unwanted part. Art is trying to manage a domain where imagination no longer exists. Someone has to take responsibility for the excess fiction. With a few exceptions, a few singularities like Francis Bacon, art no longer confronts evil, only the transparency of evil. And representation stops having any meaning. All you have here is the spectacle of the inanity of representation. And yet it keeps going on. Why? The politician's task is to skim off the squalid part of power and people are right to scorn them. The gratification of art is that clowns are now dealing with the abject.

In The Conspiracy of Art *you dismissed art's claim for exceptionalism. By now it is no different from everything else. It's all about values, careers, accumulation, consumerism on a huge scale—and everybody there is aware of it. So one can't have it both ways. The art world should drop the pretence and own up to it. Your outburst indeed was a wake-up call. Also a reminder that art was supposed to be something else.*

Yes. Art is about inventing another scene; inventing something other than reality. For art, reality is nothing. I wouldn't call classical art figurative. It was like a desire for seduction—it was a song. The purpose of art is to invent a whole other scene. So it is something quite different. At bottom, art never concerned itself with the

question of reality in its right form. And that lasted until the 19th century. Then, a fabulous adventure began. Art turned to reality in order to deconstruct it. It never addressed it before, even if some of the art that was produced at the time was just as mediocre as in contemporary art. After that art made it its goal to free reality— because everything was done in the name of liberation. Freeing art, freeing reality. But when both managed to free themselves at the same time, they cancelled each other out. It was the same with desire and revolution: in 1968 the desire for revolution and the revolution of desire ended up canceling each other out. It was the same kind of "collusion."

This brings us back to the famous statement you made in The Conspiracy of Art: *"It claims to be null, and it's really null."*

Art has become a terminal, an image-feedback to reality or hyperreality. And putting together reality and image adds up to *a sum zero equation.* That is what I meant. Artists always believe that I am casting judgment on their work and that I am telling them: "This is not good." So there is a real misunderstanding there. Art may also be null on the aesthetic level, but this is not really the problem, simply an insider's question. In any case, artists cannot grasp the internal strategy. And it is without hope, I am convinced. There are exceptions of course, but it is total misunderstanding.

It is not that art is null, but that it invalidates itself as art.

There is a mutual annulment of art and reality. Before, they used to potentialize each other, now they cancel each other out. It is the deterring effect of radical critique. Duchamp's act was not

conceptual; it was a real challenge. It was pure terrorism. Afterwards it became conceptual. Practically everything that is done today is readymade. Duchamp signals the end of the aesthetic principle. Now the system devours and surrounds you. And yet it still left a mark. Sequels coming from before this "revolution"—as it has been called—still are being assimilated in the integral reality that art now is a part of.

There is no way out of art, and no way of objecting to it. Now the system does everything, recycling itself endlessly just like fashion.

The circuit is complete, and we have achieved *integral reality* in that sense. However hard you try, you can't escape it. That's what I said in Venice in 2003: contemporary art is… purely contemporary. It is contemporary of itself. It closed this circle.

Was there anything in Venice that could have changed your mind, any idea?

Today ideas are everywhere. I only find interesting what is not really art, unidentified objects I call "strange attractors." Actually I saw something at the Israeli pavilion, characters shaped like spermatology, a kind of monstrous bio. It was inexplicable, beautiful, almost joyous, although kind of tiny. It was a biological theater of cruelty.

Only what is not art can still be art.

We have reached a critical threshold, a critical mass. Let's assume—it's a hypothesis—that something disappeared with

Duchamp and Warhol. Whatever happened afterwards therefore came after it was gone. So much for a history of art... But the same analysis could be applied to philosophy. Philosophy has disappeared. Something happened afterwards, but it was nothing like a mutation. Today, everything is aestheticized, as everyone knows. To a certain extent everything, even this so-called ordinary reality, can be seen in the light of art. We are living in the transaesthetic, we're in a giant museum.

This is not exactly the museum without walls Andre Malraux had in mind. No wonder art history has recently achieved a new visibility. The more blurred the boundaries, the more necessary it becomes to keep everything in its proper place.

According to art history, for them, first there was classical art and then modern art... But these kinds of distinctions are not really in line with contemporary art. Modern art projected itself into the future: it was the avant-garde. The avant-garde was alright. They dreamed it and it worked. Deconstruction has a transcendent dimension. Now the avant-garde does not work anymore because the system is always two revolutions ahead of us. And intellectuals are trying their best to save the empire of meaning. They are completely off-base. No one is drawing any conclusions from all of this. Politicians are *out*, and so are intellectuals, even though they resist a bit more. As for art, it has definitively gone beyond its end. We are no longer in a modern perspective of prevision, of rationalization. It is becoming exponential.

We can still hope that it will turn around, reverse itself, cancel out.

Yes, we should really engage in an extreme logic. We have that option. But there could be some uncontrolled abreactions.

As happened after you published The Conspiracy of Art. *Is this kind of acting out always violent?*

Singularity does not need to be violent; it needs to be other, out-of-bounds, invent new rules for itself. Today it can only take violent forms.

It's some kind of terrorism.

Well yes, I protested. But you cannot sustain that position systematically. Some writers have done it, but it's rather tiring. And then being indignant is a bit sentimental, a little pathetic. Indignation is a very weak rehashing, a residue of acts left unperformed. You can't go that far, so you act out—and that is the terrorist act. In any case, I set myself up as a terrorist, as you well know.

What are you really indignant about?

Money is obscene, but it's not all the financial and banking scandals that bug me most. I find all that very interesting, of course. I am an analyst of corruption. Like Mandeville, I believe corruption is the vital force of society. What I find most degrading really are discourses. The discourses of justification, of repentance. The people who use those kinds of arguments are completely dishonorable. For instance they said some really stupid things about what happened to the old folks, the deaths, the heat wave. In short, they alleged that people today are living too long. The latest poll, meticulously

orchestrated, topped it all. They found that a vast proportion of the elderly who died *were mentally diminished*. I found that truly disgraceful. Not only did they die because they lived too long, but they were declared mentally incompetent as well. So they weren't really human. People who say those things should be shot. What you get to read in the papers today makes your blood boil.

People think you're cynical. It's true you rarely get as indignant as in The Conspiracy of Art.

I am usually rather irresponsible and amoral. In terms of practical life, I have a very strong immunity. At least one has to maintain that. It's more than just temper; there is an energy involved. But it constantly needs to be restaured.

It may be a form of intolerance, *in the medical sense of the word.*

Yes, a rejection.

Still, it must have required some effort on your part to get there.

No, I never made any effort. Something just happens and I follow through. But what brings this out? An object, signs, some kind of rhetoric... I never wonder at one point whether I should find an alternative, go to the other side. No, I would never do that, it would be absurd. I remain at the limit, in a borderline state really. That's why I like Ballard, these kinds of people. Writing science-fiction would be too easy in a sense. They just stand at that point before it falls to the other side, becomes something else. Things end up organizing and disorganizing themselves on their own. It works

like a machine. Oh yes, at one point I made a special effort to break with the history of ideas, with my contemporaries, whether I liked them or not. I tried to empty out. And that must have required some work on my part. It did demand some energy.

For Roland Barthes, the energy seemed to have come from boredom, from a refusal of what was too obvious. A kind of nausea with received ideas.

That's true, absolutely. For me, it came from a kind of indifference. An indifference that was no longer subjective. A sort of desert form, not a landscape or something found in nature, let alone from culture—an unidentified object. It would be the same thing in terms of passion: some kind of apathy, an apathetic form...

Is that the kind of apathy the Marquis de Sade cultivated, the insensitivity of the amoral man, the 18th century libertine...

A stoic form, in fact. Differentiating between what concerns you and what does not, including in your own life. Refusing to account for what we're being made to be responsible for. Refusal of that kind is strategic, a kind of tactical indifference. This is true of photography, but it also for the concept. Finding the complicity that exists between the object and the objective (here technique comes into play) which gives the subject every reason to disappear, to empty itself out as a *medium*. Between object and "objective" [*an* objectif *is the French for lense*], interesting things will necessarily happen.

Is singularity still possible in art?

Art is dealing with deconstructed elements, waste in terms of form, and artists are working with that. But it is something very weak. For most of them there is no singularity because the model comes first. Singularity, meaning form, has not disappeared, however. It is everywhere.

But not necessarily in art.

No, in the world as it is. In fact, it has a fantastic singularity. Technology has changed everything. What I love about the Japanese is that they made technology a point of honor, a challenge. And they met it, they won. When you transform a material into a challenge, it becomes something altogether different. You find a dual form, a dual relationship. Everything is there.

The form you keep referring to isn't in an object, but in a kind of agonistic logic.

That's right. I don't use form in an aesthetic sense. For me, form has nothing to do with focusing positively on something, nothing to do with the presence of an object. Form rather has to do with challenge, seduction, reversibility. With language, it is the anagrams, arriving at signifying to a maximum, but signifying nothing. And it's true for the image as well. But this you can't prove it. Something comes out, but it's not what is being produced. When I take photographs, they are pictures of the end of the image. After that you can't control it, it's recouped one way or another. In the photographic act, you have to leave this kind of void around, of instantaneity, a subject/object dual relation. You don't find that anywhere now in photography, only a preparation,

a manipulation, a multi-media hybrid mixing. There is form whenever a reversal occurs and everything canceling out by excess. Georges Bataille's notion of economy already was about that. Lack isn't the real problem, it is surplus. And surplus, as you know, you can't get rid of it.

It's the question of obesity.

Yes. The question of obesity was raised in Venice and I said: "There is too much of art. But this is not only true for art: *there is too much of too much*. And that may well be a form. Francesco Bonami, the head of the Venice Biennale, didn't agree and we did a little scene together about it. "How can there be too much?" said Bonami. "You can never have enough of a good thing." And I countered, "And obesity? You don't think there's a pathology in there, do you?" "The more body, the better it is," he replied. Well, no, that's not true. A body has a form, it has measurements, a symbolic space, an initiatory form. Form is all of that. I believe a limit does exist. But you can only say it from the outside, if you are talking in terms of form, not of art. You can do the same kind of analysis with information, consumer habits, everything that is part of a linear process of production and accumulation. More is *not* better. So everything is moving towards this kind of reversal. It's inescapable.

Illusions

Art... Contemporary of Itself

The adventure of modern art is over. Contemporary art is only contemporary of itself. It no longer transcends itself into the past or the future. Its only reality is its operation in real time and its confusion with this reality.

Nothing differentiates it from technical, advertising, media and digital operations. There is no more transcendence, no more divergence, nothing from another scene: it is a reflective game with the contemporary world as it happens. This is why contemporary art is null and void: it and the world form a zero sum equation.

There is a shameful complicity shared by creators and consumers in a silent communion as they consider strange, inexplicable objects that only refer to themselves and to the idea of art. The real conspiracy, however, lies in art's complicity with itself, its collusion with reality, becoming complicit as the mere return-image of this Integral Reality.

There is no longer any possible difference in art. Only the integral calculation of reality remains. Art now is only an idea prostituted in its production.

Modernity was the golden age of the deconstruction of reality into its component parts, a minute analysis starting with Impressionism

and followed by Abstraction. It was experimentally open on all aspects of perception, sensibility, the structure of the object, and the dismemberment of forms.

The paradox of Abstraction is that by "liberating" the object from the constraints of figure to return it to the pure play of form, it chained the object down to a hidden structure, a stricter, more radical objectivity than the objectivity of resemblance. It strove to tear off the mask of resemblance and figure in order to reach the analytical truth of the object. Under the auspices of Abstraction, we paradoxically moved towards even more reality, towards an unveiling of the "elementary structures" of objectality, in other words towards something more real than real.

Reciprocally, art has invested the entire realm of reality under the auspices of a general aesthetization.

At the end of this history, the banality of art is mixed up with the banality of the real world—Duchamp's gesture, with the automatic transfer of the object, was the inaugural (and ironic) act. The transfer of all reality into aesthetics has become one of the dimensions of general exchange...

All of this in the name of a simultaneous liberation of art and the real world.

In fact, this "liberation" consisted in indexing one on the other—a deadly chiasmus for both art and the real world.

The transfer of art has become a useless function in the now integral reality because reality has absorbed everything that negated, transcended or transfigured it. Impossible exchange of this Integral Reality for anything else—it can only be exchanged with itself, repeating itself to infinity.

What could miraculously reassure us about the essence of art today? Art is simply what is discussed in the art world, in the artistic community that frantically stares at itself. Even the "creative" act replicates itself to become nothing more than the sign of its own operation—the true subject of a painter is no longer what he or she paints but the very fact that he or she paints. The painter paints the fact that he or she paints. In that way, at least, the idea of art is saved.

This is only one aspect of the conspiracy.

The other aspect is the viewer who, most of the time, does not understand anything, and consumes his or her own culture twice removed. The viewer literally consumes the fact that he or she does not understand it and that it has no necessity to it other than the cultural imperative of belonging to the integrated circuit of culture. But culture itself is only an epiphenomenon of global circulation.

The idea of art has become rarified and minimal even in conceptual art, where art ends in the non-exhibition of non-works in non-galleries—the apotheosis of art as a non-event. Reciprocally, the consumer moves through it all to test his or her non-enjoyment of the works.

Taking this conceptual and minimalist logic to the extreme, art could do no better than to disappear without any further discussion. At that point, it would no doubt become what it is: a false problem; every aesthetic theory would be a false solution.

Yes, but here is the point: it is all the more necessary to talk about art now that there is nothing to say about it. Paradoxically, the movement to democratize art only reinforced the privilege of

the idea of art, culminating in the banal tautology "art is art." Everything can supposedly be summed up in this circular definition.

Marshall McLuhan: "We have now become aware of the possibility of arranging the entire human environment as a work of art."

The revolutionary idea of contemporary art was that any object, any detail or fragment of the material world could exercise the same strange attraction and ask the same insoluble questions as those formerly reserved for a few rare aristocratic forms called art works.

That was its true democracy, not in allowing everyone access to aesthetic pleasure but in the transaesthetic advent of a world in which each object without distinction would have its fifteen minutes of fame (especially objects without distinction). Everyone is equal, everything is great. The upshot came in the transformation of art and the work itself into an object, without illusion or transcendence, a purely conceptual *acting out*, generating deconstructed objects that deconstruct us in turn.

No more faces, no glances, no human figures or bodies there—organs without bodies, flows, molecules, fractals. The relationship to the "work" is on the level of contamination or contagion: you plug in, become, absorb, immerse yourself just like in flows or networks. Metonymical linkage, chain reactions.

No more real objects at all: with readymades, the object is no longer there, only the *idea of the object*. And we no longer take pleasure in art, only in the idea of art. We are deep in ideology.

The readymade holds the double curse of modern and contemporary art: the curse of immersion in reality and banality along with the curse of conceptual absorption in the idea of art.

Saul Bellow on Picasso: "That absurd sculpture by Picasso, with its metal branches and leaves—no wings, no victory, a mere testimony, a vestige—the idea of a work of art, nothing more. Very similar to the other ideas and other vestiges that inspire our lives—no more apples, but the idea, the reconstruction by the appleologist of what an apple once was—no ice cream, but the idea, the memory of a delicious thing now made of substitutes, starch, glucose and other chemical products—no more sex, but the idea or suggestion of sex—the same for love, belief, thought and everything else...."

Art, in its form, signifies nothing. It is only a sign of absence.

Yes, but what becomes of this perspective of emptiness and absence in a contemporary universe that has already been totally emptied of meaning and reality?

Art can only ally itself with general insignificance and indifference. It no longer has any privileges. It has no final destination other than the fluid universe of communication, networks and interaction.

Speakers and receivers are all combined in the same mix: everyone a speaker, everyone a receiver. Each subject interacts with him—or herself, destined to express him—or herself without having the time to listen to others.

The Net and networks obviously increase this possibility of utterances for oneself, in a closed circuit, with each person engaging in his or her virtual performance and contributing to the general suffocation.

That is why the most interesting thing in terms of art would be to infiltrate the spongy encephalon of the modern viewer. Because the

mystery now resides there: in the receiver's brain, in the nerve center of this servility to "works of art." What is its secret?

In the complicity between the mortification that "creators" inflict on objects and themselves and the mortification consumers inflict on themselves and their mental abilities.

The tolerance for the worst has obviously worsened considerably in proportion with this general complicity.

Interface and performance: the two leitmotifs of today.

In performance, all forms of expression are combined: the plastic arts, photography, videos, installations, interactive screens. This vertical and horizontal, aesthetic and commercial diversification is now part of the work, and the work's original core is beyond repair.

A (non-) event like *The Matrix* serves as a perfect example: it is the very model of a global installation, of a total world event. Not only the film, which is only an excuse to some extent, but the spin-off products, the simultaneous projection at all points of the globe and the millions of spectators themselves who are inextricably part of it. We are all, from a global and interactive point of view, actors in this total world event.

Photography has the same problem when we decide to make it multimedia by adding to it all the resources of montage, collage, digital effects, computer generated imagery, etc. This opening onto the infinite, this deregulation leads precisely to the death of photography by raising it to the level of performance.

In this universal mixture, each register loses its specificity—just as every individual loses his or her sovereignty in networks and interaction—like reality and image, art and reality lose their respective force when they cease to be differential poles.

Ever since the 19th century, art has wanted to be useless. It turned this uselessness into a reason for praise (which was not true of classical art where, in a world that was not yet real or objective, usefulness was not even considered).

By extension of this principle, making any object useless would be enough to make it a work of art. This is precisely what the readymade does when it merely divests an object of its function, without changing anything about it, to turn it into a museum piece. It is sufficient to make reality itself a useless function to turn it into an art object, prey to the all-consuming aesthetic of banality.

By the same token, older things, coming from the past and therefore useless, automatically acquire an aesthetic aura. Their displacement in time is the equivalent of Duchamp's gesture; they become readymades as well, nostalgic vestiges resuscitated in our museum universe.

One could extrapolate this aesthetic transformation to material production as a whole. As soon as it reaches a level where it can no longer be exchanged in terms of social wealth, it becomes a giant surrealist object, seized by an all-consuming aesthetic and is included everywhere in a sort of virtual museum. Like for the readymade, an in-situ museification in the form of dormant industry for every technical waste land.

The logic of uselessness could only lead contemporary art to a predilection for waste—that which is useless by definition. Through refuse, the figuration of refuse, the obsession with refuse, art strives to display its own uselessness. It presents its non-use value, its non-exchange value—while still being sold at very high prices.

There is a contradiction here. *Uselessness has no value in itself.* It is a secondary symptom. And by sacrificing its implications to this negative quality, art goes astray in a useless gratuitousness. The scenario is similar for nullity, the claim of nonsense, insignificance, banality, all a sign of elevated aesthetic pretense.

Anti-art in all its forms attempts to escape the aesthetic dimension. But ever since the readymade annexed banality, all that is finished. The innocence of nonsense, of the non-figurative, abjection and dissidence is over.

Everything that contemporary art would like to be or become again only reinforces the inevitably aesthetic character of this anti-art.

Art has always denied itself. But it did it before out of excess, exalting in the play of its disappearance. Today, it denies itself by default—worse yet, it denies its own death.

Art immerses itself in reality instead of becoming the agent symbolically assassinating reality, instead of being the magical agent of its disappearance.

The paradox is that the closer it comes to this phenomenal confusion, to this nullity as art, the more it is overvalued and credited. To such an extent that, to paraphrase Elias Canetti, we have reached the point where nothing is beautiful or ugly, we have crossed this point without realizing it, and if we are unable to find this blind spot again, we will continue to pursue the current destruction of art.

What is this useless function good for in the end?

What does it deliver us from with its very uselessness?

Like politicians, who relieve us of the bothersome responsibility of power, contemporary art, with its incoherent artifice, relieves us of the grasp of meaning through the spectacle of nonsense. This explains its proliferation: independent of any aesthetic value, it is ensured of

prospering in function of its insignificance and vanity. Just as politicians persist despite the absence of any representation or credibility. Art and the art market therefore flourish to the extent that they decay: they are the modern charnel houses of culture and simulacra.

It is therefore absurd to say that contemporary art is null and that all of this is worthless since that is its vital function: to illustrate our uselessness and our absurdity. Or even better: to use this decay as its capital while at the same time exorcising it as a spectacle.

If, as some propose, the function of art was to make life more interesting than art, then we must lose this illusion. I have the impression that a good portion of art today is conspiring in a process of deterrence, a work of mourning the image and the imaginary, a work of aesthetic mourning. This work usually fails, leading to the general melancholy of the artistic sphere, which seems to survive by recycling its history and its vestiges.

Yet art and aesthetics are not the only ones doomed to this melancholy destiny of living, not above their means, but beyond their ends.

Our capacity for degradation is infinite, and until we have acted out all of the potential crimes that lie within in us, our journey will never be over.

— Guido Ceronetti

If man must fulfill all his possibilities, then he must also accomplish his self-destruction. For that possibility is neither the least nor the least glorious.

— Saul Bellow

1987

Towards the Vanishing Point of Art

My relationship with art and aesthetics has always, in a way, remained clandestine, intermittent, ambivalent. Probably because I am an iconoclast; I come from a moralist, metaphysical tradition, a political and ideological tradition that has always been wary of art and culture in general, that has always been wary of the distinction between nature and culture, art and reality, as something too banally obvious. I always thought siding with art was an all too direct and easy solution (the same goes for poetry and painting): no one should do art, no one should pass through to the enchanted side of form and appearance until all its problems have been resolved. And art assumes all problems have been resolved, it is not even the solution to problems that are really posed. Ideally defined, art is the solution to problems that are not even raised. But I want to raise problems. Art is profoundly seduction, and although I have spoken enthusiastically about seduction, I do not want to fall prey to the seduction of art. That is why I have spoken about seduction more in terms of simulation and simulacra—reflecting a skeptical, critical, paradoxical position and raising a challenge to both the naïve exercise of reality and the naïve exercise of art. I must insist on the fact that what I can tell you comes from somewhere else, that the perspective I may have is somewhat distant, somewhat sidereal, but

that it is the best one for judging contemporary art without pre-judging its value.

And I find some justification for speaking as an iconoclast in that art itself has for the most part become iconoclastic.

In this trajectory, which starts with Hegel when he spoke of the "rage to disappear" and of art engaged in the process of its own disappearance, a direct line links Baudelaire to Andy Warhol under the auspices of "absolute commodity." In the grand opposition between the concept of the work of art and modern industrial society, Baudelaire invented the first radical solution. Faced with the threat to art by merchant, vulgar, capitalist, advertising society, with new objectification in terms of market value, Baudelaire opposes them from the start with absolute objectification instead of a defense of the traditional status of the work of art. Since aesthetic value risks alienation from commodity, instead of avoiding alienation, art had to go farther in alienation and fight commodity with its own weapons. Art had to follow the inescapable paths of commodity indifference and equivalence to make the work of art an absolute commodity. Confronted with the modern challenge of commodity, art should not seek its salvation in critical denial (because then it would only be art for art's sake, the derisory and powerless mirror of capitalism and the inevitability of commodity), but it should go farther in formal and fetishized abstraction, in the fantasy of exchange value—becoming more commoditized than commodities. More than use value, but escaping exchange value by radicalizing it.

An absolute object is one with no value and indifferent quality, avoiding objective alienation by making itself more object than the object—giving it a fatal quality. (This transcendence of exchange value, this destruction of commodity by its very value is

visible in the exacerbation of the painting market: reckless speculation on art works is a parody of the market, a mockery in itself of market value, all rules of equivalency are broken, and we find ourselves in a realm that has nothing to do with value, only the fantasy of absolute value, the ecstasy of value. This is not only true on the economic level, but on the aesthetic level as well, where all aesthetic values (styles, manners, abstraction or figuration, neo or retro, etc.) are simultaneously and potentially at their maximum, where any value could at once, using its special effects, hit the top ten, without there being any means for comparison or eliciting any value judgment. We are in the jungle of fetish-objects, and the fetish-object, as everyone knows, has no value in itself, or rather it has so much value that it cannot be exchanged.

This is the point we have reached in art today, and this is the superior irony Baudelaire was seeking for the work of art: a superiorly ironic commodity because it no longer meant anything, was even more arbitrary and irrational than commodities, therefore circulating all the more rapidly and taking on more value as it lost its meaning and reference. Baudelaire was not far from assimilating the art work to fashion itself under the auspices of triumphant modernity. Fashion as an ultra-commodity, the sublime assumption of commodity, and thus a radical parody and radical denial of commodity...

If the commodity form shatters the former ideality of the object (its beauty, authenticity and even its functionality), then there is no need to try reviving it by denying the essence of commodity. On the contrary, it is necessary—and this is what constituted the perverse and adventurous seduction of the modern world—to make this rupture absolute. There is no dialectic between the two, synthesis is always a weak solution, dialectics is

always a nostalgic solution. The only radical and modern solution: potentializing what is new, unexpected, great in commodity, in other words the formal indifference to usefulness and value, the primacy given to circulation without reserve. This is what the work of art should be: it should take on the characteristics of shock, strangeness, surprise, anxiety, liquidity and even self-destruction, instantaneity and unreality that are found in commodities.

That is why, in Baudelaire's fantastic-ironic logic, the work of art joins fashion, advertising, the "fantasy of the code"—the work of art sparkling in its venality, its mobility, irreferential effects, hazards and vertigo—a pure object of marvelous commutability because with causes gone, all effects are possible and virtually equivalent.

They can be void as well, as we know, but it is up to the work of art to fetishize this nullity, this vanishing and draw extraordinary effects from it. A new form of seduction: no longer the mastery of illusion and the aesthetic order, but the vertigo of obscenity—who can say what the difference is between them? Vulgar merchandise spawns a universe of production—and God knows if this universe is melancholy or not. When raised to the power of absolute commodity, it spawns seduction effects.

The art object, as a newly victorious fetish (and not the sad, alienated fetish) must work to deconstruct its traditional aura, its authority and its power of illusion to stand out in the pure obscenity of commodity. It must destroy itself as a familiar object and become *monstrously unfamiliar*. But this foreignness is not the strangeness of the alienated or repressed object, it does not excel through loss or dispossession, it excels through a veritable seduction that comes from somewhere else, it excels by exceeding its own form as a pure object, a pure event.

The perspective that comes from Baudelaire's experience of the transformation of commodities at the World's Fair of 1855 is in many ways superior to Walter Benjamin's conception. In "The Work of Art in the Age of Mechanical Reproduction," Benjamin draws a desperately political (or politically desperate) conclusion from the decay of the object's aura and authenticity, which leads to melancholy modernity. Baudelaire's infinitely more modern position (but perhaps one could only be truly modern in the 19th century?) involves the exploration of new forms of seduction tied to pure events, to the modern passion known as fascination.

When Andy Warhol advocated the radical imperative to become an absolute "machine," even more mechanical than the machine, because he sought the automatic, machine-like reproduction of objects that were already mechanical, already manufactured (be it a can of soup or a star's face), he was following the same line of absolute commodity as Baudelaire. He was only carrying out Baudelaire's vision to perfection, which was simultaneously the fate of modern art, even when it denied it: the complete realization of the negative ecstasy of value, which is also the negative ecstasy of representation, all the way to the self-denial. And when Baudelaire stated that the vocation of the modern artist was to give commodity a heroic status while the bourgeoisie only gave it sentimental expression in advertising—meaning that heroism did not consist in making art and value sacred again in opposition to commodities, which would be a sentimental effect and one that continues to have widespread influence on our artistic creation, but making commodity sacred as commodity—he made Warhol the hero, or antihero, of modern art. Warhol went the farthest in the ritual paths of the disappearance of art, of all sentimentality in art; he pushed the ritual of art's negative transparency and art's radical

indifference to its own authenticity the farthest. The modern hero is not the hero of the artistic sublime, but rather the hero of the objective irony of the world of commodity, the world that art incarnates in the objective irony of its own disappearance. But this disappearance is no more negative or depressive than commodity. In the spirit of Baudelaire, it is an object of enthusiasm. There is a modern fantasy of commodity and there is a parallel fantasy of the disappearance of art. But you have to know how to vanish, of course. All of art's disappearance, and thus all its modernity, is in the art of disappearance. And all the difference between the pedestrian, exultant art of the 19th and 20th centuries, official art, art for art's sake, etc. (which has no borders and can move between figurative and abstract and any other category), the art born precisely in Baudelaire's time, the art that he hated so much, the art that is far from dead, since it is still being rehabilitated today in the major museums of the world—the difference between this art and the other is the secret denial, the almost involuntary, unconscious choice by authentic art to disappear. Warhol made this choice consciously, almost too consciously, too cynically. But it still was a heroic choice. Official art never acts out its own disappearance. That is why it rightly disappeared from our minds for a century. Its triumphant reappearance today in the post-modern era means that the great modern adventure of the disappearance of art is now over.

Something must have happened one hundred and fifty years ago that implicated both the liberation of art (its liberation as an absolute commodity) and its disappearance. An explosive practice, then an implosive one, following which the cycle was over. We are now in an end without finality, the opposite of the finality without end that, according to Kant, characterizes classical aesthetics. In other words, we are in a transaesthetics, a completely different turn

of events, a turn that is difficult to describe and delineate, since, by definition, aesthetic judgments are impossible in it.

If I had to characterize the current state of affairs, I would say that it is "after the orgy." The orgy, in a way, was the explosive movement of modernity, of liberation in every domain. Political liberation, sexual liberation, liberation of productive forces, liberation of destructive forces, women's liberation, children's liberation, liberation of unconscious drives, liberation of art. The assumption of all models of representation, all models of anti-representation. It was a total orgy: of reality, rationality, sexuality, critique and anti-critique, growth and growth crises. We have explored all the paths of production and virtual overproduction of objects, signs, messages, ideologies, pleasures. Today, if you want my opinion, everything has been liberated, the dice have been rolled, and we are collectively faced with the crucial question: WHAT DO WE DO AFTER THE ORGY?

We can only simulate orgy and liberation now, pretending to continue on in the same direction at greater speeds, but in reality, we are accelerating in empty space, because all of the ends of liberation (of production, progress, revolution) are already behind us. What we are haunted by, obsessed with, is the anticipation of every result, the availability of every sign, every form, every desire, since everything is already liberated. What to do? It is the state of simulation where we can only replay all the scenarios because they have already taken place—in reality or virtually. It is the state of accomplished utopia, of every utopia accomplished, but where you have to live paradoxically as if they had not. Because they have been realized, and because we can no longer keep the hope of accomplishing them, we are only left with hyper-accomplishment

in indefinite simulation. We are living in the infinite reproduction of ideals, fantasies, images and dreams that are now behind us and that we have to reproduce in a kind of fatal indifference.

This is true of every domain: the grand social utopia was accomplished in the bureaucratic and totalitarian materialization of the social. The grand sexual utopia was accomplished in the technological, athletic and neurotic materialization of every sexual practice. And this is true of art as well: the grand utopia of art, the great illusion, the great transcendence of art materialized everywhere. Art has thoroughly entered reality. Some say that art is dematerializing. The exact opposite is true: art today has thoroughly entered reality. It is in museums and galleries, but also in trash, on walls, in the street, in the banality of everything that has been made sacred today without any further debate. The aesthetization of the world is complete. Just as we now have a bureaucratic materialization of the social, a technological materialization of sexuality, a media and advertising materialization of politics, we have a semiotic materialization of art. It is culture understood as the officialization of every thing in terms of signs and the circulation of signs. There are complaints about the commercialization of art, the mercantilization of aesthetic values. But this is just the old nostalgic, bourgeois refrain. The general aesthetization of things should be feared more. Much more than market speculation, we should fear the transcription of every thing in cultural, aesthetic terms, into museographic signs. That is culture, that is our dominant culture: the vast enterprise of museographic reproduction of reality, the vast enterprise of aesthetic storage, re-simulation and aesthetic reprinting of all the forms that surround us. That is the greatest threat. I call it the DEGREE XEROX OF CULTURE.

With this current state of things, we are no longer in the heroic turn Baudelaire wanted to give the universe of commodity by means of art, we are only giving the world as it is a sentimental and aesthetic turn like the one Baudelaire decried in advertising. And art has become that for the most part: a prosthesis of advertising; and culture, a generalized prosthesis. Instead of the triumphant simulation envisaged by Baudelaire, we only have a depressing, repetitive simulation. Art has always been a simulacrum, but a simulacrum that had the power of illusion. Our simulation is something different; it only exists in the sentimental vertigo of models. Art was a dramatic simulacrum where the reality of the world and illusion were in play. It is only an aesthetic prosthesis now. And when I say prosthesis, I am not thinking of an artificial leg. I mean those other, more dangerous prostheses, the chemical, hormonal and genetic ones that are like somatic Xeroxes, literal reproductions that engender the body, that engender it following a process of total simulation, behind which the body has disappeared. Just as people once said that glasses would become total, integrated prostheses for species that had lost its sight, culture and art are the total prostheses of a world that has lost the magic of form and appearance.

I have said that the sublime of modern art lied in the magic of its disappearance. But the capital danger for modern art is repeating its own disappearance. All of the forms of this heroic vanishing, this heroic abnegation of form and color, of the very substance of art, have completely unfolded. *Even the utopia of the disappearance of art has been accomplished.* As for us, we have reached a second generation simulation, or a simulation of the third kind, if you prefer. We inhabit a perverse situation in which not only the utopia of

art has been accomplished, since it has entered reality (in conjunction with the social, political and sexual utopias), but the utopia of its disappearance has been accomplished as well. Art is therefore destined to simulate its own disappearance, since it has already taken place. We relive the disappearance of art everyday in the repetition of its forms—no matter whether figurative or abstract— just as each day we relive the disappearance of politics in the media repetition of its forms, and each day we relive the disappearance of sexuality in the pornographic and advertising repetition of its forms. It is necessary to distinguish clearly between these two moments: the moment of heroic simulacrum, so to speak, when art experiences and expresses its own disappearance, and the moment when it has to manage this disappearance as a sort of negative heritage. The first moment is original, it only happens once, even if it lasted for decades from the 19th to the 20th centuries. The second moment can last for several centuries, but it is no longer original, and I think we are involved in this second moment, in this surpassed disappearance, in this surpassed simulation, surpassed in the sense of an irreversible coma.[1]

There is an enlightening moment for art, the moment it loses itself. There is an enlightening moment for simulation, the moment of sacrifice, in a way, when art falls into banality (Heidegger did say that the fall into banality was the second Fall of humanity and therefore its modern destiny). But there is an unenlightened moment when art learns to survive with this very banality—something like a botching its own suicide. A successful suicide is the art of disappearance; it means giving this disappearance all the prestige of artifice. Like the Baroque, which was also a high point in simulation, haunted by both the vertigo of death and artifice.

Nevertheless, many of those who bungled their suicide did not miss out on glory and success. A failed suicide attempt, as we all know, is the best form of publicity.

In sum, to use Benjamin's expression again, there is an aura of simulation just as there is an aura of authenticity, of the original. If I dared, I would say there is authentic simulation and inauthentic simulation. This wording may seem paradoxical, but it is true. There is a "true" simulation and a "false" simulation. When Warhol painted his Campbell's Soups in the Sixties, it was a coup for simulation and for all modern art: in one stroke, the commodity-object, the commodity-sign were ironically made sacred—the only ritual we still have, the ritual of transparency. But when he painted his Soup Boxes in '86, he was no longer illuminating; he was in the stereotype of simulation. In '65, he attacked the concept of originality in an original way. In '86, he reproduced the unoriginal in an unoriginal way. In '65, he dealt with the whole trauma of the eruption of commodity in art in both an ascetic and ironic way (the asceticism of commodity, its puritanical and fantastical side—enigmatic, as Marx wrote) and simplified artistic practice by the same token. The genius of commodity, the evil genius of commodity produced a new virtuosity in art—the genius of simulation. Nothing was left in '86, only the publicizing genius that illustrated a new phase of commodity. Once again, it was the officially aestheticized commodity, falling back into the sentimental aestheticization Baudelaire condemned. You might reply: the irony is even greater when you do the same thing after twenty years. I do not think so. I believe in the genius of simulation; I do not believe in its ghost. Or its corpse, even in stereo. I know that in a few centuries there will be no difference between a real Pompeian

villa and the J.Paul Getty Museum in Malibu, and no difference between the French Revolution and its Olympic commemoration in Los Angeles in 1989, but *we* still live with this difference and draw our energy from this difference.

Therein lies the dilemma: either simulation is irreversible, there is nothing beyond simulation, it is not even an event anymore, it is our absolute banality, our everyday obscenity, we are definitively nihilistic and we are preparing for a senseless repetition of all the forms of our culture waiting for another unpredictable event—but where would it come from? Or there is an art of simulation, an ironic quality that revives the appearances of the world to destroy them. Otherwise, art would do nothing more than pick at its own corpse, as often is the case today. You cannot add the same to the same and the same, and so on to infinity: that would be poor simulation. *You must rip the same from the same.* Each image must take away from the reality of the world, something must vanish in each image, but you cannot fall into the temptation to annihilate, definitive entropy. The disappearance must remain alive—that is the secret of art and seduction. In art—and this holds for both contemporary and classical art—there is a dual conjecture and thus a dual strategy: an impulse to annihilate, to erase all the traces of the world and reality, and a resistance to this impulse. As Henri Michaux said, the artist is someone who resists with all of his or her might the fundamental impulse to leave no trace.

I said I was an iconoclast and that art itself had become iconoclastic. What I meant was the new, modern iconoclast, the one who does not destroy images but who manufactures them, a profusion of images *where there is nothing to see.* In most of the images I have seen here in New York, there is nothing to see. They are literally images that leave no trace. They have no aesthetic consequences to speak

of—except for the professionals of the profession—but behind each image, something has disappeared. Therein lies their secret, if they have one, and therein lies the secret of simulation, if it has one.

If we think about it, the problem was the same for the Icono-clasts of Byzantium. The Iconolaters were subtle people who claimed to represent God for His greater glory but who in fact simulated God in images, dissimulating at the same time the problem of His existence. Behind each image, God had disappeared. He was not dead, he had disappeared; it was no longer a problem. The problem of the existence or non-existence of God was resolved by simulation.

But one might think that it was God's own idea to disappear, and precisely behind images. God used the images to disappear, obeying the fundamental impulse to leave no trace. Thus the prophecy is carried out: we live in a world of simulation, a world where the highest function of the sign is to make reality disappear and to mask this disappearance at the same time. Art does nothing else. The media today does nothing else. That is why they are destined for the same fate.

I will change perspective to end on a note of hope. I placed this analysis under the sign "after the orgy"—what do we do after the orgy of modernity? Is simulation all we have left? With the melancholy nuance of the idea of a "vanishing point" and the "degree Xerox of culture"? I forgot to say that this expression—"after the orgy"—comes from a story full of hope: it is the story of a man who whispers into the ear of a woman during an orgy, "What are you doing after the orgy?"

There is always the hope of a new seduction.

Aesthetic Illusion and Disillusion

One has the impression that some portion of contemporary art is engaged in a work of deterrence, mourning the image and the imagination, mourning aesthetics. This mostly failed attempt has led to general melancholy in the artistic sphere, which seems to perpetuate itself by recycling its history and its relics (but neither art nor aesthetics are the only ones doomed to the melancholy fate of living less above their means than beyond their own ends).

It seems we are slated for an infinite retrospective of everything that preceded us. This is true of politics, history and morality but also of art, which benefits from no special status in this regard. The entire movement of painting has pulled out of the future and been displaced to the past. Quotation, simulation, reappropriation: current art has started to reappropriate in a more or less playful, more or less kitsch way all the forms and all the works of the distant or near past, even contemporary ones. Russell Connor has called this the "abduction of modern art." Of course these remakes and this recycling intend to be ironic, but their irony is like a worn weft of fabric, it only results from the disillusion of things; it is fossilized irony. The conceit of juxtaposing the nude in the *Déjeuner sur l'herbe* with the *Joueur de cartes* by Cézanne is just an advertising gag; the humor, irony, trompe-l'oeil critiques that characterize advertising today have now flooded the art world. It is the irony of repentance and resentment towards one's own culture.

Maybe repentance and resentment make up the final stage of the history of art, just as for Nietzsche they are the final stage of the genealogy of morals. It is a parody and at the same time a palinode of art and art history, a parody of culture for itself and a form of revenge, characteristic of radical disillusion. As if art, like history, were rummaging through its own trash cans, seeking to redeem itself with its waste.

The Lost Illusion of Cinema

You only have to look at movies (*Basic Instinct, Wild at Heart, Barton Fink*, etc.) that leave no room for critique because they destroy themselves from the inside. Quotational, loquacious, high-tech, they carry the canker of cinema, its internal excrescence, stricken with the cancer of their own technique, their own stagecraft, their own film culture. It seems as though the directors are afraid of their own films, that they cannot handle them (either through an excess of ambition or a lack of imagination). Nothing else would explain the profusion of resources used to invalidate their own films through an excess of virtuosity, special effects, megalomaniac clichés—as if it were a question of harassing images themselves or making them suffer by exhausting their effects, even making the script they dreamed of (one hopes) into a sarcastic parody, a pornography of images. Everything seems programmed to disillusion the spectator, who has no other alternative than to witness this excess of cinema bringing the illusion of cinema to an end.

What can be said of cinema except that, during its technological evolution, from silent movies to sound, to color, to high-tech special effects, illusion in the strongest sense[1] disappeared from it? As this technology, this cinematographic efficiency grew, illusion withdrew. Cinema today knows neither allusion nor illusion: it links everything on a hypertechnical, hyperefficient, hypervisible level. No blanks, no

gaps, no ellipses, no silence, just like television, with which cinema has become increasingly assimilated by losing the specificity of its own images. We are moving ever closer to high definition, in other words to the useless perfection of images. Which by the same token are no longer images, having been produced in real time. The closer we reach absolute definition, the realist perfection of images, the more its power of illusion is lost.

Take the Peking Opera. With the mere dual movement of two bodies on a skiff, an entire stretch of river is brought to life. Two bodies brushing against each other, moving as close as possible without touching, in an invisible copulation, could imitate the physical presence on stage of the darkness in which this struggle was taking place. There the illusion was total and intense; more than aesthetic, it was a physical ecstasy, precisely because any realist presence of night and the river had been eliminated and only bodies were used to create the natural illusion. Today, tons of water would flood the stage, the duel would be filmed in infrared, etc. Misery of the oversophisticated image, like CNN during the Gulf War. Pornography of the three or four-dimensional image, of three or four or forty-eight or more tracks—it is always by adding to the real, by adding real to real in order to create the perfect illusion (the illusion of resemblance, the realist stereotype) that illusion is thoroughly killed. Pornography, adding a dimension to the image of sex, removes something from the dimension of desire and disqualifies any seductive illusion. The height of this dis-imagination of images, of the exceptional efforts to make an image more than an image, are computer-generated images, digital images, virtual reality.

An image is precisely an abstraction of the world into two dimensions, removing a dimension from the real world and therefore inaugurating the power of illusion. Virtuality, on the contrary, by

making us enter the image, by recreating a realist image in three dimensions (while adding a kind of fourth dimension to reality, making it hyperreal), destroys this illusion (the equivalent of this operation in time is "real time," which closes the loop of time back on itself, instantaneously, thereby abolishing any illusion of the past or the future). Virtuality tends towards perfect illusion. But it is not at all the same creative illusion as the image (of the sign, the concept, etc.). It is a "recreative" realist, mimetic, hologrammatic illusion. It brings the play of illusion to an end through the perfection of reproduction, the virtual reissuing of the real. Its only aim is to prostitute, to exterminate reality through its double. On the contrary, trompe l'oeil, by removing a dimension from real objects, makes their presence magical and restores dreams, total unreality in its minute exactness. Trompe l'oeil is the ecstasy of the real object in its immanent form, which adds the spiritual charm of the artifice, the mystification of the senses to the formal charm of painting. The sublime is not enough; subtlety is also necessary, the subtlety that consists in diverting the real by taking it literally. This is what we have forgotten in modernity: subtraction brings force, power is born of absence. We have not stopped accumulating, adding, raising the stakes. And because we are no longer capable of confronting the symbolic mastery of absence, we are now plunged in the opposite illusion, the disenchanted illusion of profusion, the modern illusion of the proliferation of screens and images.

Art, Exacerbated Illusion

It is very difficult to speak of painting today, because it is very difficult to see it. Because, most of the time, it no longer wants to be seen but visually absorbed, circulating without leaving a trace.

In a way, this is the simplified aesthetic form of an impossible exchange.

So much so that the discourse most capable of rendering it would be a discourse which has nothing to say. The equivalent of an object that is not one.

But an object that is not an object is not just nothing, it is an object that keeps captivating you with its immanence, its empty and immaterial presence. The problem is to materialize this nothingness at the limits of nothingness, to trace the edge of emptiness at the limits of emptiness, to trace the filigree of emptiness, to play according to the mysterious rules of indifference at the limits of indifference.

Art is never the mechanical reflection of the positive or negative conditions of the world, it is its exacerbated illusion, its hyperbolic mirror. In a world devoted to indifference, art can only add to this indifference. Circling around the contours of the emptiness of the image, the object that is no longer an object. Thus in film, directors such as Wenders, Jarmusch, Antonioni, Altman, Godard, Warhol explore the insignificance of the world through the image, and through their images they contribute to the insignificance of the world, they add to its real, or hyperreal, illusion. Films like the recent works by Scorcese, Greenaway and others, however, only fill the emptiness of the image through high-tech and baroque machinery, through frenetic and eclectic agitation, thereby contributing to the disillusion of our imagination. Just like the New York Simulationists who, by hypostatizing the simulacrum, merely hypostatized painting itself as a simulacrum, as a machine confronting itself.

In many cases, (*Bad Painting, New Painting*, installations and performances), painting denies itself, parodies itself, spits itself out. Plastic, glazed, frozen dejecta. Waste management, immortalized

waste. There is no longer even the possibility of a glance—it no longer even solicits viewing because, in all meanings of the word, it no longer regards you.[2] If it no longer pays attention to you, it leaves you completely indifferent. And this painting has in fact become completely indifferent to itself as painting, as art, as an illusion stronger than the real. It no longer believes in its own illusion and falls into the simulation of itself and derision.

The Disembodiment of Our World

Abstraction was the grand adventure of modern art. In its "irruptive," primitive, original phase, be it expressionist or geometric, it was still part of the heroic history of painting, a deconstruction of representation and breaking down the object. By dissolving its object, the subject of painting itself moves to the limits of its own disappearance. However, the multiple forms of contemporary abstraction (and this is also true of New Figuration) have moved beyond this revolutionary episode, beyond this disappearance "in action"—they only bear the trace of the undifferentiated, banalized, diluted field of our daily life, of the banality of images that have entered our customs. New abstraction and new figuration are only opposed in appearance—in fact, they each retrace the utter disembodiment of our world in both its dramatic and its banal phases. The abstraction of our world is now a given, it has been for some time, and all the art forms of an indifferent world carry the same stigma of indifference. This is neither a denial nor a condemnation, it is the state of things: an authentic contemporary painting must be as indifferent to itself as the world has become—once the essential implications have disappeared. Art as a whole is now merely the metalanguage of banality. Can this de-dramatized simulation go on

forever? Whatever the forms we have to deal with may be, we have embarked for the duration on the psychodrama of disappearance and transparency. We must not be fooled by a false continuity in art and its history.

In short, there is, to use Walter Benjamin's expression, an aura of the simulacrum just as he described an aura of the original; there is authentic simulation and inauthentic simulation.

This may seem paradoxical, but it is true. There is a "true" simulation and a "false" simulation. When Warhol painted his *Campbell's Soups* in the 1960s, it was a feat for simulation and for all modern art. In one fell swoop, the commodity-object, the commodity-sign were ironically made sacred—which is the only ritual we still have, the ritual of transparency. But when he painted the *Soup Boxes* in 1986, it was no longer a feat, but the stereotype of simulation. In 1965, he attacked the concept of originality in an original way. In 1986, he reproduced unoriginality in an unoriginal way. In 1965, the entire aesthetic trauma of commodity bursting into art was dealt with in an ascetic and ironic way (the asceticism of commodity, both Puritan and magical—enigmatic as Marx said) that in one stroke simplified artistic practice. The genius of commodity, the evil spirit of commodity provoked a new genius in art—the genius of simulation. None of that remained in 1986, where it was merely advertising genius illustrating a new phase of commodity. Once again, official art aestheticizes merchandise, a return to the cynical and sentimental aestheticization that Baudelaire stigmatized. One might think that it is a superior form of irony to do the same thing after twenty years. I do not. I believe in the (evil) genius of simulation, not in its ghost. Or its corpse, even in stereo. I know that in a few centuries, there will be no difference between a real Pompeian city and the J. Paul Getty

Museum in Malibu, no difference between the French Revolution and its Olympic commemoration in Los Angeles in 1989, but we still feed off that difference.

Images Where There is Nothing to See

There lies the dilemma: either simulation is irreversible, there is no going beyond simulation, it is no longer even an event, it is our absolute banality, it is an everyday obscenity, we are in terminal nihilism, and are preparing ourselves for a mindless repetition of all the forms of our culture, waiting for an unpredictable event—but where would it come from? Or there is an art of simulation, an ironic quality that resuscitates the appearances of the world each time to destroy them. Otherwise art would do nothing more, as it often does today, than work over its own corpse. The same cannot be continuously added to the same *ad infinitum*: that is poor simulation. The same must be torn from the same. Each image must take away from the reality of the world, something must disappear in each image, but one must not give in to the temptation of annihilation, of definitive entropy, the disappearance must remain active: that is the secret of art and seduction. In art—and this applies to contemporary art as well as classical art—there is a dual postulate, and therefore a dual strategy. An impulse to annihilate, to erase all traces of the world and reality, and the contrary resistance to this impulse. In Henri Michaux's words, the artist is "the one who resists with all his strength the fundamental impulse to leave no traces."

Art has become iconoclastic. Modern iconoclasm no longer consists in destroying images, but in manufacturing a profusion of images where there is nothing to see.

These are literally images that leave no trace. They have no aesthetic consequences to speak of. However, behind each of them, something has disappeared. There lies their secret, if they have one, and there lies the secret of simulation. On the horizon of simulation, not only has the real world disappeared, but the very question of its existence has no meaning.

If you think about it, the problem was the same for the iconoclasm of Byzantium. The Iconolaters were subtle people who claimed to represent God for his greater glory but who, in reality, simulated God in images, thereby dissimulating the problem of His existence. Each image was a pretext to avoid raising the problem of the existence of God. Behind each image, in fact, God had disappeared. He was not dead, but He had disappeared. In other words, the question was no longer asked. The problem of the existence of the non-existence of God was settled by simulation.

But one might think that it is God's own strategy to disappear, and precisely behind images. God uses images to disappear, obeying in turn the impulse to leave no trace. The prophecy thus comes true: we live in a world of simulation, a world where the highest function of the sign is to make reality disappear and by the same token to mask its disappearance. Art does nothing else. Today's media does nothing else. That is why they are condemned to the same fate.

Something lies hidden behind the orgy of images. The world concealing itself behind the profusion of images may be another form of illusion, an ironic form (cf. Elias Canetti's parable on animals: one has the feeling that something human is hidden behind each of them, taunting you).

The illusion that emerged from the capability, through the invention of forms, to tear something away from reality, to counter

it with another scene, to pass through the looking glass, the capability to invent another game and other rules for the game is by now impossible because images have entered things. Images are no longer the mirror of reality, they have invested the heart of reality and transformed it into hyperreality where, from screen to screen, the only aim of the image is the image. The image can no longer imagine the real because it is the real; it can no longer transcend reality, transfigure it or dream it, since images are virtual reality. In virtual reality, it is as if things had swallowed their mirror.

Having swallowed their mirror, they have become transparent to themselves, they hide no more secrets, they cannot fake illusions (for illusion is linked to secrets, to the fact that things are absent from themselves, drawn back from themselves in their appearances). Here, there is only transparency, and things, completely present to themselves in their visibility, in their virtuality, in their inexorable transcription (possibly in digital terms with all the latest technology), are only inscribed on one screen, on the billions of screens where the real, but also the image properly speaking, has disappeared from the horizon.

In coming to pass, all of the utopias of the 19th and 20th centuries have chased reality from reality and have left us in a meaningless hyperreality, since any final perspective has been absorbed, digested, leaving only the residue of a surface without depth. Maybe technology is the only force that still binds together the scattered fragments of reality, but what happened to the constellation of meaning? What happened to the constellation of secrecy?

We have finished with the end of representation, then, with the end of aesthetics, with the end of the image itself in the superficial virtuality of the screens. Yet—and here there is a perverse and paradoxical effect, though perhaps a positive one—it seems that, at the

same time as illusion and utopia were chased by force out of the real by all of our technologies, by dint of these same technologies, irony has moved into things. There would therefore be a compensation for the loss of the illusion of the world: the appearance of the objective irony of this world. Irony as a universal and spiritual form of the disillusion of the world. Spiritual in the sense of being spirited, emerging from the very heart of the technological banality of our objects and our images. The Japanese perceive a divinity in every industrial object. For us, this divine presence has been reduced to a weak ironic glow, though it still remains a spiritual form.

The Object, Master of the Game

It is no longer a function of the subject, the critical mirror in which the uncertainty, the irrationality of the world are reflected; it is the mirror of the world itself, of the objectal and artificial world surrounding us, where the absence and transparency of the subject are reflected. Succeeding the critical function of the subject is the ironic function of the object, an objective and no longer subjective irony. From the moment when they are manufactured, and by their very existence, products, artifacts, signs, commodities, things exercise an artificial and ironic function. There is no need to project irony onto the real world, no need for an outside mirror offering the world the image of its double: our universe has swallowed its double, it has become spectral, transparent, it has lost its shadow, and the irony of this incorporated double bursts forth at each instant, in each fragment of our signs, our objects, our images, our models. The need no longer exists, as it did for the Surrealists, to exaggerate this functionality, to confront objects with the absurdity of their function, in a poetic unreality. Things have taken charge of casting

an ironic light on themselves, they discard their meaning effortlessly, with no need to call attention to artifice or nonsense. This is all part of their very representation, of their visible, all too visible linkage, of their superfluousness, in which they parody themselves. After physics and metaphysics, we have reached a pataphysics[3] of objects and commodity, a pataphysics of signs and operations. All things, deprived of their secret and their illusion, are condemned to existence, to visible appearance; they are given over to advertising, to make-believe, to self-display and self-valuation. Our modern world is essentially advertising. As it is, one might say that it seems to have been invented to be publicized in another world. We shouldn't believe that advertising came after commodity; there is an advertising evil genius at the heart of commodity (and by extension at the heart of our entire universe of signs), a trickster who has incorporated the clowning of commodity and its staging. A brilliant scriptwriter (maybe even capital itself) has led the world into a phantasmagoria of which we all are the fascinated victims.

All things want to manifest themselves today. Technical, industrial, media objects, artifacts of all kinds want to signify, be seen, be read, be recorded, be photographed.

You assume you're photographing a given thing for your own pleasure, but in fact it wants its picture taken and you are only a figure in its staging, secretly moved by the self-advertising perversion of the surrounding world. There lies the pataphysical irony of the situation. All metaphysics is brushed aside by this reversal of the situation where the process no longer originates with the subject, who is only the agent or the operator of the objective irony of the world. It is no longer the subject who represents the world to itself (*I will be your mirror!*[4]), the object refracts the subject and subtly, using all our technologies, imposes its presence and its aleatory form.

The subject is no longer the master of the game, and there seems to have been a reversal in the relationship. The power of the object cuts a path through the play of simulation and simulacra, through the very artifice we have imposed on it. It acts like an ironic revenge: the object becomes a strange attractor. And we find here the limits of aesthetic adventure, of the aesthetic mastery of the world by the subject (but it is also the end of the adventure of representation). For the object as a strange attractor is no longer an aesthetic object.

Deprived of all secrets, of all illusions by technology itself, deprived of its origin, since it is generated by models, deprived of all connotations of meaning and value, taken out of both the orbit of the subject and the precise mode of vision that is part of the aesthetic definition of the world—then it becomes, in a way, a pure object, and it recovers some of the force and the immediacy of forms that existed before, or after the generalized aestheticization of our culture. All of these artifacts, all of these artificial objects and images exercise a sort of artificial influence or fascination on us. Simulacra are no longer simulacra, they have become materially evident— fetishes, perhaps, both completely depersonalized, desymbolized and yet at maximum intensity, directly invested as *medium*—just like fetish objects, with no aesthetic mediation. That may be where our most superficial, stereotyped objects recover the power of exorcism, equal to sacrificial masks. Exactly like masks, which absorb the identity of the actors, the dancers, the spectators, and which have the function to provoke a sort of thaumaturgic (traumaturgic?) vertigo. In the same way, I think all of these modern artifacts, from advertising to electronics, from the media to virtual reality, objects, images, models, networks, are made to absorb and provoke the vertigo of the interlocutor (us, the subjects, the alleged

agents) much more than communicating or informing—and at the same time to eject and reject it as did prior forms of exorcism and paroxysm. *We shall be your favorite disappearing act!*[5]

These objects therefore meet, well beyond aesthetic form, the forms of aleatory play and of vertigo of which Roger Caillois spoke and that were opposed to the mimetic and aesthetic play of representation.[6] They illustrate our type of society, which is also a society of paroxysm and exorcism. In other words, it is a society where we have absorbed our own reality, our own identity to the point of vertigo, and where we seek to reject it with the same force, where reality as a whole has absorbed to the point of vertigo its own double and seeks to get rid of it in all its forms.

These banal objects, technological objects, virtual objects, are the new strange attractors, the new objects beyond aesthetics, transaesthetic, these fetish-objects with no signification, no illusion, no aura, no value that are the mirror of our radical disillusionment of the world. Ironically pure objects, like Warhol's images.

Warhol: an Introduction to Fetishism

Andy Warhol starts by eliminating the imaginary aspects of any image and turning it into a pure visual product. Pure logic, unconditional simulacrum. Steve Miller (and all those who "aesthetically" rework video, scientific or digital images) does the exact opposite. They redo the aesthetic with raw materials. One *uses* the machine to remake art, the other (Warhol) *is* a machine. Warhol is the true machinic metamorphosis. Steve Miller only does machinic simulation and arraigns technology to create illusion. Warhol gives us the pure illusion of technology—technology as radical illusion—which is far superior today to the illusion of painting.

In this respect, a machine can never become famous, and Warhol only ever sought the kind of mechanical fame that has no consequences and leaves no traces. A photogenic fame that calls for everything and for every individual today to be seen, to be celebrated by sight. This is what Warhol is: he is merely the agent of the ironic appearance of things. He is only the medium for this giant advertisement that the world gives itself by means of technology and by means of images, forcing our imagination to evaporate, our passions to externalize themselves, shattering the mirror that we were holding in front of it, hypocritically by the way, in order to capture it for our own benefit.

Through images, through technical artifacts of all kinds, of which Warhol's artifacts are the modern "Idealtype," the world imposes its discontinuity, its fragmentation, its stereophonics, its superficial instantaneity.

Evidence of the Warhol-machine, of this extraordinary machine for filtering the world in its material evidence: Warhol's images are not banal because they would reflect a banal world but because there is no attempt by a subject to interpret it—his images manage to raise the image to a state of pure figuration without the slightest transfiguration. It is therefore no longer a transcendence but an increased power of the sign. Having lost its natural signification, the sign shines in the vacancy of all its artificial light. Warhol is the first to introduce fetishism.

However, if you think about it, what do modern artists do anyway? Do our modern artists—like the artists who, since the Renaissance, thought they were doing religious painting and in fact painted works of art—think they are producing works of art while doing something altogether different? Aren't the objects they produce something altogether different from art? Fetish-objects, for

example, but disenchanted fetishes, purely decorative objects for temporal use (Caillois would say: hyperbolic ornaments). Literally superstitious objects, in the sense that they no longer emerge from a sublime nature of art and no longer respond to a profound belief in art but nonetheless perpetuate this superstition in all its forms. Fetishes, then, of the same inspiration as sexual fetishism, which is also sexually indifferent: by establishing their object as a fetish, they deny both the reality of sex and sexual pleasure. They do not believe in sex but only in the idea of sex (which is, of course, asexual). In the same way, we no longer believe in art but only in the idea of art (which of course is not at all aesthetic).

That is why art, subtly nothing more than an idea, began working with ideas. Duchamp's bottle stand is an idea, Warhol's Campbell's can is an idea, Yves Klein's selling air for a blank check in a gallery is an idea. All of these are ideas, signs, allusions, concepts. They no longer signify anything at all, but they signify. What we call art today seems to bear witness to an irremediable void. Art is travestied by the idea, the idea is travestied by art. It is a form, our form of transsexuality, of transvestism extended to the entire realm of art and culture. Art traversed by the idea, by the empty signs of art and particularly by the signs of its own disappearance, is transsexual in its own way.

All modern art is abstract in the sense that it is more pervaded by ideas than by imagined forms and substances. All modern art is conceptual in the sense that it fetishizes the concept, the stereotype of a cerebral model of art in the work—in exactly the same way that what is fetishized in commodity is not its real value but the abstract stereotype of value. Condemned to this fetishistic and decorative ideology, art has no distinct existence. From this perspective, one could say that we are on the way to the complete disappearance of art as a specific activity. This can lead either to a reversion of art into

pure technique and craftsmanship, eventually transferred into electronics, as can be seen everywhere today, or towards a primal ritualism, where anything can serve as an aesthetic gadget, with art ending in universal kitsch, like religious art ended in Saint-Sulpician kitsch. Who knows? Art as art may have only been an aside, a sort of ephemeral luxury of the species. The problem is that this crisis in art may become unending. And the difference between Warhol and all the others, who deep down welcome this unending crisis, is that with Warhol the crisis of art is essentially over.

Recovering Radical Illusion

Is there still an aesthetic illusion? And if not, a path to an "anaesthetic" illusion, the radical illusion of secret, seduction and magic? Is there still, on the edges of hypervisibility, of virtuality, room for an image? Room for an enigma? Room for a power of illusion, a veritable strategy of forms and appearances?

Against all modern superstitions of "liberation," it must be said that forms are not free, figures are not free. They are on the contrary bound: the only way to liberate them is to chain them together, in other words to find their links, the ties that create and bind them, that chain them gently together. Moreover, they connect and engender themselves, and art has to enter into the intimacy of this process. "It is better for you to have enslaved one free man with kindness than to have freed a thousand slaves" (Omar Khayyam).[7]

Objects whose secret is not their expression, their representative form, but on the contrary their condensation and their subsequent dispersion in the cycle of metamorphoses. In fact, there are two ways to escape the trap of representation: by never-ending deconstruction, where painting never ceases to watch itself die in the

shards of the mirror, even if it scrapes something together with the remains, it is always interdependent on the lost signification, always wanting a reflection or a story. Or by simply leaving representation behind, forgetting any concern for reading, interpretation, decoding, forgetting the critical violence of meaning and mistake, returning to the womb of the appearance of things where they merely state their presence, albeit in multiple forms, multiplied by the specter of metamorphoses.

Entering the specter of the dispersion of the object, the womb of the distribution of forms is the very form of illusion, of the return to play (*illudere*). Going beyond an idea means negating it. Going beyond a form means passing from one form to another. The first defines the critical intellectual position that is often the position of modern painting in its contact with the world. The second describes the principle of illusion where there is no other fate for form than form. In this sense, we need illusionists who know that art, and painting, are illusions, in other words as far from intellectual criticism of the world as from aesthetics proper (which presupposes a reflective discrimination between the beautiful and the ugly), who know that art is first of all a trompe l'oeil, a "trompe life," just as any theory is a "trompe meaning" and all painting, far from being an expressive, and therefore supposedly true, version of the world, consists in creating snares in which the presumed reality of the world is naïve enough to get caught. Just as theory does not consist in having ideas (and therefore of flirting with truth), but in setting snares, traps in which meaning is naïve enough to get caught. Finding, through illusion, a form of fundamental seduction.

It is a delicate command not to succumb to the nostalgic charms of painting, and to remain on the subtle line that is closer to the lure than aesthetics, inheriting a ritual tradition that has never

really mixed with the tradition of painting: the tradition of trompe l'oeil. A dimension that, beyond the aesthetic illusion, reconnects with a much more fundamental form of illusion that I would call "anthropological"—to designate the generic function of the world and its emergence, whereby the world appears well before being interpreted or represented, well before becoming real, which it only became lately, and no doubt fleetingly. Not the negative and superstitious illusion of another world, but the positive illusion of this world, of the operatic stage of the world, of the symbolic operation of the world, of the vital illusion of appearances that Nietzsche spoke of—illusion as a primitive scene, long before and much more fundamental than the aesthetic scene.

The realm of artifacts reaches largely beyond the realm of art. The reign of art and aesthetics is a conventional management of illusion, a convention that neutralizes the wild effects of illusion, that neutralizes illusion as an extreme phenomenon. The aesthetic is a sort of sublimation or mastery through form of the radical illusion of a world that would otherwise destroy us. Other cultures accepted the cruel evidence of this original illusion of the world by establishing an artificial balance. Our modern cultures no longer believe in this illusion of the world but rather in its reality (which is of course the final illusion) and we have decided to temper the ravages of illusion through this cultivated, docile form of simulacrum known as the aesthetic form.

Illusion has no history. Aesthetic form does. But because it has a history, it also only has one time and we are no doubt now witnessing the disappearance of this conditional form, of this aesthetic form of the simulacrum in favor of an unconditional simulacrum, in other words a certain primitive scene of illusion where we return to the inhuman rituals and phantasmagoria of the cultures preceding our own.

Implosions

1978

The Implosion of Beaubourg

Jean-Luc Hennig and Jean-François Fogel: *In a study that has been kept very quiet in Beaubourg, sociologist Pierre Bourdieu tried to analyze the changes in Beaubourg's public over the past year. His conclusion: a massive return to a homogenized public, except in the media library and the new exhibits space on the lower level...*

Jean Baudrillard: In fact, Bourdieu left out a crucial fact: the stark divergence between the size of traditional museum-going publics and the public of Beaubourg. The irruption of a mass that doesn't exactly fit the definition of a cultural public is a new occurrence. It calls into question both Beaubourg and any sociological explication. This mass is flocking there according to a principle of fascination. Bourdieu analyzed this as well as the "Roissy effect." And it affects a domain that in principle should remain unaffected by fascination. This proves that culture no longer has any specificity. It can be completely eroded when submitted to the effects of fascination. The focalization of this effect on Beaubourg is certainly new in comparison to other cultural clusters.

So the "Beaubourg effect" is completely negative? Everything is absorbed, digested, undifferentiated...

I don't think it is negative at all. What interested me is that the mass imposed its practices on the spot, thwarting the concerns issuing from the cultural sphere or the government. This reversal of the situation was not pessimistic. It proves that an "indistinct," "blind," completely "ignorant" mass, with all the sociological prejudices we may have, is capable of subverting such a powerful institution, to engage in practice I would call original, positive, to thwart the trap that was set for it. But I am pessimistic about the Beaubourg's cultural effect, about traditional mass cultivation. There is no hope there.

But for the artists, many people can find a place to turn to here, a quicker, more approachable, more open…

That's the danger. People say: the more the better. Everything can go in. Every artist should have his or her chance. But once there are too many, as soon as it becomes an infinite succession, a tactical juxtaposition of everything that is possible in cultural terms, then the project reaches a catastrophic limit. You accept everything like you accept the succession of programs on television. At that point, you fall into a lack of distinction, an indifference to everything. It is all received and absorbed with the same fascination. And if some people are worried that it isn't pedagogical enough, the institution will prop it all up with mechanisms for training, education, etc. Actually, it has been revealed that a large majority of people don't care, and setting up those structures would just take up space. This pedagogical project in any case contradicts this mobile, polyvalent, tactile, tactical construction. It is not a pedagogical space at all and they realized this immediately. When they wanted to explain, draw attention anew, etc. they had to carve up the space again, hang

canopies all over the place, redo the ceilings, etc. Beaubourg is really a space of total diffusion. So people must be rather stunned. It challenges them. Obviously they do not know where it is coming from, whether it is architectural or political. It is really a pure object. What is fascinating is this sort of global uselessness, absurdity, challenge. It is certainly not a dialectical process of learning culture. People come to see a good bit of spectacle.

Isn't Beaubourg a good reading of today's culture in its emptiness, its dispersion, its non-corrosive effects?

Beaubourg is indeed the best reading of a culture of total dispersion, of combination... Mixing, random, manipulating, that is the real culture. In this respect, Beaubourg is the ideal monument. But it expresses this unwillingly, because its objectives are radically different, yet the masses respond to the most directly contemporary utterance. There is the outward discourse of the institution trying to justify itself and there is the real, positive operation of Beaubourg where the masses enter perfectly well.

Like a shopping mall?

But this is the first time we have been able to put culture outside in a shopping mall. This reduction, this flattening out, this possibility of an indefinite supply of culture is something new. But you should note that there are both sides in Beaubourg. It operates traditionally with the Museum—a good sanctuary—but the public hardly goes there. Out of 20,000 entries, only 1500 wander around the museum. All the others spread around an indistinct, indeterminate space that is Beaubourg's true challenge. The drugstore or

those spaces that can contain everything, they are the strategic stakes of culture. Our reality is the idea that there is no longer any difference between levels of quality, that everything can be contained in one polyvalent space, selling and consuming at the same time. That is the starting point. In a way, the architecture and organization acknowledge this molecular nature of culture. And then somewhere there is a kind of resistance, people trying to fix the situation with old norms of training, etc.

But that is a rather passive use. No open, localized subversion, no wild dazibaos... It could be a cause for political groups, surrealist groups, a formidable starting point for perversion. Why does that never happen?

Exactly. Compared to this culture of the neutral, to this implosive process initiated in the central building, the parvis, the marginality, all that is old hat, it doesn't work. The building is far newer than anything that could happen on the parvis. The implosion happenning there is not surrealist, it is hyperrealist. Neither subversive nor transgressive. It may be in this neutrality that something is really happenning. Spectacular violence becomes meaningless in the face of an event like this. It may not be by accident that there has never been an eruption, no direct and violent interventions.

Is this tale of 'alert' levels beyond which everything would fall apart really true?

They say it cannot reach 30,000. There must be some real panic about the building's structure in terms of the flexibility of its suspension. But there is really a threat of saturation of the space. For an open, polyvalent space, the absolute paradox is to be stuffed...

You have made Beaubourg the sign of a new kind of violence, a violence of institutions, culture and power and not a dialectical or strategic violence. A violence by saturation, absorption, deterrence. An emptying violence.

With Beaubourg, we have pushed a system of accumulation to the saturation point. And the problem of saturation is present at every level, including power, to the extent that it can become completely instantaneous, interstitial, omnipresent through information structures, etc. It will also reach a limit where it will immediately be absorbed, absorbing itself. The term "implosion" is a metaphor to describe this process. It is physically like what happens to star clusters whose density becomes so phenomenal that they implode and nothing is left around them. Then they have the possibility of absolutely capturing and neutralizing all the energy, all the light radiation that approach them. In that case, our old ideas of violence do not work. Acts of violence or subversion that confront the system openly because they are even more expansive or explosive do no work anymore. The system has reached such a point of saturation that one cannot go beyond it.

Isn't there a saturation of information, diffusion and production of the event by the media at the Pompidou Center...

It's true that information is the medium of the implosion, but Marshall MacLuhan already realized that with television. The instantaneous generalization and globalization of information produces total atomization. Neutralizing everything, it creates a sort of absolute void. Every bit of information today is devoured in the mode of fascination; this fascination may even be the extreme

intensity of the neutral. When there is positive and negative, you have an investment, an affect, energy, etc. In a neutralized field, you don't have that anymore, you only have fascination and a possible instantaneous reversion of the process when it reaches its limit. How can you maintain a memory, a will and even a representation when you are in a universe like Beaubourg? When people move in en masse, anonymously, submerged by this monument, they immediately fall into a sort of cultural catalepsy...

But isn't it a never-ending self-cumulative process? Isn't there a point when too much is not enough? Can't we imagine a super-Beaubourg?

I don't think so. It's accumulation, the series, that helps develop the fantasy of infinity, but what you do not see is the threshold of critical mass. At some point, too much is too much. The process is the equivalent of the abolition of all these qualities. It's a black hole. I suppose that in any political, cultural field, one always has the impression that one is accumulating and that there is a positive dimension to the infinite. And then at one point, bang!, you reach the implosive point of critical mass.

People have had the contrary impression that Beaubourg was going to devour the entire territory, centralize every creation. In fact, it seems that there is a certain regional rejection and continued production of core companies, autonomous reviews, etc.

These forms of autonomy that resist centralization and recreate themselves in local bases, we could call them processes of slow implosion. They operate differently from our universalistic system of expansion, but they do not stand up to the phenomenon of

violent implosion occurring at the top, massively, blindly, escaping analysis. Beaubourg hasn't yet occupied everything, but it has gathered the same power that a satellite has, an orbital machine that reconfigures everything. In reality, the vast domains of power, society and culture first would have to implode violently for us to find a kind of implosive regulation…

But there is an acceleration today. Cultural phenomena do not reach very far. They are highly concentrated and immediately self-destruct, like the punks…

We are indeed no longer in a process of continuity, history, memory, everything is taken immediately in a cyclical dimension, an accelerated curve. Of course, there is an attempt to resist, to create fabulous memories on the computer, to archive everything, to halt the flow of events that cancel themselves and can no longer be capitalized…

An accelerated cultural entropy then?

In information theory, the term "entropy" is negative. It is a decline, the most degraded form of energy. Attali takes it in this sense when he says: you have to take information all the way; the more information, the better. This is a way of taking information and its theory as a new historical philosophy without taking into account its implosive aspect. Nothing says that this aspect is negative. If you calculate in terms of accumulation of meaning, of messages, it is definitely entropy since the contents are neutralized. But the sovereignty of the medium is an original situation that may have its own laws and in any case unforeseen consequences.

But at the same time, it is an inevitable phenomenon…

We can only experience it in a desperate way, but in itself, it's quite fascinating… You can certainly interpret it in terms of death, death by a loss of difference… In Italy, all the cypress trees have a strange disease. They are all dying, just like that. No explanation. The hypothesis they came up with is that they are dying because of the lack of difference between the seasons. True or not it's fabulous, don't you think?

The Violence of Indifference

François Ewald: *"I have hate." That was one of the slogans of the young people who were demonstrating last spring against the CIP.*[1] *It's a strange expression...*

Jean Baudrillard: Indeed, the expression is strange, for there's no object in the phrase "I have hate." It's the problem of these passions that no longer have an object. It's like the statement: "I demonstrate" [*Je manifeste*] which really means I demonstrate myself. But for what? For whom? This is the destiny of expressions where the verb has become autonomous. They are constructed in the first person, but the object has disappeared. Take also the phrase: "I take on" [*J'assume*]. What does he or her take on? They would be quite hard pressed to say. It's a subject without an object who is speaking.

There's also the "I have," as opposed to "I am." A passion like hate, one is it, *more than one* has *it. From a syntactic point of view as well, the expression is curious.*

It's not exactly a syntax any more, it's a logo, a kind of label. Like graffiti, it displays a modality of living: "I exist," "I live here."

Period. Within reason, or beyond all reason. Hate may be something that subsists, that outlives any definable object. Whom can one make an object of hate today? And where can young people indeed find an object of hate?

It's a kind of status, a kind of modality of living, that also sounds like a condemnation. It's quite desperate.

We mustn't overdo death or despair. They may look desperate but I'm not sure that they are actually desperate. They might well be less desperate than others, less disaffected. Hate is still an energy, even if it's negative or reactional. Today, there is nothing but these passions: hate, disgust, allergy, aversion, deception, nausea, repugnance, repulsion. People don't know what they want any more. People are only sure about what they don't want. The current processes are processes of rejection, of disaffection, of allergy. Hate is part of this paradigm of reaction passions, abreactional passions: "I'm sorry, I don't want any. I won't join the consensus. It's not negotiable. It's not reconcilable."

In the expression, "I have hate," there's also a way of positioning oneself without demanding anything, finally. "I have hate" is not "I hate you." This kind of objection parades as pure affirmation, pure position. As such, it's irrecoverable.

Indeed, "I have hate" is like a king of final asset. But even so, there's a king of alterity, someone in front of you, it can always be negotiated in one way or another, even negotiated with power.

Does one encounter this type of affect in other places besides France?

I've just returned from Australia, where my encounter with the aborigines made me experience a kind of radical anthropological shock. Alterity is truly a great problem there. The aborigines—it's the anthropological extreme, but a revealing extreme—have a kind of visceral, profound rejection of what we represent and what we can be. As if these people also "had hate." There's something irremediable, irreducible in this. We can offer them all the universal charity we are capable of, try to understand them, try to love them, but there's in them a kind of radical alterity that does not want to be understood and that will not be understood.

Between these people and the world that, since the enlightenment, has been developed around the universal, I have the impression that the gulf is expanding. At the same time that the universal was invented, the other was discovered, the real other, precisely the one that does not fall back into universal, the one whose singularity is insistent, even when disarmed and impotent. I have the impression that the gulf is hardening and deepening between a culture of the universal and those singularities that remain. These people cannot allow themselves offensive passions; they don't have the means for them. But contempt is still available to them. I believe that they have a profound contempt for us; they dislike us with an irreducible feeling of rejection. The young people in the banlieues[2] are one of the possible versions of this phenomenon—but an integrated one, whereas in the third world, what remains of all that has been destroyed or virtually exterminated holds onto a passion of radical vengeance, a kind of absolute reversion that's not about to subside.

Is this current feeling of hate similar to what we used to call class hatred not so long ago?

I don't think so. Class hatred, paradoxically, has always remained a bourgeois passion. That hate had an objective; it could be theorized and was theorized. It was formulated, one could act on it: it provided for historical and social action. There was a subject (the proletariat) and structures (the classes) and contradictions. The hate that we are talking about does not have a subject; one cannot act on it. It's only expressed by acting out. Its modality of existence is no longer that of historical action, but that violent, self-destructive acting out. Hate can easily turn against itself, it can also become self-hatred, self-destruction. Look at the suicide of the lead singer of the rock group Nirvana. He wanted to give his last album the following title: "I hate myself and I want to die." From now on, class hatred is part of our heritage—the European heritage at least.

In the 1980s, certain intellectuals diagnosed the end of political passions. Isn't hate a new form, the new face of political passion?

So we're past the end then? Why couldn't there be a political indifferenciation, now—one which would not necessarily be the last word of history with, at a given moment, a turnaround, a hate for … Maybe the last drives are against history, against politics. Maybe what comprises an event is no longer constructed in the direction of history or in the political sphere, but against them. There's a disaffection, an ennui, an indifference, which can suddenly crystallize into a more violent form, through a process of instantaneous passage to the extreme. It can accelerate as well. Indifference is not at all a quiescent sea, the flat encephalogram. Indifference is also a passion.

Indifference is a passion?

Of course. There are strategies of indifference. Indifference describes an original situation, which is not absence, or nothing. Masses, for example, are indifferent bodies, but there's mass violence, mass virulence. Indifference causes damage. The term indifference might appear flat, but it can also enter into an incandescent state. There's certainly a violence of indifference.

You were speaking about acting out a moment ago. Isn't that a game played in the popular media? A form of passion in the television age?

The popular media is always taken to be a kind of mirror capable of creating such special effects such that what was there at the start can no longer be found. That's the most common analysis. But the forms of popular media themselves are the site of indifference, they are what produce indifference. They produce something original: the production of indifference. One believes that power manipulates the masses through the popular media. One can also think that the reverse is true: it may be the masses who neutralize and destabilize power through the popular media. The media may be the site of where rational and historical action is reversed. They paralyze and immobilize almost everything.

Obviously, the stage is occupied, it's full, but we know that nothing happens there, virtually nothing. This is what produces catastrophic effects. Information fills our space, but in fact the emptiness digs deeper, into a kind of black hole. Besides do people believe in information? Everybody pretends to. There's a kind of consensus based on credulity; one pretends to believe that what happens to us through the popular media is real or true; one believes in a kind of principle of divine right. But in the end, do people believe in it? I am not so sure. They're more in a state of

fundamental incredulity. This incredulity is not necessarily passive. It's a resistance. It means something: "We don't want that, That doesn't concern us, That's not a part of our universe." For the great majority, it's true that it doesn't relate to them, it doesn't concern them. There's a kind of enormous ... not anomie, in the sense where there would be small groups of people outside the law, outside the norm; but instead a kind of profound anomaly.

Take Paulin, the Guadeloupean man who, a few years ago, murdered those old ladies in Paris. His trial was held, he was convicted and sentenced, he died of AIDS in prison. *I Can't Sleep* ("J'ai pas sommeil"), a film that tells his story, just came out. Here is a person who was absolutely monstrous—but cool, displaying no apparent hate. He was identity-less, of indeterminate gender, of an indistinct race: a kind of anticipation of a completely hybrid [*metissée*] society having become perfectly indifferent. He carried out his murders without violence, without bloodshed. He was even extremely courteous, lucid, calm. He told the police about the murders with an odd detachment, a kind of indifference. One could take it to be a true indifference: someone who had become so indifferent to himself, to his own identity, that he could eliminate beings who were likewise indifferent themselves: little old men, or ladies. One might also imagine that, behind all this, there's a core of radical hate. Paulin may have had hate, but he was too stylized, too cultivate to express it in a violent way. That hypothesis is also possible.

Can one say that hate has become our dominant political passion?

Comunication, in becoming universal, has been accompanied by a fantastic loss of alterity. There's no more other. Perhaps people

are searching for a radical alterity, and hate, a desperate form of the production of the other, may be the best way to make it appear, as well as the best way to exorcise it. In this sense, hate would be a passion, in the form of provocation, of defiance. Hate is something strong; it must provoke a sharp adversity, and our world hardly provokes adversity anymore, because conflicts are immediately shut off, circumscribed, invisible. Hate is an ambivalent sentiment that can be inverted. It's a much stronger way of relating than love, affection, consensus or conviviality, which are weak modes of communication.

One cannot avoid comparing the present situation to the 70s, when people were talking about "peace and love" all the time. It was the era of resistance to the Vietnam war, beatniks, hippies, "under the cobblestones, the beach," John Lennon's Imagine. *There was so much love everywhere that finding a way to love power became a big question.*

It's true that at that time, everything revolved around the libido, desire and libido, things that curiously have weakened considerably since then, except in advertising. As to power: where is it? No one is able to capture power any more, even to fight against it. Hate is no longer class hatred, since it no longer sets the rich in opposition to the poor, the bosses against the workers. It's a hate for the class of politicians, an aversion for the political class, a global hate that has found a way to express itself in various political scandals, without being reduced to them.

Can one say that this hate comes at the end of history? Is it the passion that accompanies what Francis Fukuyama has described as the end of history?

I was just in Frankfurt with Francis Fukuyama, actually. I told him he was optimistic talking about the end of history. That would mean that history has taken place, that it's finished. It would suppose that history happened. Ultimately, there's more of a king of passage beyond, beyond an interminable history. Hate is more the violent reaction to the fact that there's no solution, that there's no possible resolution to all the problems posed by history. It's a rejection of the course of history; it's a king of loop, a regression. One doesn't know what one is dealing with. Perhaps, beyond the end, in these border regions where things are inverted, it's possible that there's an indeterminate passion—one which necessarily would not be a positive one, the way love is positive. Whatever energy remained would be inverted in negative passion, a rejection, a repulsion. Identity today is found through rejection; it hardly has any positive base any more. All that remains now is self-anti-determination, more through the expulsion of the other than by relation or affective dialectic. This is a situation which is becoming jammed. Certainly, there has been a kind of rupture that has not really been perceived. We've been swinging back and forth, not in a kind of positivity of time, a linearity of time any longer, but in a kind of countdown. Take the numeric clock at Beaubourg: it testifies to the fact that we are in an odd temporality, no longer in a time which is counted up from the origin and increasing, but instead, in a countdown. The end is there, and there's nothing else to do but count what separates us from it. Counting from the end, it's truly an odd perspective; it obviously is not done in order to increase our positive passions.

What politics is possible in the age of hate?

Rediscovering political passions: this is the great desperate hope of intellectuals. There have to be stakes in politics again. I believe that the true passion, the fundamental passion, is that of the game; it's the one which overdetermines all the others. When you play, you are impassioned. If you play, there are stakes, then there's a passion, neither positive nor negative, a passion of battle that expends itself. You play, you lose, you win, it's not a question of progressing, whatever you win you lose right back, etc. Passions come from there. In contemporary politics, where are the stakes? They have been shut off, there's nothing but stakes in this or that category, corporate stakes. It's as if there's an impossibility of putting something at stake. Thus, there's no more passion in politics. There's only an apathy, and one on the other side—to play on words—a *com*passion. We are no longer in impassioned politics; we are in compassion, through the extension of Human Rights, of solidarity.

The humanitarian issue?

There's a sort of radical dilution of passion into a sort of compassion, which Hannah Arendt analyzed and criticized long ago when she explained that, with the revolution, the compassion for the happiness (and especially for the unhappiness) of others took the place of passion, of freedom, of action, which are politics proper. We've fallen into the consensual universal of Human Rights, which conceals and nourishes violent singularities that secrete hate precisely to the degree that this universal is inadmissible—it's the utopia that can reveal itself to be murderous. It begins in enthusiasm, but when the system truly arrives at the point of the universal, to the point of saturation, it produces a terrible reversion, and all the

accidents we're seeing now, in the form of virulence, which has in a way replaced historical violence. From now on, we will have to deal with anomalous systems that secrete all sorts of virulence: AIDS, computer viruses, etc. Hate may also be a virus of this kind. Perhaps hate is vital, vital in the sense that it's the worst thing that can happen if you have no enemies anymore, no more adversity, no more antagonism, even virtual antagonism. If you take away hate's natural predators, it destroys itself. There's a vital metastability, a kind of equilibrium that implies that there's an other, and an evil other, some enemy. If you don't have to defend yourself anymore, you end by destroying yourself. This is what I have called depredation, in the sense that the predators have been removed. Hate may also be a last sign of life.

It's said that hate is nationalist, and that nationalism is hateful. What do you think of the current analyses of the return of nationalism.

They're superficial, overly moralizing. The analysis should be a bit harder, tougher, and it shouldn't immediately short-circuit phenomena with value-judgments: "This is not good; Le Pen or Islam shouldn't exist." It's not necessary to call for a return of Human Rights, since it's precisely that culture of universal values that secretes the current state of things.

Is there a danger in the universalism of Human Rights?

One doesn't need psychoanalysis to know that a human being is an ambiguous animal, that one cannot root the evil out of him or her, or simplify them to the point that they would be no more than a positive and rational being. Yet, it's upon this improbability that

the ideologies rest. It's necessary to have adversity, incompatibilities, antagonisms, things that are irreconcilable, at the risk that the most sordid passions might be revealed. There's no choice. It's necessary to work with these things.

Modern politics begins with the will to dialecticize, to equilibrate forces, to find strategies of compromise between things, which are always thought to be negotiable. The principle of modern politics is that nothing should be able to evade this enterprise of reconciliation and negotiation. If there has to be conflict, it's meant to be resolved. Modern politics includes a final solution principle, which leads sometimes to "the" final solution. This is dialectic. But the reality is not dialectical; it's made up of irreconcilabilities, truly antagonistic things, as Freud posited Eros and Thanatos to be: radically mutually exclusive, and absolutely irreconcilable even to an infinite degree. Other cultures know how to manage this fundamental ambiguity symbolically, through the use of sacrifice, of rituals, of the ceremonial. But we don't want to take it into account. We start with the principle that things must become clear, become transparent. At the same time, there's a residue that's not dealt with, because it cannot be dealt with; it becomes necessarily residual and negative, and transforms itself naturally into hate. In pushing the universal as far as it will go, as we have done, one necessarily provokes a reversibility of these things, and other singularities will be provoked in turn. I am not a pessimist; the singularities are indestructible.

Can hate be universalized? Can one imagine a federation of hates? That the banlieues might make an alliance with various nationalisms, which themselves might make an alliance with something else in a sort of international of hate?

One would almost wish for such a scenario to be implemented. But by definition, inertia, indifference cannot be put into solidarity, since it results from the breaking up of solidarities, from the failure of the universal. It's fractal, fragmented, it erupts here or there, without the optimistic possibility of finding a political coherence. No, the worst is not always possible.

If there had to be a linkage, it would be of the order of a chain reaction, which is the current way in which events are propagated. Not through information anymore, nor knowledge, nor reason, with its reasoned and reasonable progressivism. There're trigger moments, uncontrollable linkages, like those described by Elias Canetti in *Crowds and Power*. The mass is a dull type of body, but transmission in it is ultra-rapid, through an effect that remains mysterious to traditional sociological analysis. Fashion is a kind of ultra-rapid contagion. It's the virulence of the virus, but not all viruses have perverse negative effects; some of them have perverse positive effects. We're in a universe of ultra-reaction, of overreaction, of chain reaction, of immediate contiguity. This is the modality of the popular media today, the modality of communication. Obviously, in a universe of this kind, political action is much more difficult.

Traditionally, political philosophy starts from the principle of a self-conservation which resists the dangers that threaten the individual. Today, with people like André Glusckmann, one seeks to base a morality on the recognition of a principle of radical evil—in a certain way, then, through a sort of hate of all evil. Could hate be the principle of a new morality?

I have nothing against evil, the principle of evil. With evil, it seems to me, there's an active principle, on the condition that one doesn't

demonize evil, that one doesn't pathologize it, as Glucksmann does. There were all those analyses, in Georges Bataille for example, according to which the energy of societies comes from the principle of evil. Not from their positive passions, but from their negative ones. This is also what I've called the transparence of evil: evil is no longer played out, it no longer plays a part. It moves elsewhere, and appears transparent everywhere. Instead of being graspable, it becomes ungraspable. It takes the form of all these viruses that worry us today. But does that mean we need to use a demonic principle?

Isn't there a lot of that in Nietzsche? The idea that it's also necessary to know how to hate.

You have to be ruthless: you have to push everything that is leaning, so it falls. That's the strategy of the very worst, upping the ante, a passage beyond. I like that logic very much. It's necessary to know how to go to extremes. The problem is that more often we fall short of good and evil. We've lost the values, and the standard opposition of values—not by passing beyond then, but in falling short of them. From now on, values will be indiscernible, they will drift.

The good is when there's a regulated opposition of good and evil. The good completely admits the existence of evil, but admits that there's a possibility of reconciliation. All our religions, our ideologies start from the principle of good. Evil is when there's no more possible reconciliation between good and evil, when the two poles are torn apart. We are thus now within evil, in the sense of irreconcilability, which is inadmissible from a moral point of view. Evil means that there's no possible reconciliation between the two.

That doesn't give much of a future to our present politics of integration.

It's true that, until the middle of the 1980s, in our cultures, the process had not been going in the direction of exclusion. That has changed. Now something completely evades social regulation. Even if it's not the end of history, it's certainly the end of the social. Something has been dissociated; a principle of dissociation is at work, and there's no end in sight.

We are no longer in anomie, but instead in anomaly. Anomie was quite pleasant. Anomie arises in a bourgeois society. Anomie is that which, through a temporary exception, is not within the law, but which ones hopes to re-inscribe within the law, to put it back on the right track through solidarity. As for anomaly, it's irrecoverable. It's not about light disturbances. Anomaly is not what evades the law, according to some rule of evasion. It's more profound: the rules of the game are not necessarily articulated. No one is necessarily supposed to know them. One might not know anything about them; yet, one knows that people avoid the game completely, escape the possibility of playing the rules of the game. The law is explicit, one can contest it, and anomie provided a principle of resistance, of subversion, whereas anomaly is completely irrational; it's what falls elsewhere, what cannot be played out anymore, what's no longer in the game, what's outside of the game. One doesn't know what's fomented there, in anomaly.

Can anomaly have hate as a passion?

Perhaps we live in a general process of reversion of things—a process that would be augmented by various passions, like hate. Without knowing it, we would have passed to the other side, we

would have moved into systems which are more and more sophisticated, functional, operational, and at the same time more and more threatened by a breakdown, by a violent reversion. It may well be that this is the very problem of the species itself, and not only the problem of certain cultures that might be trapped in a process of self-destruction. We've already seen cultures collapse just like that, in one fell swoop, without knowing why.

We're all Incas, then…

One doesn't have to go so far: just look at Communism.

Viral Economy

AIDS, the stock market crash (followed by a series of corporate raiders and hostile takeovers), electronic viruses—we are spoiled in terms of "superconductor" events, the kind of untimely intercontinental torrents that no longer strike states, individuals or institutions but whole transversal structures: sex, money, information and communication.

These three events are not identical, but they resemble each other. AIDS is a kind of crash of sexual values. We can't forget that computers, infected by a kind of AIDS, played a "virulent" role in the Wall Street crash. But their unbridled contamination could also resemble a crash of computer values. The contagion is not only active within each system, it has spread between systems.

They are all related to a generic figure: the catastrophe. Indeed, signs of this virulence, of this internal disturbance had long been present in each system: endemic AIDS; the crash with its famous predecessor in '29 and its constant threat in the panic over stock prices; a 20-year history of computer piracy (and consecutive accidents). But the conjunction of all these endemic forms and their almost simultaneous passage into virulent state, to the state of unbridled anomalies, creates an altogether original and exciting situation. Their effects are not all the same in the collective

consciousness: AIDS can be experienced as a real catastrophe (but it needs the additional virulence of rumors); the crash appears as a catastrophic game; and as for electronic viruses, they are certainly dramatic in their virtual consequences, but they are also a hilarious irony. They are like a catastrophic parody, like how laughter is contagious (laughter is a form of contagiousness created by the—even minute—disaster of reality; laughter is a homeopathic catastrophe) and the sudden epidemic striking computers, destroying their defense systems and their immunity, can cause, at least in the imagination, a justified delight (except for computer professionals).

I would add to these different aspects of a single eccentric nebula two very different things, two things that irresistibly invoke the same mechanisms: art, which is now everywhere subjected to the problem of the fake, the authentic, the copy, the clone, the simulation—a veritable contagion that destabilizes aesthetic values, causing them to lose their immunity as well—and simultaneously undergoing the delirious, speculative bidding wars of the art market. It is no longer a market in fact; it is a centrifugal proliferation of value that corresponds exactly to the metastases of a body irradiated by dough.

The second effect is political: it is terrorism. Nothing resembles the interstitial chain reaction of terrorism in our irradiated societies (irradiated by what, in fact? By the over-infusion of happiness, security, information and communication? By the disintegration of symbolic centers, fundamental rules, social contracts? Who knows?) more than AIDS, the corporate raiders and hackers. The contagion of terrorism is just as punctual, ephemeral, enigmatic and unmanageable as all these phenomena. Hostage taking is also contagious: when a software creator introduces a "soft bomb" in a program, using its potential destruction as a means to exert pressure, what is

he doing other than taking the program and all of its future operations hostage? And what do corporate raiders do other than seize companies and take them hostage while speculating on their death or resurrection on the stock market? We can therefore say that all of these effects operate in the same mode as terrorism (where hostages have a quoted market price like stocks or paintings) with the same overbidding, the same unpredictability, the same destabilizing effects and chain reactions. But we could just as well integrate terrorism using the model of AIDS, electronic viruses or hostile takeovers. One does not take precedence over the others; there is no cause and effect process. They are all part of the same constellation of contemporary and complicit phenomena.

The crash is continued in the frenzy of buyouts. They no longer buy just stocks, but whole companies. This creates a virtual effervescence whose potential incidence on economic reconstruction is, despite what they say, purely speculative. The desired result is that this forced circulation will lead to a broker's fee exactly like in the stock market. Not even an objective profit: the profit of speculation is not exactly a surplus, and it certainly presents something other than capitalist implications. Speculation, like poker or roulette, has its own logic of enthusiasm, chain reactions, escalation (*Steigerung*) where many people find the excitement of the game, outbidding. (That is why it is impossible to oppose it with economic logic. This is also what makes these phenomena exciting: overrunning economics with an aleatory and vertiginous form).

The game is such that it becomes suicidal: the major companies end up buying back their own stocks, something that is aberrant from an economic point of view. They end up buying themselves out! But it is part of the same madness. Companies are not exchanged or circulated like real capital or a unit of production in

the case of a takeover. They are exchanged as a group of stocks, as the only probability of production sufficient to create a virtual movement in the economy. It is very probable that this precedes other crashes, just as for stocks when they circulate to quickly. One could even imagine that work itself, the force of work enters this speculative cycle. The worker would no longer sell his or her force of work for a salary—as in the classic capitalist process—they would sell the job itself, the work station, in order to buy others and resell them depending on the fluctuations of the employment market, which would then take on the full meaning of the term. It would then be less a question of performing a job but rather to circulate them, creating a virtual movement of employment that would replace the real movement of work.

Is this science fiction? Only barely. The very principle of information and communication is the principle of a value that is no longer referential but is based on pure circulation. Pure value added by the fact that message and meaning pass from picture to picture, screen to screen. It is not even the surplus and exchange value of commodity (although it already anticipates this process) which in principle articulate themselves around the use value and therefore still belong to the economic sphere. Here, there is no longer any exchange as such; we are in pure circulation and chain reactions through the networks. It is a completely new definition of value, a purely centrifugal value tied to pure speed and the multiplication of exchanges. This is to a large extent what is happening in the domains of communication and information—made up of operational yet never operating virtuality.

This model of "transeconomic" value already exists, however, in primitive cultures. The *kula* is a cycle of gifts that take on increasing value depending on whether they have been given or received

the most times. They can even come back to the starting point without changing but worth a hundred times more. (Isn't the same true today of the art market?) The mere fact of changing hands creates a sort of symbolic energy of circulation that is transformed into value. But this value cannot be realized, it cannot be "produced" or transferred into the circuit of useful values (*ginwali*). It can only circulate indefinitely and multiply as it circulates (or perhaps crumble if the movement stops). The *kula* is in a way the sacred level, the prestigious level of (symbolic) exchange. The other level, the level of bartering, of equivalencies, has no symbolic value: it is functional. Potlatch is also a speculative structure of overbidding, of producing value by pure and simple raising of the stakes.

Is there an echo of *kula* and potlatch in these disordered effects that fundamentally contradict the economic principle of value and equivalency, the principle of work and production? In all logic (even the logic of radical critique), we cannot condemn this excess. Everyone in fact enjoys it as a spectacle (the stock market, the art market, the raiders). We all enjoy it like the spectacular improvement of capital, its aesthetic delirium. At the same time, we take a more difficult, more painful pleasure in a more ambiguous way from the spectacular pathology of this system, of viruses like AIDS, the crash and computer viruses that happen to graft themselves to this beautiful machinery and cause it to break down. But it is in fact the same logic: viruses and virulence take part in the logical, hyperlogical coherence of all our systems. They take the same paths, they even trace out new ones (electronic viruses explore the confines of the networks that even the networks did not foresee). Electronic viruses are the expression of the deadly transparency of information in the world. AIDS emanates from the deadly transparency of sexual liberation at the level of entire groups. Market crashes are the

expression of the deadly transparency of economies to each other, of the lightning-fast circulation of value that is the very basis of the liberation of production and exchange. Once "liberated," all the processes enter into surfusion, like the nuclear surfusion that is the prototype. This surfusion of factual processes that detach from their real substance is not the least charming aspect of our time.

It is not the least paradox either to see the triumphal return of the economy to the agenda, especially in the media (we cannot forget that the media universe is also a viral universe and that the circulation of images and messages functions as a perpetual rumor). But can we in fact still speak of "economy"? Or political economy (the logic of capital)? Certainly not. At the very least, the dazzling immediacy of the economy no longer has anything close to the same meaning as in Marxist or classical analysis. For its impetus is no longer the infrastructure of material production at all, or the superstructure. Its impetus is the destructuration of value, the destabilization of markets and real economies, the triumph of an economy cleared of ideology, social sciences, history, political economy and handed over to pure speculation, a virtual economy cleared of real economies (not really, of course: virtually—but precisely reality today does not hold power; virtuality does) a viral economy that connects in this way to all the other viral processes. As the place of special effects, unforeseeable (almost meteorological) events, as the destruction and exacerbation of its own logic, it once again becomes an exemplary theater of current events.

1996

Radical Thought

"The novel, which is a work of art, exists, not by its resemblances to life, which are forced and material, [...] but by its immeasurable difference from life."

— Stevenson[1]

Thinking, therefore, is not as valuable for its inevitable resemblances to truth as for the immeasurable divergences that separate it from truth.

It is not true that we need to believe in our own existence to live. It is not necessary. Our consciousness is in fact never the echo of our own reality, of our existence in "real time," but rather the echo in delayed time, the dispersion screen of the subject and its identity. We are only indistinguishable from ourselves in sleep, unconsciousness and death. This consciousness, which is something altogether different than belief, comes more spontaneously from challenging reality, from siding with objective illusion than from objective reality. This challenge is more vital for our survival and for the survival of the species than the belief in reality and existence, which are spiritual consolations for use in another world. This world, here, is as it is, and is no less real. "The most powerful instinct of human kind is to enter into conflict with truth and therefore with reality."

Belief in reality is one of the elementary forms of religious life. It is a weakness of the understanding, a weakness of common sense, and also the final stand of the moral zealots, the apostles of the legality of reality and rationality who say that the reality principle can never be cast in doubt. Fortunately, no one lives according to this principle, not even those who profess it, and for good reason. No one fundamentally believes in reality or in the evidence of his or her real life. That would be too sad.

But then, these good apostles say, you are not going to discredit reality in the eyes of those who already have so much trouble living and who have just as much right to reality and rationality as you and me. The same underhanded objection is made for the Third World: you are not going to discredit abundance in the eyes of those who are dying of hunger. Or: you are not going to discredit class struggle for people who have not even had their bourgeois revolution. Or: you are not going to discredit feminist and egalitarian protests for all the women who have never even heard of women's rights… If you don't like reality, don't ruin it for everyone else! It is a question of democratic morality: you should not demoralize Billancourt.[2] You should never demoralize anyone.

A deep disdain underlies these charitable intentions. First, it establishes reality as a kind of life insurance or permanent concession, like the smallest human right or the greatest mass consumption good. But most of all, by only crediting people for putting their hope in reality and in visible proofs of their existence, by attributing this Saint-Sulpician realism to them, they take them for innocent fools. It must be said in their defense that the thurifers of realism cast this disdain on themselves first by reducing their

own lives to a series of facts and proofs, causes and effects. Well-organized resentment always begins with the self.

Say "I am real, this is real, the world is real," and no one laughs. Say "this is a simulacrum, you are a simulacrum, this war is a simulacrum," and everyone breaks out laughing. With forced, condescending or convulsive laughter, like for a childish joke or an obscene suggestion. Everything that touches simulacra is taboo or obscene, just like everything that concerns sex and death. Yet it is in fact reality and obviousness that are obscene. Truth should be laughable. You could imagine a culture where everyone spontaneously rolled with laughter when someone said: this is true, this is real.

These things define the unsolvable relationship between thought and reality. A certain form of thinking supports reality. It starts with hypothesis that there is a real reference for ideas and a possible ideation of reality. The perspective of meaning and deciphering is a comforting point of view. Its polarity is found in ready-made dialectical and philosophical solutions. The other thought is on the contrary exterior to reality, excentered from the real world—and therefore outside dialectics, which plays on opposing poles, and even outside critical thinking, which always refers to an ideal reality. In fact, it is not even a denegation of the concept of reality. It is illusion, in other words a play with reality, just as seduction is a play with desire (it puts desire in play), just as metaphor is a play with truth. This radical thought does not come from philosophical doubt or utopian transference (which always suppose an ideal transformation of reality) or from ideal transcendence. It puts this world in play; it is material illusion,

immanent to the so-called "real" world—it is non-critical thought, non-dialectical thought. It therefore seems to come from somewhere else. In any case, thought and reality are incompatible. There is no necessary or natural transition between the two. No alternation, no alternative: only alterity maintains the tension between them. Only this rupture, this distance, this strangeness ensure the singularity of thought as a singular event, like the singularity of the world through which it is an event.

This was probably not always the case. We can imagine the happy combination of ideas and reality, in the shadow of the Enlightenment and modernity, in the heroic times of critical thought. But this thought, which acted against a certain superstitious or religious or ideological illusion, is basically over. And even if it survived its catastrophic secularization in all the policies of the 20th century, this ideal, almost necessary relationship between concept and reality, between sign and referent would now be destroyed no matter what. It unraveled under the pressure of a massive technical and mental simulation, a precession of models providing autonomy for the virtual, freeing it from reality, and the simultaneous autonomy of reality that we now see functioning for itself—*motu proprio*—in a hallucinatory perspective, in other words self-referential ad infinitum. Cast out from its own framework, from its own principle, extraneous, reality has itself become an extreme phenomenon. In other words, we can no longer think of it as reality, but only as otherworldly, as if seen from another world—as an illusion.

Think of how mind-boggling it would be to discover a real world other than ours. Our real world, we discovered it one day. We found the objectivity of the world just like we found America,

and at about the same time. What you discover, you can never invent it again. That is how we found reality, which remains to be invented (alternative version: that is how we invented reality, which remains to be discovered). Why couldn't there be just as many real worlds as imaginary ones? Why would there only be one real world? Why such an exception? In truth, the real world, among all other possible worlds, is unimaginable. Unthinkable, except as a dangerous superstition. We have to separate ourselves from it like critical thought once detached itself (in the name of reality) from religious superstition. Thinkers, try again!

In any case, the two orders of thought are irreconcilable. Each follows its course without mixing with others; at best, they slide over each other like tectonic plates and sometimes their collision or subduction creates fault lines that swallow up reality. Fatality is always at the crossing of these two lines of force. In the same way, radical thought is at the violent crossing of sense and nonsense, truth and untruth, the continuity of the world and the continuity of nothingness.

Contrary to the discourse of reality and rationality, which counts on the fact that there is something (meaning) rather than nothing and therefore claims to have its final foundation in the guarantee of an objective and decipherable world, radical thought wagers on the illusion of the world. It claims to be illusion restoring the non-veracity of facts, the non-signification of the world, making the opposite hypothesis that there might be nothing rather than something, and tracking this nothing running underneath the apparent continuity of meaning.

Radical predictions always predict the non-reality of facts, the illusion of the state of fact. A prediction only begins with the foreboding of this illusion and is never mixed up with the objective state of things. Confusion of this kind would be on par with confusing the messenger with his message, which still leads today to eliminating the messenger bearing bad tidings (for example, the news of the nullity of our values, the uncertainty of reality, the non-occurrence of certain events). Any confusion of thought (writing, language) with the order of reality—thought's so-called "faithfulness to reality" that alone brought forth reality as a whole—is hallucinatory. This confusion also relies on a complete misunderstanding of language, of the fact that language is illusion in its very movement, that it carries the continuity of the void, the continuity of nothingness in the very heart of what it says, that it is, in its very materiality, the deconstruction of its signification. Just as a photo (an image) suggests disappearance, the death of whatever it represents, its intensity and the intensity of writing, whether it is fiction or theoretical fiction, comes from the void, the underlying nothingness, the illusion of meaning, the ironic dimension of language correlative to the ironic dimension of the facts themselves, which are never more than what they are—in every sense: they are nothing more than what they are and they are never only what they are—a perfect amphibology. The irony of facts in their miserable reality is precisely that they are only what they are, or at least that is what some try to force them to say: "Reality is reality." But by this very fact (appropriately enough) facts are necessarily outside, for de facto existence is impossible: nothing is completely evident without becoming enigmatic. Reality, in general, is too obvious to be true.

This ironic transfiguration by language constitutes the event of language. And the work of thought should be to restore the fundamental illusion of the world and language, but not by taking it stupidly as literal—taking the messenger for his message, sacrificing him in advance.

The two modes of thought thus have radically opposed objectives: one mode aims to bring about the objective reality of this world but wants to be different as thought; the other aims to restore the illusion of the world in which it participates. The first aims for a kind of general gravitation, a concentric effect of meaning; the other aims for an anti-gravitation, an excentering of reality, a general attraction of the void to the periphery (Jarry).

The demand of thought is double and contradictory. It is not the demand to analyze the world to extract an improbable truth. It is not to adapt dialectically to facts in order to abstract some logical construction. It is more subtle than that, more perverse. The demand is to put in place a form, a matrix of illusion and disillusion, a strange attractor that is spontaneously fed by a seduced reality and that therefore relentlessly verifies itself (only the objective needs to vary from time to time). Reality asks for nothing more than to submit to hypotheses. It validates all of them: that is its ruse and its vengeance. The theoretical ideal would be to set up propositions in such a way that they could be, that they had to be refuted by reality, so that reality would have no other choice, in desperation, but to oppose them violently and therefore unmask itself. Because reality is an illusion and it is the task of all thought to try to unmask it. In order to do so, thought must also advance in disguise and establish itself as a lure without concern for its own truth.

It must place its pride in not being a tool for analysis, a critical instrument, because it is up to the world to analyze itself. The world itself has to reveal itself as illusion, not reality.

It is necessary to trap reality, to move faster than it. The idea also has to move faster than its shadow. But if it goes too fast, it can lose its shadow: not having a shadow of an idea... Words go faster than meaning, but if they go too fast, madness ensues: the ellipsis of meaning can even lead to a loss of taste for the sign. What can be exchanged for this share of shadow and work, this share of intellectual economy and patience—what can we sell it to the devil for? It is rather hard to say. In fact, we are the orphans of a reality that came too late, which is only, like truth, an observation after the fact.

The best scenario would be for the idea to disappear as an idea to become a thing among things. That is where it would find its culmination. By becoming consubstantial with the world around it, it would no longer have cause to appear or to be defended as such. Evanescence of the idea by silent dissemination, obviously antinomic to any intellectual celebration. An idea is never destined to burst, but rather to be extinguished in the world, in its transparition in the world and in the transparition of the world in it. A book only ends with the disappearance of its object. Its substance should leave no traces. It is like a perfect crime. Whatever its object, writing must let the object's illusion extend out and become an elusive enigma—unacceptable for the specialists and Realpoliticians of the concept. The objective of writing is to change its object, to seduce it, to make the object disappear in its own eyes. It aims for a total resolution, a poetic resolution according to Saussure, the rigorous dispersion of the name of God.

If thought utters something as true, it defies that thing to verify itself. The trouble with reality is that it anticipates the hypotheses that deny it. It capitulates at the slightest demand, it bows to any conceptual violence; its distinguishing sign is voluntary servitude. Reality is a dog. Contrary to what is said about it (reality is what resists, an obstacle for all hypotheses), reality is not very solid, or less and less solid, and seems disposed to fall back into disorder. Entire pieces of reality crumble—like in the collapse of Buzzatti's *Baliverna* where the slightest crack leads to a chain reaction—decomposed vestiges are everywhere—like in *The Map and the Territory* of Borges. Not only does reality offer no resistance to those who denounce it, but it escapes those who take its side. It may be a way to take revenge on those who claim to believe in it in order to transform it: sending the zealots back to their own desire. In the end, it might be more of a sphinx than a dog.

More subtly, reality also takes revenge on those who contest it, by paradoxically proving them right. When a somewhat adventurous idea or a cynical or critical hypothesis is found to be right, it is a rotten trick, you are duped and disarmed in the face of the dreadful confirmation of your statements by a reality with no scruples.

You can therefore advance the idea of simulacra—while secretly not believing in it, hoping that reality will take its revenge—theory is not necessarily convinced of itself. Unfortunately, only the reality fanatics react negatively. Reality does not seem to want to refute it, on the contrary, all simulacra have free reign in reality. Reality today is nothing more than the apocalypse of simulation. To such an extent that the supporters of reality (which they defend like a moral value or a virtue) now play the role of those who were once called the fanatics of the Apocalypse.

The idea of the simulacrum was a conceptual weapon against reality but it was stolen. Not that it was plundered, vulgarized or transformed into a commonplace (which is true but of no consequence) but because it was spirited away by reality itself. Reality absorbed the simulacrum and now adorns itself in all of the rhetoric of simulation. The simulacrum has become reality—a travesty. Reality, having secreted away the idea (I am not referring to those who vulgarized it completely), now adorns itself in the rhetoric of simulation. Today, the simulacrum ensures the continuity of reality, the simulacrum now hides not truth but the fact that there is no truth, in other words, the continuity of Nothingness.

This is the paradox of any thought that lodges a challenge to reality—when reality steals the concept from you by realizing it. And at the same time escapes all criticism. Events, deprived of meaning themselves, steal meaning from you. They adapt to the most fantastic hypotheses like natural species and viruses adapt to the most hostile environments. They have extraordinary mimetic capabilities. A reversal also occurred there: theories no longer adapt to events, events adapt to theories. In any case, they mystify us, for a verifiable theory is no longer a theory. A realized hypothesis is no longer a hypothesis. It is terrifying to see a hypothesis verified to such an extent. Terrifying to see an idea suddenly correspond to reality. It is the agony of the concept. The epiphany of reality is the twilight of its concept.

We have lost the advance of ideas on the world, the distance that makes an idea stay an idea. Thought must be anticipatory, exceptional and on the margins—the shadow cast by future events. But we are now trailing behind events. They can sometimes give the

impression that they are regressing, not being what they should be. In fact, they passed us long ago. The simulated disorder of things was faster than us. The reality effect disappeared in the face of acceleration—the anamorphosis of speed. What happens to the heterogeneity of thought in a world given to the most insane hypotheses and prefabricated madness? Even interpreting events becomes problematic. For in their accelerated unfolding, they have in a way swallowed their interpretation; things have swallowed their meaning. They are therefore like black bodies: you cannot reflect on them, they have no reflection. They are what they are, never behind themselves, always beyond their meaning. Interpretation is lagging behind, and is nothing other than the retrospective figure of the unpredictable event.

What can we do? When everything suddenly conforms to the ironic, critical, alternative, catastrophic model that you made for it (conforms beyond expectations, for somewhere you don't even believe it that much, otherwise you would never have been able to invent it)? Well, it's paradise! We are beyond the final judgment, entering immortality—the only thing is to survive. Irony, challenges, anticipation, evil spells all end here just as inexorably as hope is abandoned at the gates of hell. In fact, that is where hell begins, the hell of the unconditional realization of all ideas, the hell of reality. You can understand (Adorno) why concepts prefer suicide or sabotage to ending up there.

Something else was stolen from us: indifference. The power of indifference, which is a quality of the mind, as opposed to the play of differences, which is a characteristic of the world. This indifference was taken from us by a world that became indifferent,

just as the extravagance of thought was taken from us by an extravagant world. When things, events, refer to each other and to their undifferentiated concept, then the equivalency of the world meets and cancels out the indifference of thought—and boredom ensues. No more altercations, no more implications. It is the parting of dead seas.

How beautiful it was, this indifference, in a world that was not indifferent, in a different, convulsive and contradictory world with stakes and passion! The mind's indifference was thus at stake and was a passion as well, diametrically opposed. It could antici-pate the becoming-indifferent of the world and make an event out of this indifference. Today, it is difficult to be more apathetic, more indifferent to their own meaning than facts themselves. Our operational world is an apathetic one, indifferent to itself, dispas-sionate and deadly boring. And it is useless to be dispassionate in a passionless world. Being carefree in a disinvested world has no meaning. That is how we became orphans.

It is not a question of defending radical thought. Every idea we defend is presumed guilty, and every idea that does not defend itself on its own deserves elimination. However, it is necessary to fight any accusation of irresponsibility, nihilism and despair. Rad-ical thought is never depressive—a total misunderstanding. Ideological and moralist critique obsessed with meaning and con-tent, obsessed with the political ends of discourse, never takes into account writing, the act of writing, the poetic, ironic, allusive form of language, the play of meaning. This critique does not see that the resolution of meaning is there in the very form, in the for-mal materiality of expression. Meaning is always unhappy; analysis

is by definition unhappy, since it comes from critical disillusion. But language is happy, even if it indicates a world without illusion or hope. This would be the definition of radical thought, even here: intelligence without hope but with a happy form. Critics, unhappy by nature, always choose the battlefield of ideas. They never see that, while discourse always tends to produce meaning, language and writing always make illusions—they are the vibrant illusion of meaning, the resolution of the misery of meaning by the happiness of language. That is really the only political, or transpolitical act that someone who writes can accomplish.

Everyone has ideas, more than are needed. What is important is the poetic singularity of the analysis. Only this, this *Witz*, this spirituality of language can justify writing, not the miserable critical objectivity of ideas. There will never be a solution for the contradiction of ideas except in language itself, in the energy and happiness of language. Thus the loneliness or sadness in the paintings of Edward Hopper is transfigured by the timeless quality of the light, a light from beyond that gives the whole more than a figurative meaning, an intensity that makes this solitude unreal. "I do not paint sadness or loneliness," said Hopper, "I only seek to paint light on this wall."

In any case, a desperate analysis in a happy language is better than an optimistic analysis in a language despondent with boredom and hopeless with platitudes, as is more often the case. The formal boredom secreted by this idealistic thought of value or this willful thought of culture, is the secret sign of its despair—not in relation to the world, but to its own discourse. That is where true depressive thought lies, with those who only speak of moving forward and transforming the world while they are incapable of transforming their own language.

Radical thought is in no way different from the radical use of language. It is therefore foreign to any resolution of the world in terms of objective reality and its deciphering. Radical thought does not decipher. It anathematizes and anagrammatizes concepts and ideas, just as poetic language does with words. And in its reversible progression, it accounts for the fundamental illusion of meaning while at the same time accounting for meaning. Language accounts for the very illusion of language as a definitive strategy and, through it, for the illusion of the world as an infinite trap, a seduction of the mind, a spiriting away of all mental faculties. While it is a vector of meaning, language is at the same time a superconductor of illusion and nonsense. Language is only the unwitting accomplice of signification—in its very form, it calls for the spiritual and material imagination of sounds and rhythms, the dispersion of meaning in the event of language, like the dispersion of muscular functions in dance, like the dispersion of reproductive functions in erotic games.

This passion for artifice, this passion for illusion is the seductive joy of undoing the all too beautiful constellation of meaning. Letting the deception of the world, its enigmatic function, show through as well as the mystification of the world, which is its secret. All the while it gradually reveals its own pretense—deceiving rather than validating meaning. This passion wins out in the free and spiritual use of language, in the spiritual game of writing. It only disappears when language is used for restricted ends, the most common use of all: communication. In any case, if it wants to talk about illusion, language must also become illusion. If it wants to talk about seduction, it must become seduction. When talking about reality, language cannot do it, properly speaking, because language is never real. Even when it appears to be indicating

things, it does so in unreal, elliptic, ironic ways. Objectivity itself and truth are metaphorical in language, whether the apodictics and apodidactics like it or not. That is how language is the bearer, unconsciously or not, of radical thought, in that it always starts from itself like a witticism in relation to the world, like an ellipsis and source of pleasure. Even the confusion of languages in the Tower of Babel, a powerful illusory mechanism for the human race, source of non-communication and end of the universal language, will finally be revealed to be a gift from God rather than a punishment.

Cipher, not decipher. Work on illusion. Make illusions to make events. Make the clear enigmatic, make the intelligible unintelligible, make the event itself illegible.

Work on all events to make them unintelligible. Accentuate the false transparency of the world in order to spread terrorist confusion, the germs of the virus of radical illusion, in other words the radical disillusion of reality. Insidious, viral thought corrupting meaning, an accomplice in the erotic perception of reality's disturbance.

Erase all traces of the intellectual conspiracy in oneself. Steal the reality file to erase its conclusions. But it is in fact reality that fuels its own contradiction, its own denial, its own loss through our meager reality. This is what gives us the inner feeling that this whole affair—world, thought, language—comes from somewhere else and could disappear as if by magic. For the world is not trying to exist more or persevere in its existence. It is on the contrary trying to find the most spiritual means to escape reality. It is seeking, through thought, what could lead to its demise.

The absolute rule, the rule of symbolic exchange, is to return what has been given to you. Never more, never less. The absolute rule of thought is to return the world as it was given to us—unintelligible—and if possible a little more unintelligible. A little more enigmatic.

Reality-Shows

Dust Breeding

All our reality has become experimental. In the absence of fate, modern man is left to limitless experimentation on himself.

Two recent illustrations: the first, *Loft Story*, is the media illusion of live reality; the second, Catherine Millet, the illusory fantasy of live sex.[1]

The *Loft* has become a universal concept, a condensed version of the human zoo, the ghetto, No Exit, and the Exterminating Angel. Voluntary reclusion as a laboratory of synthetic conviviality and telegenically modified sociability.

It is at the point when everything is on display (like in Big Brother, reality-shows, etc.) that we realize there is nothing left to see. Contrary to every objective, the mirror of platitudes, of the degree zero holds the proof of the disappearance of the other; and even of the fact that human beings are not fundamentally social. The equivalent of a readymade—the transposition as such of *everyday life*,[2] life that has already been rigged by all the dominant models. Synthetic banality manufactured in closed circuit on the control screen.

The artificial microcosm of the *Loft* is thus like Disneyland, giving the illusion of a real world, an exterior world, despite the fact that each world is the exact image of the other. The entire United

States is Disneyland and we are all in the Loft. There is no need to enter the virtual double of reality—we're already there. The television universe is only a holographic detail of global reality. Down to our most daily existence, we are already in a situation of experimental reality. And that is where the fascination comes from, from immersion and spontaneous interaction. Is it pornographic voyeurism? No. Sex is everywhere, but it is not what people want. What they deeply want is the spectacle of banality, which is the true pornography, the real obscenity: nullity, insignificance and platitude. The extreme opposite of the Theater of Cruelty. But it may be a form of cruelty, at least virtually. At a time when television and the media are increasingly unable to give an account of the world's (unbearable) events, they have discovered daily life and existential banality as the most deadly event, the most violent news, the very scene of the perfect crime. And indeed it is. People are fascinated, fascinated and terrified by the indifference of the Nothing-to-say, Nothing-to-do, by the indifference of their very existence. Watching the Perfect Crime or banality as the new face of fate has become a veritable Olympic sport or the latest form of extreme sports.

All of this is reinforced by the fact that the public is called on to judge; the public has become Big Brother. We are beyond the panopticon, beyond visibility as a source of power and control. The question is no longer to make things visible to an outside eye, but to make them transparent to themselves by infusing the masses with control while erasing all traces of the operation. The audience is therefore involved in a vast negative countertransference with itself; and once again, this is the source of the dizzying attraction of this type of spectacle.

Fundamentally, all of this corresponds to the imprescriptible right and desire to be Nothing and to be seen as Nothing. There are

two ways to disappear: either one demands not to be seen (which is the current problem over image rights) or one turns to the delirious exhibitionism of one's own nullity. One makes oneself null to be seen and watched as null—the ultimate protection against the necessity to exist and the obligation to be oneself.

From this springs the simultaneous and contradictory demand not to be seen and to be perpetually visible. Everyone plays on both sides at the same time and no ethics or legislation can resolve this dilemma—the unconditional right to see and the equally unconditional right not to be seen. Maximum information is a human right and therefore forced visibility is as well, overexposure to the light of information.

Self-expression as the ultimate form of confession, as Foucault said. Keeping no secrets. Talking, talking, endlessly communicating. And at the same time this expression is violent to language since it makes language lose its originality; it becomes nothing more than a medium, a visibility operator, losing its ironic or symbolic dimension where language is more important than what it is talking about.

The worst part of this obscenity and immodesty is the forced sharing, the automatic complicity of the viewer that is the result of a veritable blackmail. That is the most obvious objective of the operation: the servitude of its victims, but voluntary servitude, with the victims taking pleasure in the wrongs done to them and their compulsory shame. An entire society sharing its fundamental mechanism: exclusion—and interactive exclusion at that! Chosen together, consumed with enthusiasm.

If everything ends in visibility, which like heat in the theory of energy is the most degraded form of existence, the crucial point is to succeed in making this loss of all symbolic space, this extreme

form of disenchantment with life an object of contemplation, amazement and perverse desire. "Humankind, which in Homer's time was an object of contemplation for the Olympian gods, is now an object of contemplation for itself. Its self-alienation has reached such a degree that it can experience its own destruction as an aesthetic pleasure of the highest order." (Walter Benjamin).[3]

Experimentation thus takes the place of reality and the imaginary. Everywhere we are inoculated with the protocols of science and verification and we are in the process of dissecting—vivisecting under the scalpel of the camera—the relational and social dimension outside all language and any symbolic context. Catherine Millet is also experimental—another kind of "vivi-sex-ion" where all the imaginary of sexuality is swept away, leaving only a protocol in the form of a limitless verification of sexual functioning, a mechanism that no longer has anything sexual about it.

A double misinterpretation (*contresens*):

—making sexuality itself the ultimate reference. Repressed or explicit, sexuality is at best only a hypothesis and as a hypothesis, it is wrong to make it a truth and a reference. The sexual hypothesis may only be a fantasy and in any case, it is only through repression that sexuality took on its authority and its aura as a strange attractor—when explicit, it even loses this potential quality.

—thus the nonsense and the absurdity of performing the act and of systematic sexual "liberation": no one "liberates" a hypothesis. As for proving sex by means of sex, how sad! As if everything were not in displacement, detour, transference, metaphor—everything is in the love potion of seduction, in diversion (*détournement*); not in sex and

desire but in the play of sex and desire. That is what makes any "live" sex procedure impossible, just like "live" death or "live" events on the news—it is all incredibly naturalist. The pretension of making everything come into the real world, hastening everything into integral reality. To a certain extent, this is the very essence of power. "The corruption of power is to ascribe to reality everything that was on the order of dreams…"

Jacques Henric[4] gives us the key in his conception of the image and photography: no use denying it, our curiosity towards images is always sexual—all we are looking for in the end is sex, and especially the feminine sex. It is not only the Origin of the World (Courbet), but the origin of all images. Let us go there directly and let us photograph this one thing, let us obey without hindrance the scopic drive! That is the principle of a "Realerotik." Its equivalent for the body is the perpetual, copulating *acting-out* of Cathcrine Millet: since finally what everyone wants is the unlimited sexual use of the body, let us move directly to the execution of this program!

No more seduction, no more desire, no more pleasure (*jouissance*); everything is there in numberless repetition, in an accumulation where quantity is above all most suspicious of quality. Foreclosed seduction. The only question we would ask her is the one a man murmurs into a woman's ear during an orgy: "What are you doing after the orgy?" But the question is futile since for her there is no "after the orgy." She is in fact beyond the end, where all processes take on exponential speed and can only increase indefinitely. Just as for Jarry's *Supermale* (*Surmâle*), once the critical threshold of love is reached, one can do it indefinitely; it's the automatic stage of the sexual machine. When sex is no more than *sex-processing*, it becomes transfinite and exponential. It does not

reach its goal, however, which would be to exhaust sex, to reach the end of its use. This is obviously impossible. This impossibility is all that remains of the revenge of seduction or of sexuality itself on its unscrupulous operators—those with no scruples for themselves, their own desire or their own pleasure.

"Think like a woman taking off her dress," said Bataille. Yes, but the naiveté of all the Catherine Millets is to think that they are taking off their dress to get undressed, to be naked and therefore reach the naked truth, the truth of sex or of the world. If one takes off one's dress, it is to appear: not to appear naked like truth (and who can believe that truth remains truth when its veil is removed?) but to be born to the realm of appearances, to seduction—which is the contrary.

This modern and disenchanted view is a total misunderstanding if it considers the body to be an object waiting only to be undressed and considers sex a desire only waiting to pass into action and reach orgasm. Especially since all cultures of the mask, the veil and ornaments say precisely the contrary: they say that the body is a metaphor and that the true objects of desire and pleasure are the signs and marks that tear it from its nudity, naturalness and "truth," from the integral reality of its physical being. In all places, seduction is what tears things from their truth (including their sexual truth). And if thought takes off its dress, it is not to reveal itself naked, it is not to unveil the secret of what had been hidden until then, it is to make the body appear as definitively enigmatic, definitively secret, as a pure object whose secret will never be lifted and has no need to be lifted.

In these conditions, the Afghan woman behind a Moucharabieh window, the veiled woman on the cover of *Elle* represents a striking alternative to the crazed virgin Catherine Millet. Excessive secret

versus excessive immodesty. Furthermore, this very immodesty, this radical obscenity (like the obscenity of *Loft Story*) is still a veil, the final veil, the insurmountable veil that drops when we think all veils have been torn down. We would like to touch the worst, the paroxysm of exhibition, total nakedness, absolute reality, live and skinned alive—we never can. There is nothing to do—the wall of obscenity is insurmountable. And paradoxically this wasted quest brings out the fundamental rule of the game all the more clearly: the rule of the sublime, secret and seduction, the very rule that is hunted to the death in the succession of torn veils.

And why not make the opposite hypothesis to voyeurism and collective stupidity: what people—all of us—are looking for in hitting this wall of obscenity is to sense that precisely there is nothing to see, that we will never know the punch line and thus verify *a contrario* the ultimate power of seduction. A desperate verification, but the experimental is always desperate. *Loft Story* claims to verify that humans are social beings—which is not certain. Catherine Millet claims to verify that she is a sexual being—which is not at all certain either. The only things verified in these experiments are the conditions of experimentation themselves, simply taken to their limit. The system is best decoded in its eccentricities, but it is the same everywhere. Cruelty is the same everywhere. It can all be reduced, finally, to quote Duchamp, to "dust breeding."

Telemorphosis

The problem with *Loft Story* is threefold: there is what happens in the Loft, which in itself is uninteresting and, in contradiction with this insignificance, the immense fascination it has elicited. Yet this fascination itself is an object of fascination for the critical eye. Where is the original event in all of this? There is none. All that remains is this mysterious contagion, this viral chain that works from end to end and that we are a party to even in analysis. There is no need to refer to all kinds of economic, political and marketing data—the market is the market and any commentary is just part of the cultural and ideological market. Mass effects are beyond manipulation and have no common measure with causes. Which makes them exciting, like everything that resists the intelligence.

First hypothesis: the size of the audience is not so large despite the show's stupidity, but because of its stupidity and nullity. That seems to be a given. But it opens two possibilities that are not necessarily exclusive. Either the viewers are immersed in the nullity of the show and take pleasure in it as they would from their own image, one with a fresh facelift for the occasion. Or they take pleasure in feeling less stupid than the show—and therefore never tire of watching it. It may in fact be a media strategy to offer shows that are dumber than reality—hyperreal in their stupidity, providing

viewers with a differential possibility of satisfaction. This hypothesis is appealing, but it gives the creators credit for a lot of imagination. It is therefore preferable to keep the presumption of nullity—just as we say the presumption of innocence. And that is radical democracy. The democratic principle involved merit and an equivalence (relative, of course) between merit and recognition. Here, in the Loft, there is no equivalence between merit and glory. It all comes for nothing. A principle of total non-equivalence. The democratic illusion is thus raised to the highest degree: maximum exaltation for minimal qualifications. And while the traditional principle only ensures partial recognition for merit, the Loft operation ensures virtual glory for all in function of their lack of merit. In a way, it is the end of democracy through the elimination of all criteria of qualification, but in another way, it is the triumph of radical democracy based on the beatification of the man without qualities. It is a giant step forward for democratic nihilism.

There is a kind of rupture of the social contract in this imbalance that leads to another type of injustice and anomaly: while one could accuse traditional democracy of not compensating citizens for their just merits, in this case, the accusation would be for overestimating everyone indifferently on the basis of nothing.

This strange glory granted to anyone might seem funny and ferociously ironic, for this form of radical democracy is a derision of the entire establishment and of all those—politicians, intelligentsia or stars—who claim any glory on the basis of their status and value. At least this unfair competition between the "start-ups" of glory reveals the deception latent to all systems of distinction as well as the absurdity of democracy carried away in the logic of the worst. This said, if these new stars, who are touching in their insignificance and transparency, if these usurpers produced by

unbridled speculation on the egalitarian whole, if these pirates of the hit parade do not deserve the excess glory, the society that offered itself the enthusiastic spectacle of this masquerade has certainly gotten what it deserves. *Loft Story* is both the mirror and the disaster of an entire society caught up in the rush for insignificance and swooning to its own banality.

Television has succeeded in a fantastic operation of controlled consensualization, a veritable coup de force, a hostile takeover of society as a whole, a kidnapping—a formidable success on the way to a total telemorphosis of society. It creates a global event (or better yet, non-event) in which everyone is caught. "A total social fact," as Marcel Mauss said—except that in other cultures it meant the converging power of all aspects of the social whereas here it means bringing society to the parodic level of a total farce, an unstoppable image-feedback of its own reality. Television has done what the most radical critique, the most extreme subversive imagination and Situationist derision were unable to accomplish.

Television has emerged as the strongest force in the science of imaginary solutions. But if television did it, it means we wanted it. There is no use condemning the media and money powers or even the stupidity of the public to leave hope that there might be a rational alternative to this total technical and experimental socialization that we are now engaged in and that leads to the automatic linking of individuals in irrevocable consensual processes. Let us call this the integral event of a society with no contract, with no rules and no system of values other than a reflexive complicity, with no rules or logic other than immediate contagion and promiscuity that mix all of us together into an immense indivisible being. We have become individualized beings, in other words non-divisible in ourselves and non-divisible between each other. This individuation of

which we are so proud is by no means a personal freedom. On the contrary, it is the sign of general promiscuity. Not necessarily the promiscuity of bodies in space, but rather the promiscuity of screens from one end of the world to the other. This may even be the true promiscuity: the indivisibility of all human particles for tens of thousands of miles—like millions of twins who cannot separate from their double. Umbilical limbo.

It may also be the promiscuity of an entire population with the inhabitants of the Loft. Or the promiscuity of the "interactive" couple that continuously projects its conjugal life in real time over the Internet. Who watches them? They look at each other, but who else does, since everyone can virtually enjoy the same integrated domestic circuit? Soon there will only be auto-communicating zombies that only have the umbilical connection of image-feedback—electronic avatars of defunct shadows that wander beyond Styx and death, each for itself and spending its time perpetually telling its story. There is still some movement, but just enough to give the retrospective illusion of reality beyond the end—or the illusion of sexuality in the case of Catherine Millet—or the illusion of the social, only evoked in desperate interaction with itself.

One of the signs of this promiscuity is the compulsion for confinement appearing everywhere: in the self-enclosed Loft, an island, a ghetto of luxury or pleasure or any enclosed space where an experimental niche or a zone of privilege is recreated—the equivalent of an initiatory space where the laws of open society are abolished. It is now less a question of saving a symbolic territory than locking oneself up with one's own image, living in promiscuity with it like in a niche, in incestuous complicity with it, with all the effects of transparency and image-feedback that come with a total screen and that only have relationships to others like an image to an image.

Furthermore, the Loft could just as well have been created using computer generated images—and it will be in the future. But they are essentially digital images already. The movements, words and actors already meet all the conditions of prefabrication and pre-programmed presence. Just as we will one day biologically clone human beings, the *Loft* participants basically already have the mental and cultural profile of clones.

Is this promiscuity made of mental involution, social implosion as well as "online" interaction? Is this denial of any dimension of conflict an accidental consequence of the modern evolution of societies or is it a natural condition of humanity, which finally will not rest until it denies its social being as an artificial dimension? Are human beings social beings? It would be interesting to see what will happen in the future of a being with no profound social structure and no organized system of relation and values—in the pure contiguity and promiscuity of networks, on automatic pilot and in a deep coma to some extent—thus contradicting all the presuppositions of anthropology. But don't we have an all too anthropological conception of humanity, as Stanislaw Lec tells us?

In any case, given the success of *Loft Story* and the enthusiastic support of this portrayal of experimental servitude, it is easy to guess that freedom is certainly not an anthropological given and that humankind, if it ever possessed freedom, won't rest until it is abandoned for more animalistic techniques of collective automatism. "Man has difficulty enduring the freedom of others because it is not in accordance with his nature and because he cannot endure it for himself." (Dostoyevsky) But there is something more now, since we have added enjoyment of the spectacle of servitude to servitude itself. And its audience has grown according to the usual format of the media outlets rivaling each other, which makes

the show self-propagating in a prophetic mode—a self-fulfilling prophecy. To a certain extent, the ratings are an illusion, since they are part of the advertising spiral and repetition. But none of this is of any interest. Only the original idea has any worth, the idea of submitting a group to an experiment in sensory deprivation to record the behavior of human molecules in a vacuum—and probably the plan to see them tear each other apart in this artificial promiscuity. We have not reached that point yet, but this existential micro-situation serves as a universal metaphor of the modern being enclosed in a personal loft that is no longer his or her physical and mental universe but a tactile and digital universe, the universe of Turing's "spectral body," of digital humans caught in the labyrinth of networks, of people becoming their own (white) mice.

Most striking of all is to offer this properly unbearable situation to the eyes of the crowd, to have them savor the intricacies of an orgy without tomorrow. A fine feat indeed, but one that cannot stop there. What will soon follow, logically, are the televised snuff movies and bodily harm. Death should logically enter the screen as an experimental event. Not at all as a sacrifice—at the same time as they try to make it disappear technologically, death will reappear on the screen as an extreme experience (the foreseen revival for certain groups of trench warfare or Pacific combat—still Disneyland but with a little more childish cruelty). Yet at the same time it will enter as a pseudo-event because—such is the irony of experimental masquerades—in parallel with the increase of these spectacles of violence, the concern over the reality of what is shown will grow. Did it happen or not? The farther we go in the orgy of images and viewing, the less we can believe. "Real time" vision only adds to the unreality of things. The two paroxysms—

the violence of the image and the discrediting of the image—
increase according to the same exponential function. Which
means we are constantly heading for deception (obviously more
and more so with computer generated images), but spurred on by
this very deception. This profound uncertainty (strategic, politi-
cal—but who benefits from it?) has a large role in sustaining the
insatiable demand for this kind of spectacle.

A vertiginous curiosity that some have taken for voyeurism but in
fact, in each case, in the case of the *Loft* and Catherine Millet, has
little to do with sex. The curiosity is visceral, organic, endoscopic.
It brings to mind the Japanese strip club where clients are invited
to plunge their nose and eyes into the woman's vagina apparently
to explore the secret of her entrails—fascinating in a different way
than sexual penetration. Speleological pleasure (not far removed
from videoscopy of the inside of the body by micro-cameras), a
cleft opened onto the abyss of the entire body. This is not far from
the story of the caliph who had a dancer skinned alive after her
striptease in order to know more. Sex and the knowledge of sex are
superficial in relation to that. The veritable abyssal curiosity is of
the "deep down inside." This compulsive, fetal, involute opening is
what I see active in the so-called "sexual" activity of Catherine Mil-
let and the fascination she has caused. Can we penetrate farther,
farther than the sexual? Can we completely possess and be com-
pletely possessed?

This adventure has no exit, obviously. It can only end with the
endless repetition of a sexual act that will never attain absolute
knowledge of the body or the mortal orgasm (jouissance) of its
exhaustion. In Jarry's *Supermale* (Surmâle), when Ellen and Mar-
cueil flirt with the limits of sexual energy, Ellen dies (momentarily)

at the end of their feat of prowess. Nothing like that happens to Catherine Millet whose adventure is more like a frustrated sexual anorexia. The interesting aspect of her adventure is that by pushing sex to the absurd, all the way to seriality where it is only defined by its automatism (equal to Jarry's velocipedic corpses who pedal even better after they are dead), by stripping sex of the pleasure principle itself, she also tears it from its reality principle and forces the question: What is a sexual being? Is sexuality, contrary to all natural evidence, a hypothesis? Since it is verified to exhaustion here, it leaves one to wonder. Verified beyond its ends, it no longer knows what it is... It must all be reviewed: with *Loft Story*, the evidence of humans as social beings; with Catherine Millet, the evidence of humans as sexual beings; with the increase of transparency and information, the evidence of reality itself.

We are certainly sexed—and Catherine Millet as well—but are we sexual? That is the question. We are socialized (and sometimes by force) but are we social beings? It remains to be seen. Realized, yes—but real? Nothing is less certain.

What Catherine Millet has in common with the people in the Loft through her choice of serial fucking is the same submission to sensory deprivation—leaving room for the same minimal, radical, exclusive activity that by its very repetition becomes virtual. Not only does she get rid of all dual exchange and sexual sharing, but she also abandons any obligation to take pleasure and any obligation to choose—and fundamentally she gets rid of her own body. There is a kind of asceticism in the refusal of choice and of any elective affinities, a shedding of the will (which, as we know, is only a subjective illusion) that would make Catherine Millet, as some have said, a saint...

But what about sexuality? It is certainly a less illusory hypothesis than the will, but is it good to put an end to sexuality by verifying it with such determination? If finishing with desire and its concept can be characterized as a nihilism of the will, then this repeated proof of the existence of sex by means of sex can be considered sexual nihilism. Unless…

Unless the secret aim is to get rid of sex itself? To exhaust this mechanical function of the body before moving on to the main game… That is of course the underlying meaning of: What are you doing after the orgy? Once the bet has been taken and the performance made (we did it!) couldn't we move on to serious matters and really please ourselves? Just as the true gastronome, according to Noëlle Châtelet, makes sure to take sustenance, to feed his or herself first before passing to pleasures of the table, which hunger should not disturb.

After her sexual rally with Marcueil, Ellen states: "It was not at all amusing." Marcueil, moreover, compares a tetanic erection and the parallel situation in a woman to "sclerosis" or a spasmodic tightening of the flesh. Ellen then secretly invites him to begin again, but this time "for pleasure" (and without the watchful eye of Bathybius the scientist who scientifically recorded their feat).

If this reversal does not occur, what is there after the orgy? Nothing, except, with Jarry once again, the hero of absolute love, Sengle, who in the middle of his erotic exertions starts counting his strokes and upon losing count, cries out: "Okay! Forget everything, let's start again!"

The same sensory deprivation for Catherine Millet as in the *Loft*, the same attractive opening in the spectacle of the Loft as in the sexual offering of Catherine Millet. The same vaginal and more than

vaginal, uterine curiosity for the Loft's hole but this time open on another abyss, the chasm of emptiness and insignificance. Going ever deeper towards the true primal scene of modernity. Where is the secret of banality, of nullity that is overexposed, lighted and informed on all sides and that leaves nothing left to be seen because of its constant transparency? The veritable mystery becomes the mystery of this forced confession of life as it is... It is both the object of a veritable dread and a dizzying temptation to plunge into this limbo—the limbo of an empty existence stripped of all signification: the very spectacle offered by the *Loft* and its actors.

The 20th century saw all types of crimes—Auschwitz, Hiroshima, genocide—but the only true perfect crime was, to use Heidegger's terms, "the second fall of man, the fall into banality."

The lethal violence of banality is precisely the most subtle form of extermination because of its indifference and monotony. A veritable theater of cruelty, of our cruelty, completely de-dramatized and without a trace of blood. A perfect crime in that it abolishes all the stakes and erases its own tracks—but especially in that we are both the murders and victims. As long as that distinction exists, the crime is not perfect. In all the historic crimes we know, the distinction is clear. Murderer and victim are only the same in suicide, and in this sense the immersion in banality is indeed the equivalent of a suicide of the species. The other aspect of this deadly banality is that it erases the theater of operations of the crime: it is now everywhere in life, on every screen, in the indistinctness between screen and life. We are on both sides at once. And while we receive images of other crimes and violence ("Shoah," "Apocalypse Now") that are distinct from life, this quiet extermination is shown to us in a type of spectacle, *Loft Story* and others, that are a part of it and

of which we are a part. We are facing a veritable Stockholm syndrome on a collective level—when the hostage becomes an accomplice of the hostage takers—and therefore a revolution in the concept of voluntary servitude and the master-slave relationship. When society as a whole becomes an accomplice to those that have taken it hostage but also when each individual is divided, in him- or herself, between hostage and hostage taker.

This growing promiscuity has a long history starting with the heroization of daily life and its irruption into the historic dimension all the way to the inevitable process of immersion in the real, all too real, in the human, all to human, in the banal and residual. But the last decade has seen an extraordinary acceleration of this banalization of the world relayed by information and universal communication—and especially by the fact that this banality has become experimental. The field of banality is no longer merely residual: it has become a theater of operations. Brought to the screen, like in *Loft Story*, it becomes an experimental object of leisure and desire. A verification of what McLuhan said about television: it is a perpetual test and we are submitted to it like guinea pigs in an automatic mental interaction.

But *Loft Story* is only a detail. "Reality" as a whole has shifted camp to the other side like in the movie *The Truman Show* where the hero is telemorphosed but all the others are as well—accomplices and prisoners in the full light of the same hoax. There was a time—in movies like *The Purple Rose of Cairo*—when characters left the screen and came down to be incarnated in real life—a poetic reversal of the situation. Today, it would be reality that is transfused in the screen to be disincarnated. Nothing separates them anymore. The osmosis, the telemorphosis is complete.

Pleasantville gave the opposite, heroic example of a pair of young television viewers who enter a show and change its course by bringing back human passions (curiously, in fact, since sex does not resuscitate real life and return color to this black and white world—the secret lies elsewhere). But all of this is part of a bygone back and forth between screen and reality. Now the screen is not the television screen but the screen of reality itself—what we can call total reality. *Loft Story* is total sociality. Catherine Millet is total sexuality. The immanence of banality, the more real than real is total reality. Reality is a process moving to completion by absorption, in information and virtuality, of all fatal dimension, by the murder underlying the pacification of life and the enthusiastic consumption of hallucinatory banality. A return to limbo, to the crepuscular zone where everything comes to an end in its very realization.

Somewhere, we are mourning this naked reality, this residual existence, this total disillusion. And there is something in this whole story of the Loft, something like collective mourning. But mourning that links all of us criminals together—murderers in the crime against real life, wallowing in its confession in front of the screen, which serves as a kind of confessional (the confessional is one of the key rooms in the Loft). That is our true corruption, mental corruption—in the consumption of this mourning and this deception, a source of frustrated pleasure. In any case, however, the disavowal of this experimental masquerade showed through in the mortal boredom emerging from it. This said, there is no reason why people should not loudly demand their right to banality, insignificance and nullity—at the same time as the opposite demand. The right, in any case, is part of the banalization of existence.

Total sociality—total sexuality—total reality. This entire process would be catastrophic if there was a truth to the social, a truth to the sexual, a truth to the real. Luckily, these are only hypotheses and although they have now taken the form of monstrous reality, they are still only hypotheses. Ones that will never be verified—the secret will never be lifted. The truth, if it existed, would be sex. Sex would have the final word in this story... But there is none... That is why sexuality will only ever be a hypothesis.

In other words, the absolute danger of a systematic implementation of the social, a systematic implementation of the sexual and a systematic operation of the real is only... virtual.

Which leads to the other question, in the form of a conclusion: Who was laughing in the *Loft*? In this immaterial world with no trace of humor, what monster could be laughing behind the scene? What sarcastic deity could laugh at that deep down inside? The human, all too human must has rolled over in its grave. But, as we know, human convulsions are the distractions of the gods, who can only laugh at them.

The Matrix Revisited

Aude Lancelin: *Your ideas on reality and the virtual are among the key references used by the makers of* The Matrix. *The first episode explicitly referred to you. The viewer clearly saw the cover of* Simulacra and Simulation *on the screen. Were you surprised?*

Jean Baudrillard: Certainly there was a misunderstanding, and I have been hesitant to speak about *The Matrix* until now. After the release of the first episode, the staff of the Wachowski brothers got in touch with me, hoping to get me involved with the following ones. But this was out of the question. [laughter]. Something of the kind occurred in the 1980s when the New York-based Simulationist artists contacted me. They took my hypothesis of the virtual for an irrefutable fact and turned it into a concrete fantasy. What is special about this universe, though, is that the traditional categories of the real to no longer apply.

The film and the vision you developed in The Perfect Crime, *for example, are strikingly similar. The film evokes a "desert of the real," totally virtualized spectral humans who are hardly more than the energetic reserve of thinking objects...*

Yes, but other films have already dealt with the growing blurring between the real and the virtual: *The Truman Show*, *Minority Report*, or even *Mulholland Drive*, David Lynch's masterpiece. *The Matrix*'s chief value is that it pushes all these elements to a paroxysm. Yet it does it more crudely and in a far less complex way. Either the characters are in the Matrix, and belong to the digitized universe, or they are radically outside it—in Zion, the resistors' city. It would be interesting to show what happens at the point where these two worlds meet. The most embarrassing part of the film is that it confuses the new problem raised by simulation with its arch-classical, Platonic treatment. This is a serious flaw.

The idea that the world is nothing more than a radical illusion has challenged every great culture, and it has been resolved through art and symbolization. What we invented in turn, in order to tolerate this kind of suffering, is a simulated real capable of supplanting the real and bringing about its final solution: a virtual universe from which everything dangerous and negative has been expelled. And *The Matrix* entirely belongs to that process. Everything that has to do with the dream, utopia and fantasy is given expression, "realized." It is a world of integral transparency. *The Matrix* is the kind of film about the Matrix that the Matrix itself could have produced.

It is also a film that outwardly denounces technicist alienation, and yet at the same time it relies entirely on the fascination induced by the digital universe and computer generated images.

What is striking about *Matrix Reloaded* is that it doesn't have the slightest glimmer of irony, nothing that might allow viewers to turn this huge special effect around. There is not one sequence

that could provide the *punctum* Roland Barthes talked about, the kind of stunning detail that brings you face-to-face with a true image. Actually, this is what turns the film into an informative symptom, and the very fetish of the technological universe of the screen. There is no longer any way of distinguishing between the real and the imaginary. *The Matrix* really is an extravagant object, at once candid and perverse, since it is neither here nor there. The pseudo-Freud who speaks at the end of the film says it perfectly: there is a point where the Matrix had to be reprogrammed in order to integrate anomalies into the equation. And you, the resistors, are a part of that equation. It seems that we are entirely caught within a virtual circuit, devoid of any exterior. Once again I am in theoretical disagreement with it. (Laughter). *The Matrix* projects the image of a monopolistic superpower the likes of which can be seen today, and it participates in its refraction. Projecting this on a global scale is an integral part of the film itself. At this point it is worth turning to Marshall McLuhan: the medium is the message. The message of *The Matrix* is its own dissemination through an uncontrollable and irrepressible contagion.

It is rather astounding that all contemporary American marketing block-busters, from The Matrix *to Madonna's new album, explicitly claim to be a critique of the very system which massively promotes them.*

That is exactly what makes our era so oppressive. The system produces a *trompe-l'oeil* negativity embedded in products of the spectacle just as obsolescence is built into industrial products. It is the most efficient way of locking out all genuine alternatives. There is no longer any external Omega point to anchor one's perception of the world, no antagonistic function; only a fascinated

adhesion. One should know, however, that the more a system nears perfection, the more it approaches the total accident. It is a kind of objective irony that relies on the fact that nothing is ever final. September 11th participated in this. Terrorism is not an alternative power; it is little more than the metaphor of Western power's almost suicidal reversal on itself. I said it very clearly at the time, and it was not received. We don't need to be nihilistic or pessimistic in the face of all this. The system, the virtual, the Matrix —all of these will perhaps return to the dustbin of history. Reversibility, challenge, and seduction are indestructible.

War Porn

...tomorrow there will be nothing but the virtual violence of consensus, the simultaneity in real time of the global consensus: this will happen tomorrow and it will be the beginning of a world with no tomorrow... This is what the Americans seek to do, these missionary people bearing electro-shocks which will shepherd everyone towards democracy. It is therefore pointless to question the political aims of this war: the only (transpolitical) aim is to align everybody with the global lowest common denominator, the democratic denominator ... the New World Order will be both consensual and televisual. That is indeed why the targeted bombings carefully avoided the Iraqi television antennae... The crucial stake, the decisive stake in this whole affair is the consensual reduction of Islam to the global order.[1]

World Trade Center: shock treatment of power, humiliation inflicted on power, but from outside. With the images of the Baghdad prisons, it is worse, it is the humiliation, symbolic and completely fatal, which the world power inflicts on itself—the Americans in this particular case—the shock treatment of shame and bad conscience. This is what binds together the two events.

Before both a worldwide violent reaction: in the first case a feeling of wonder, in the second, a feeling of abjection.

For September 11th, the exhilarating images of a major event; in the other, the degrading images of something that is the opposite of an event, a non-event of an obscene banality, the degradation, atrocious but banal, not only of the victims, but of the amateur scriptwriters of this parody of violence.

The worst is that it all becomes a parody of violence, a parody of the war itself, pornography becoming the ultimate form of the abjection of war which is unable to be simply war, to be simply about killing, and instead turns itself into a grotesque infantile reality-show, in a desperate simulacrum of power.

These scenes are the illustration of a power which, reaching its extreme point, no longer knows what to do with itself—a power henceforth without aim, without purpose, without a plausible enemy, and in total impunity. It is only capable of inflicting gratuitous humiliation and, as one knows, violence inflicted on others is after all only an expression of the violence inflicted on oneself. It only manages to humiliate itself, degrade itself and go back on its own word in a sort of unremitting perversity. The ignominy, the vileness is the ultimate symptom of a power that no longer knows what to do with itself.

September 11th was a global reaction from all those who no longer knew what to make of this world power and who no longer supported it. In the case of the abuse inflicted on the Iraqis, it is worse yet: power no longer knows what to do with itself and cannot stand itself, unless it engages in self-parody in an inhuman manner.

These images are as murderous for America as those of the World Trade Center in flames. Nevertheless, America in itself is not on trial, and it is useless to charge the Americans: the infernal machine exploded in literally suicidal acts. In fact, the Americans have been overtaken by their own power. They do not have the means to control it. And now we are part of this power. The bad conscience of the entire West is crystallized in these images. The whole West is contained in the burst of the sadistic laughter of the American soldiers, as it is behind the construction of the Israeli wall. This is where the truth of these images lies; this is what they are full of: the excessiveness of a power designating itself as abject and pornographic.

Truth but not veracity: it does not help to know whether the images are true or false. From now on and forever we will be uncertain about these images. Only their impact counts in the way in which they are immersed in the war. There is no longer the need for "embedded" journalists because soldiers themselves are immersed in the image—thanks to digital technology, the images are definitively integrated into the war. They don't represent it anymore; they involve neither distance, nor perception, nor judgment. They no longer belong to the order of representation, nor of information in a strict sense. And, suddenly, the question whether it is necessary to produce, reproduce, broadcast, or prohibit them, or even the "essential" question of how to know if they are true or false, is "irrelevant".

For the images to become a source of true information, they would have to be different from the war. They have become today as virtual as the war itself, and for this reason their specific violence adds to the specific violence of the war. In addition, due to their omnipresence, due to the prevailing rule of the world of

making everything visible, the images, our present-day images, have become substantially pornographic. Spontaneously, they embrace the pornographic face of the war. There exists in all this, in particular in the last Iraqi episode, an immanent justice of the image: those who live by the spectacle will die by the spectacle. Do you want to acquire power through the image? Then you will perish by the return of the image.

The Americans are having and will make of it a bitter experience. And this in spite of all the "democratic" subterfuges and the hopeless simulacrum of transparency which corresponds to the hopeless simulacrum of military power. Who committed these acts and who is really responsible for them? Military superiors? Human nature, bestial as one knows, "even in democracy"? The true scandal is no longer in the torture, it is in the treachery of those who knew and who said nothing (or of those who revealed it?).

In any event, all real violence is diverted by the question of transparency—democracy trying to make a virtue out of the disclosure of its vices. But apart from all this, what is the secret of these abject scenographies? Once again, they are an answer, beyond all the strategic and political adventures, to the humiliation of September 11th, and they want to answer to it by even worse humiliation—even worse than death.

Without counting the hoods which are already a form of decapitation (to which the decapitation of the American corresponds obscurely), without counting the piling-up of bodies, and the dogs, forced nudity is in itself a rape. One saw the GIs walking the naked and chained Iraqis through the city and, in the short story "Allah Akhbar" by Patrick Dekaerke, one sees Franck, the CIA agent, making an Arab strip, forcing him into a girdle and net stockings, and then making him sodomize a pig, all that

while taking photographs which he will send to his village and all his close relations.

Thus the other will be exterminated symbolically. One sees that the goal of the war is not to kill or to win, but abolish the enemy, extinguish (according to Canetti, I believe) the light of his sky.

And, in fact, what does one want these men to acknowledge? What is the secret one wants to extort from them? It is quite simply the name in virtue of which they have no fear of death. Here is the profound jealousy and the revenge of "zero death" on those men who are not afraid—it is in that name that they are inflicted with something worse than death... Radical shamelessness, the dishonor of nudity, the tearing of any veil. It is always the same problem of transparency: to tear off the veil of women or abuse men to make them appear more naked, more obscene...

This masquerade crowns the ignominy of the war—until this travesty, it was present in this most ferocious image (the most ferocious for America), because it was the most ghostly and the most "reversible": the prisoner threatened with electrocution and, completely hooded, like a member of the Ku Klux Klan, crucified by its ilk. It is really America that has electrocuted itself.

Imaginary Solutions

Pataphysics

Ubu, the gaseous and lampooned state, the small intestine and the grandeur of emptiness. Seeing that everything may be stucco, or a knock-off, even a wooden tree—and that powerful sham that makes the dough of phenomena rise—nothing stops this katabasis towards the knock-off and the blah from starting well before the form now taken by so-called true objects—and that everything was before being born, in its cancerous and imaginary state—can only be born in the cancerous and imaginary state—which does not prevent things from being less false that you think, in other words...

Pataphysics is the greatest temptation of the mind. The horror of ridicule and necessity leads to the enormous infatuation, the enormous flatulence of Ubu.

The pataphysic mind is the nail in the tire—the world, a puffball. The paunch[1] is at one and the same time a hot air balloon, a nebula, or even the perfect sphere of knowledge. The intestinal sphere of the sun. There is nothing to get from death. Can a tire die? It releases its rubber soul. Farting is the source of breath.

The principle is to exaggerate: that is how to destroy reality. In Ubu's arrogance, willpower, importance, faith and all things are

raised to their paroxysm where one can naturally see that they are made of the same wind that makes farts, the same meat made into grease and ash, the same bone made into fake ivory and fake galaxies. This is not ridicule. It is inflation, the abrupt passage into an empty space that is no one's thought—for there is no pataphysic thought, there is only the pataphysic acid that sours and embalms life like milk, that bloats it like a drowned body and bursts it like the greenish truffle of the Palotin's[2] brains.

Pataphysics: philosophy of the gaseous state. It can only define itself as a new, undiscovered language because it is too obvious: tautology. Even better: it can only be explained by its own term, thus: it does not exist. It revolves around itself and ruminates the diarrheic incongruence, unsmilingly, mushrooms and rotting dreams.

The rules of the pataphysical game are far worse than any other. It is a deadly narcissism, a mortal eccentricity. The world is an inane protuberance, an empty jerk-off, a kitsch and papier-mâché delirium, but Artaud, who thinks the same way, believes that from this member brandished for nothing could one day emerge a real sperm, that the theater of cruelty could come from a caricatural existence, in other words a real virulence. Whereas Pataphysics no longer believes in either sex or theater. The façade is there and nothing behind it. The ventriloquacity of the hoodwinked (the bladders and lanterns)[3] is absolute. Everything is born infatuated, imaginary, an edema, a fiddler crab, a dirge. There is not even a way to be born or to die. That is reserved for stone, meat, and blood, for things with weight. In Pataphysics, all phenomena are absolutely gaseous. Even recognition of this state, even the awareness of the fart, the itch and the coitus for naught is not serious... and the awareness of this awareness, etc. Aimless, soulless, without phrases and imaginary, albeit necessary, the pat-

aphysic paradox is simply to burst. Artaud, pushed to the edge by the renewed emptiness before and around him, did not commit suicide because he believed in some incarnation, a birth, a sexuality, a drama. All on the stage of cruelty, since reality could not receive them. There were stakes to be won and Artaud's hope was immense. The confines of the bladder had the scent of a Chinese lantern. Ubu blew out all the lanterns with his fat fart. And, moreover, he was convincing. He convinced everyone of nothingness and constipation. He proved that we are an intestinal complication of the Lord of Limbo who, when he farts—well, like that, you see—will resolve everything, will put everything in order. We are nothing more than the state of virtual farts; the notion of reality is given to us by a certain state of the abdominal concentration of wind that has not yet been released. Gods and bright horizons come from this obscene gas accumulated since the world is world; and the pyramidal Ubu digests us before expulsing us pataphysically into the obscure emptiness that smells of cold farts: the end of this world and of all possible worlds...

The humor of this story is crueler than Artaud's cruelty, since Artaud was only an idealist. Most of all, the humor is impossible. It proves the impossibility of thinking pataphysically without committing suicide. It is, if you will, the radius of an unknown spherical *gidouille* whose only limits are the imbecility of spheres but that becomes infinite like humor when it explodes. Humor comes from the detonation of Palotins, from their servile and naïve way of returning to nature in the form of stuck-up farts (*péts-eux*) who thought they were so aware, beings and not merely gas—and one after the other they spark an incommensurable humor that will shine at the end of the world—from the explosion of Ubu himself. Thus Pataphysics is impossible. Do we have to kill

ourselves to prove it? Certainly, since it isn't serious. But what if that were how it was serious... Finally, to exalt Pataphysics, better to be an unconscious pataphysician—and we all are. Humor wants humor about humor, etc. Pataphysics is science...

Artaud is the perfect foil. Artaud wants to renew the value of creation and of birth. He tears an image, like Soutine tears one from his rotting beef, not an idea. He believes that by piercing this abscess of sorcery, a lot of pus will flow, but in the end, good god, some real blood will come and when the whole world is heaving like Soutine's beef, the playwright will be able to start over with our bones for a grand, serious festival where there are no more spectators. In contrast, Pataphysics is bloodless and avoids getting wet. It moves around in its parodic universe like the absorption of the mind into itself without a trace of blood. And in the same way: every pataphysic process is a vicious circle in which panic-stricken forms, to their surprise, eat each other up like crabs in the reeds, digesting each other like stucco buddhas and from every angle only give off the fecal sound of pumice and dried boredom.

Because Pataphysics reaches such a level of perfection in play and because it gives so little importance to everything, it has so little itself. In it, all the solemn nullities, all the figures of nullity fail and turn to stone before the gorgon eye of Ubu. In it, every thing becomes artificial, venomous, a path to schizophrenia, with pink stucco angels whose extremities meet in a curved mirror... Loyola—the world can be rotten, as long as I reign. If a soul does not resist the printed curves, the spirals and vortexes, caught at the moment of climactic tartuffery, then it is delivered to the sumptuous Ubu, whose smile returns every thing to its sulfurous uselessness and its latrine freshness... Such is the sole imaginary solution to the absence of problems.

Forget Artaud

Sylvère Lotringer: *You very rarely refer to Antonin Artaud by name, but I have always suspected that your approach was very close to his. Artaud struggled very hard to reclaim "the rugged reality of things" (Rimbaud) and you were the first to proclaim the passage from reality to hyperreality. Yet I always assumed that you were actually upping the ante of Artaud's thought. It also was a far more radical way of having done with any kind of judgment. A long time ago you told me that, as a young man, you tried to write like Artaud and finally settled for being Baudrillard. The idea of inviting you to talk publicly about Artaud, probably surprising to most, therefore came to me very naturally.[1] I was a bit taken aback, though, that your reaction was rather cool. Actually you protested and flatly refused at first. Why?*

Jean Baudrillard: I can talk about Chance or things of that sort anytime, but Artaud is another story altogether. I don't mean to say that talking about Artaud should be forbidden, but it is a special case, something very singular. Artaud belongs to a secret sphere, like Rimbaud or Nietzsche. His work is in a secret place, a reserved domain and talking about that, exposing that to the light would amount to making one's secret visible.

At first I thought there was some kind of superstition on your part, but then you had your reasons. You believed there was some risk involved in bringing it all to the surface. Acting Artaud out, so to speak, could be dangerous. I replied that the time may have come to break it open, and you said: "Artaud's block is already full of cracks." We didn't seem to go anywhere, so we finally agreed to hold an informal discussion about him with a possible title: "To Have Done with Artaud." But can one ever be done with Artaud?

Artaud no longer is a reference for me, but I don't know what kind of existence it can assume anymore. I also read Nietzsche very exhaustively, and in German—I am a Germanist by training—and it was some sort of perfect integration into that universe. After that I never read Nietzsche again. It became another secret, another kind of secret efficiency, maybe a poetic one, I can't tell for sure. It became another singularity. So I was a bit reluctant when you asked me to talk about Artaud, but I'll do it willingly.

Foucault seemed to have experienced something of the kind. Nietzsche's presence in his work was so massive that he could no longer refer to him explicitly. He would have had to quote him at every single line.

For me it was more of a symbolic exchange. I don't claim, and nobody really could, to be able to deliver a secret or an ultimate clue about Artaud; it would just be absurd. The only adequate response would be to write anew exactly as he did, re-embodying or repeating exactly the same text or the same traces that he left behind. But, of course, that's impossible as well. We may wish then that something like Nietzsche's Eternal Return would happen, that we would be able to play the same game, and then replay it...

You sent me an unpublished text on Ubu to facilitate our dialogue. I assume it belongs to the period I alluded to earlier on. You must have been, twenty, or twenty-one.

Yes. I wrote this text very early on and it was something compulsive, not especially theoretical. I was very fond at the time not of theory, but of poetry. I read Rimbaud, Artaud, Hölderlin, Pierre Klossowski. It wasn't a romantic or mystical impulse, but factual, material. A spiritual impulse as Artaud had it. Actually I was writing on Ubu as well as on Artaud because I found myself torn between these two extremes. "Ubu" is a relic of the past, a kind of fossil text, almost in an archeological sense. Later on I decided— well no, it wasn't exactly a decision—I was determined not to deal with that anymore. I switched to other things. I turned to politics, theory, and so on.

Your "Ubu" made me think of these packed texts from The Umbilicus of Limbo[2] *in which Artaud vampirized the mind of Paolo Uccello or of Abelard in order to plumb his own abysses. You didn't vampirize the pataphysical mind in the same way. In any case it would be impossible because pataphysics belongs to no one. But you managed to vaporize it even further. To the gaseous state of Ubu you opposed Artaud's "true sperm." In "Paul the Bird or the Place of Love," the first text Artaud ever wrote, and you seem to re-write it in your own way, Artaud was already struggling to give himself a body of his own and sperm could be seen at the end swirling, and rising in the air like a big white bird. Artaud called this piece a "mental drama" because what he was actually doing wasn't writing a play, but registering the abrupt jumps of his mind as it attempted to capture his characters. Was your own mental relation to Artaud comparable in any way?*

Everyone should have a singular, personal relation to Artaud. With him we always are on a very inhuman level. He has become an impersonal being. He has been disidentified, he belongs to his own time. Artaud decided to go through the mirror. He became some sort of a myth, a material being in his virtual body, in his spiritual body, for him it was all the same. And any attempt to assign him a place in the history of ideas, or in the history of aesthetics, let alone express a romantic admiration towards him, remains very problematic. But I wouldn't object to that. [*He chuckles.*] I strongly believe that there can't be a collective admiration, or a collective reference to Artaud. Even if we share—more than an admiration I would call a *complicity*—it can't possibly take the form of a contract, of a cultural contract, even in terms of the theater. It must be a pact, a pact of blood, of body and bone, as Artaud himself did. And in this pact we disappear as individuals, as he himself once disappeared.

People who identify with Artaud preclude the possibility of understanding anything about his work. But everyone involved with Artaud's work is bound to go through that stage and become one of his clones. Still you have to get beyond that. What actually shook me out of this trap, I believe, was something apparently trivial. I managed to get hold of the questionnaires Artaud had to fill out every time he sought to be admitted to a detox clinic. In his answers he kept complaining of his cowardliness, of his lack of will, of his incapacity of experiencing the slightest emotion. At once my eyes opened. His blazing violence suddenly reversed into its contrary, and his suffering ceased to be personal. Both were springing from the absence of any meaning and of any sense of self. Artaud himself destroyed the possibility of any identification. He never identified with those people he mentally

squatted, any more than he ever managed to occupy the place of love. Ransacking his doubles was just another way of emptying himself and looking around for some reality.

Artaud had no need to identify with anyone. Either he found himself from the start in a total alterity—mind you, this is no alienation, but alterity from his own body—or he participates in a chain of beings, and not necessarily human beings but those who inhabit language or situations. This goes back to what we were saying at the very start, to the delusion of assuming that talking about Artaud is possible. It's like finding oneself defenseless because invoking alterity is just an abstraction. Even Artaud's words, as sub lime as they are, can't be taken literally in terms of their meaning and signification. That's just about all I could say about him. The way Artaud proceeds is akin to the symbolic strategies of primitive societies. He doesn't need to identify with his own culture in order to transgress it or go beyond a nostalgic culture devoid of meaning or depth. He already stands in the filter of the void.

Artaud has no way of connecting to his own alterity. He can only grasp it by projecting it onto another being.

It's the same problem with the world. The definition of the world or of the universe is that there's none that could be expressed in its totality. There's no mirror in which the reflection of the world could be caught. And it goes the same way for the individual: there's no mirror in which his soul could be perceived, only the void of nothingness. It is possible to identify with that without disappearing in it in a suicidal way. This virtual void could be turned into a creative space. A creation out of the energy of signs, not of

the accumulation of meaning. In fact the contrary is true: we must aim to destroy it. We must create a void such that everything that exists would have to assume a concrete form. Then a pure event would come about: a total spectacle. By "spectacle" I mean here the exact opposite of a representative spectacle.

Artaud demanded from the actor something of the kind : emptying oneself out, developing a musculature of emotions that had nothing personal about it. Projected outward, these forces would make up a separate organism, some kind of affective spectrum capable of acting upon the actor from the outside. After all, affects are not owned by anyone. This is totally at variance with the Actor's Studio Method entirely based on interiority. It is precisely these impersonal forces that Artaud summoned when he happened to be at the lowest point in his life and about to embark on his fatal journey to Ireland. Failing to succeed in the theater, he managed to turn the world into his stage.

Everywhere Artaud challenged the process of identification. He said that people should identify with actors materially through gestures and signs—pure signs and events. It was totally opposed to the modern psychology of the actor. Actors create affects, but they don't belong to them. It's like the athlete who works out, but at a distance.

The affects liberated by Artaud—the "sucking void" of the actor, as he called it—are what affect us most. It would therefore be a huge mistake to fill this void, assuming that these forces belong to him. To expose oneself to the "Artaud effect" one must forget Artaud. Furthermore the only way of responding to a collapse of that magnitude is through an even more radical collapse. I assume that this is what

you called a symbolic exchange, with all the risks attached to it.
Something of the kind may also have been played out, in a lesser way,
between Foucault and you. Foucault was asked to respond to your
Forget Foucault, but he never did, I am convinced that it affected
him deeply as well as his own work. It also ended up costing you
dearly, at least in French intellectual circles, where Foucault remains
untouchable.

The first time we both met—a long walk on Venice beach in Los
Angeles in 1979—we talked about the possibility of publishing a
translation in English of this pamphlet. At the time I wasn't especially
in agreement with you, but I estimated that your upping the ante on
Foucault's spiral of power raised a number of questions that deserved to
be taken seriously. It was, I believed, also a perfect introduction to your
own theoretical approach. And you countered my offer with a broad
smile: "I think we should call it 'Remember Foucault.'" There was no
*way we could have come up with a title like that—*Forget Foucault
was bad enough. Foucault's death a few years later made it even more
impossible to pursue the project. So I brought out instead in Semio-
text(e) *the volume now known here as* Simulations. *Forget Foucault*
finally came out ten years later in 1987, but I purposely added a sec-
ond part to the book, a dialogue like the one we're having now, with a
second title at the back mirroring the first: Forget Baudrillard.[3]

I had the idea of launching a series of FORGET—Forget Fou-
cault, Forget Lacan, Forget Baudrillard, Forget Lotringer, and so
on. And when this would have been completed, we would have
started another series with REMEMBER—Remember Bau-
drillard, etc. It would have been a huge success and it would have
lasted a very long time.

Nothing in the United States ever lasts that long. And there could only be one Forget Foucault, *that's why it is so memorable. You sent Foucault's notions of power and sex spinning away like Artaud's sperm until they literally reversed themselves—if power is everywhere, then it is nowhere; if sexuality is no longer repressed, then it ceases being sexual. In your hands Foucault turned out not to be Foucaldian enough—or not Baudrilliardian enough actually…*

Well, not enough…

You escalated Foucault's concepts the better to exterminate them. But your early "Ubu" already worked along those lines. Jarry happened to be a major reference for Artaud's theater, but few people drew conclusions from it. The first company Artaud founded with Roger Vitrac, another transfuge from the Surrealist movement, bore Jarry's name. Artaud never stated explicitly what attracted him to Jarry, but the main feature of his theatre, its logical absurdism and literalism, deadpan humor, "absolute laughter" and systematic provocation clearly are derived from the author of Ubu King. *Heliogabalus is a solar version of Ubu and the old Cenci, tyrannical and incestuous, clearly is his Elizabethan travesty. Artaud wrote that Alfred Jarry is bent on "accentuating and aggravating the conflict it denounces between the ideas of freedom and independence that it allegedly stands for and the hostile powers which oppose it." Like Jarry, Artaud kept pushing things to the extreme, but you were right to say that Artaud still meant to restore a "real virulence" and stage an authentic Theater of Cruelty. As you wrote, Artaud still believed in the possibility of "an incarnation somewhere, in birth, in sexuality, in drama… Something real was at stake and Artaud was immensely hopeful." Artaud indeed was an idealist, but an integral one. Although he faced the*

void inside and outside, Artaud never committed suicide—nor did Jarry for that matter.

No, but unlike Artaud's, Jarry's logic of paroxysm in Jarr is very cool. It's as if Jarry already were off-limits, beyond the limits of his own death. Jarry said that, like Faustroll, he was born at age 63. But it's not really the time of birth or death that was at stake anymore. Jarry had burnt all his bridges, it's as if he were already dead. Whether he was born or not born, or whether it was better to be dead than alive wasn't the point. Jarry was posthumous, and he liked, by the way, to play macabre, morbid games. He already was beyond all these things. And Artaud was not. He was not born yet.

He was macerating in his Limbo.

Yes.

This comes up in his paradoxical answer to the questionnaire André Breton circulated to all the members of the Surrealist group: "Is Suicide a Solution?" I wish I could commit suicide, Artaud replied, but first I want to make sure that I am alive. And I can't be sure of that, so suicide is ruled out. It isn't a possibility. This wasn't an admission of powerlessness, as it is usually assumed, but a powerful way of casting doubt on all uncertainties. Artaud was an agent provocateur in his own way. He kept challenging death to reappear for without death life would remain improbable.

And he attempted to generate himself, to give birth to himself. By forceps, of course. [*Laughter from the audience.*] It is very difficult

to eject oneself into a very real world. The world we ourselves live in is very confusing. Artaud wanted to burst out, explode out of himself, out of the body, the common body of the world. Instead, Jarry remained buried in himself.

You talked about suicide as well recently, or rather you sang a song of suicide. It happened during the Chance conference Chris Kraus produced a few days ago in a casino near Las Vegas.[4] At one point you (reluctantly) accepted to don a golden lamé suit à la Elvis Presley and go onstage. While Mike Kelley's Chance Band was playing, you somberly read the lyrics of "Motel-Suicide," a song you wrote in the mid-80s. In Cool Memories, *you gave an idea of what this "Academy of Suicide" would be and it sounds to me like an Aztec ritual hallucinated by Georges Bataille. A costumer checks in to a motel and the management treats him like a royalty, giving him everything he wants, women, wine, philosophy. But then when time comes they kill him. This is not exactly Artaud's kind of motel.*

Well no, but that was an ironic narrative. The idea was that no one is truly responsible for one's own life and death. Once you become conscious of this fact, and aware of this fundamental irresponsibility, it is not something that you could transgress. The idea of responsibility, of self-consciousness is very utopian. It is the modern ideology of the individual. But at bottom there is no such thing as *self*-responsibility. One doesn't have a choice. And since death is certain, unavoidable, one has to make sure that it comes from elsewhere, from others, not from oneself. Committing suicide would be a very pretentious, very conceited idea. "Motel-Suicide" was a way of delivering oneself into the hands of others. "I don't want to know about that, you can take charge of me, of my death!" I think

everybody does that in one way or another. In our virtual world, it is not possible to talk about responsibility, freedom, etc.

Jarry reminded us that freedom is slavery.

Well, of course. All the concepts of will turn around the idea of a voluntary servitude. And it's worse to be a slave of oneself than a slave of another.

So we may not need God's Judgment for that after all. David Rattray, Artaud's best translator in English, once asked me if he could go as far as to translate Artaud's title by: "To Have Done with God." It was indeed a huge leap of faith, and we both were aware of that. Artaud opposed the doctrine of judgment (the book) by means of the physical system of cruelty. But he wasn't just fighting God in the outside, he was also trying to root him out from his own body. Nietzsche himself never claimed that we had gotten rid of God. Murdering him was the ultimate proof of his existence. Were you ever involved in this question as Artaud was?

Well. [*Laughs a bit uneasily.*] The question doesn't apply. Times have changed. When Nietzsche spoke about the death of God, he meant it as a murder, as a symbolic act, a symbolic acting out of humanity, and this had very profound consequences for the modern world. But that God was dead didn't mean that he had disappeared. Death is not likely to disappear yet either. As I said in my last book, *The Perfect Crime*, the difference is that the murder of reality has nothing to do with the murder of God. Assassinating reality is an extermination, not a symbolic murder. And what we are left with in our world, our virtual world, can't even be called traces of reality, let

alone liberty or responsibility. The entire system of values disappeared without leaving any traces behind—virtually, of course. I am not even sure that we are now experiencing any nostalgia for reality. Reality is very boring anyway, very annoying. We don't like reality. God, on the other hand, is not boring. The concept of reality results from the banalization of the sacred, of religion, of all the illusion of the world. When there is no more illusion about the world, there is no God. What we still have to do with objective reality is up the ante on the very nullity and nothingness of the world.

Reality has become interminable. It keeps dying because it has no more energy to expend. The big mythical oppositions keep on extenuating themselves in TV serials. It is no longer possible to cut the umbilicus off and be really born into this world, as Artaud wished he would. The umbilici now can be found everywhere (it's called communication) and Redemption nowhere.

Then it isn't a symbolic murder, it's an extermination. Artaud wanted this murder to be a source of exploding energy, but this energy finds its source elsewhere, not exactly in reality as a material force, but in the energy of illusion, of the spiritual illusion which gathers together the disparate parts of the material world in a kind of coherent "chain." It is the energy of signs. It is also a sort of cult. Not a religious one, not violent either, but a principle of rigor that sustains the notions of irreducibility, of incompatibility against the banalization of the individual.

It was cult against culture, cruelty against representation, the actor's impersonality against improvisation and sentimentality. It's all this that Artaud sought to exorcize in his theater, and ended up applying to himself.

A great confusion occurred when people attempted to materialize Artaud's concepts in the theater. It is true that he strived to do it metaphysically, but it would be a mistake to believe that it is possible to turn his theoretical/metaphysical vision into reality. Artaud's vision was very singular, but this singularity may only have been for him alone. After that there was some materialization of his theater of cruelty in Grotowski or in the Butoh. Ten years ago I attended some of their performances and what I saw was extremely impressive. I would say that the experiences of the Peking Opera or performances of the same kind converge as well with this vision or un-vision of the world. Because the theater is not in the theater anymore, but in the intellectual ceremony of the world. These ceremonies are very spiritual, but not in a mystical sense. They obey very strict rules. Artaud discovered that in the Balinese theater, but his theater had nothing to do with the expressionist theater it has often been confused with. This was bound to bring about a degradation of his thought, even in the hands of someone like Jean-Louis Barrault.

Artaud already contributed to this degradation when he staged his own play, The Cenci, *in 1935. It was a resounding failure, and not just because Artaud didn't have the means to pull it off. It may be true that failing to train his actors the way he intended to, he fell back on a script that was hardly different from those he attacked in his manifestoes—a loquacious and inflated text. He probably counted on the waves of bodies sweeping over the stage and the intense acoustic bombardment to hypnotize the spectators' sensibility, but the very conception of the play was at fault. Artaud was steeped in the Elizabethan theater, but his play was only nominally metaphysical. It never reached this concrete language half-way between gesture and mind that*

he had so powerfully evoked in his manifestoes on cruelty. The violent
externalization of the action in language had a contrary effect to the
one he was hoping to trigger.

As soon as Artaud started writing for the theater, he turned his own
theory into a caricature. What results from it is a banal cruelty and
this text, when you read it, is hardly different from many other
texts. Artaud isn't Shakespeare.

He managed to be the Shakespeare of his own body by working against it.

Yes. He ended up achieving his theater in himself, in his delirium,
in his experiences which were experiences of the mind. I never
believed that there was a necessary relationship between what
Artaud thought and what he tried so hard to do, except in what he
did to himself—playing like an actor according to his own princi-
ples. And this involves the question of language. It satisfies this
intellectual—and not instinctive—compulsion of becoming the
world, but not through words. The function of language, its only
function really, is not to communicate or inform, transmit some-
thing—all this is secondary—but to captivate. What is
fundamental in language is its capacity to seduce. There exists a
strategy of seduction, and symbolic exchange is seduction itself.
Because, like challenge, it is a reversible form. Other people go
through the mirror very calmly, like Alice. They reach the state of
seduction, which is the most sublime of states, far more sublime
than the state of things. This challenge of seduction, some people
reach it effortlessly, gracefully because they exist in some sort of state
of poetic grace, like Hölderlin, in some kind of poetical vanishing
point. Someone like Hölderlin was beyond the cruel experience

that we had with the gods, he transcended this state. He was beyond this pataphysical or this cruel game. He achieved a state of superior seductivity. Artaud and Jarry aren't the only models we have at our disposal. Artaud disindentified himself and Jarry overidentified himself with the appeerances, but the irony of the world can find other, more adequate, strategies. They also exist in other cultures, although it may have become impossible to bring them out in our modernity except through other strategies, cruelty, simulacrum, pataphysics, etc., all bound to a more or less desperate future. Artaud tried very hard to take stock on the material form of language, on signs of force, on impulses and not meaning, on material things. On signs as signals of themselves. This kind of language, foreign to ordinary language, he experienced in himself. Not in the theater, or what he wrote for the stage, rather through an incarnate silence. This silence is an empty, natural or artificial space—and this is where the theater comes in—in which the pure advent of a theater of signs can occur. What is materialized is a real theory of language, not something personal. I have never been especially impressed by Artaud's writings on the theater, far more by—how could one say—not his poetic texts, but by his texts that are indefinable. Someone like Hölderlin has reached another point, a vanishing point which is a poetic point. No one else ever managed to bring the explosive silence of language to such limits.

People generally tend to take Artaud's pathos in the first degree as if his suffering belonged to him and that he should be pitied to have been subjected to it. Artaud, it is true, suffered enormously—the greatest quantity of suffering in the history of literature, Susan Sontag wryly wrote—but he also was a gambler with of his own pain. It is perceptible from the start in his correspondence with Jacques Rivière

where he manages to intimidate the powerful editor by presenting himself as a pathological case. Artaud used suffering as a bait, and in every possible way, procuring drugs, staging cruelty in his own body. Artaud was driven by pain. It was both the material for his art and a sign of election, his way to salvation. He saw it in light of the Christian martyrology he had avidly absorbed in his childhood. Artaud was the suffering artist the way Kafka was the hunger artist. This suffering was organically based, but its symbolic charge was far stronger. It would be absurd then to consider him a powerless victim. Artaud challenged the world, and the world answered in kind—shock, electroshock—revealing itself for what it was. Its cruelty, if anything, proved that he was right. For Artaud it is death itself that was posthumous, so everything could be pushed to a paroxysm. And this is true as well, I believe, of your own approach to theory. I mean, you always seem to go along and willingly embrace everything, but at the price of an implacable retaliation. It is the "radical" strategy you seem to share with Artaud. And yet he didn't go all the way either in this kind of exasperated logic. Invoking Jarry in your text clearly was a way of challenging Artaud to do just that and terminate pataphysically his spiritual pregnancy.

You're right about the strategies, the logical strategies. I would agree more with Jarry in that Pataphysics is the science of imaginary solutions, a way of surpassing physics and metaphysics. And I still believe in that. It is another way of surpassing the opposition of body and soul, of knowledge and nothingness, and so on. But I don't believe Artaud wanted to recreate reality, or attempted to recover a level of reality. Reality—the term, of course, is highly problematic...

Pataphysics always ups the ante, and as you said, "That's how reality is demolished." This is true for Artaud as well. His Passion demanded that he destroy his own reality.

Artaud was trying to recover a sense of materiality, not of reality. Pataphysics signals the end of reality. After that, reality is not a possibility anymore. Today dealing with Artaud is very difficult because his material, symbolic model probably is too radical for us. Pataphysics is far more radical than any analysis we can do ourselves in terms of the hyperreal, of transparency, absurdity and irrationality. The irruption of a vision of the world, or anti-vision of the world, is far stronger, far more original than anything we could ever come up with. We came after, we are nothing but epigones. But is there a relation between Jarry and Artaud? I don't think the opposition between them was as clear as I suggested in this text. Oppositions of this kind still have something rhetorical about them.

You didn't merely oppose them. Artaud is coiled up in Ubu's "gidouille" (paunch) waiting to be released like a resounding fart. Reality according to Jarry is nothing but an obscene gas. Ubu's inflated strategy, his "enormous" flatulence explodes like a blaring trumpet-call, or the Last Trump... I'm amazed how close this text is also to Artaud's "explosive affirmation" of his own body. And yet Artaud's scatology wasn't gaseous, but material: If God is a being, then he is shit. If he is not shit, then he is not. Both used scatology as part of a logical/theological argument...

It may have been an attempt to challenge God through this obscenity. We shouldn't allow God to judge us, to be exterior to

our bodies and souls—and to be right. God's judgment is always right for him. Like the old anchorites and monks, Artaud was a sacrificial being, but not in a religious sense. One sacrifices one's own body to get an answer from God. And he must meet this challenge.

Artaud didn't challenge God, he challenged Him to exist.

But God doesn't exist without this challenge. Consequently, in this duel you are God's creator. God's existence, in fact, is incidental. As a symbolic exchange, God is only the interstitial term of the transaction. Thus it has no consequence for us to believe in it.

But the God Artaud defies is not the one who created reality. One gets closer here to Artaud's radical Manichaeism, which you're playing with as well in your own way.

Evil rules the world; Good is an exception. This is the fundamental principle of Manichaeism rightly understood—the most beautiful theory in the world. Manichaeism, which is a dualism, always relies on some kind of antagonism, or irreconcilablility. It advocates an absolute antagonism, not a dialectical polarity. Manichaeism throws its lot in with Evil, obviously.

This is what Artaud calls anarchy: *contradiction in the principle.*

Secretly it could be said that both Artaud and Jarry were anarchists of the spirit. Both confronted nothingness, the nullity of the world, of this world, and so did Pataphysics.

Artaud was an anarchist, but a crowned one, like Heliogabalus, the mad emperor who perverted Rome from the top down. Artaud's idea of order was the application of a rigorous logic that he first directed against himself.

Yes, you're right about the logic. There's a whole paradigm of visions of the world and I don't think we have gone beyond that. We haven't invented that much in that respect since Artaud, Jarry, Bataille or Klossowski. Logic is always an extreme logic, but it can take different forms. Bataille's logic was an extreme form of logical conformism, a hyperconformism, a parodic extremity that could well be considered a fatal strategy. Not every logic is a logic of extremity. Nietzsche's logic, for example, is a parabolical logic that turns into the Eternal Return—a genealogical logic. Both Artaud and Jarry assumed an extreme logic—a very radical, ironic, parodist logic of conformism for Jarry, and for Artaud a logic of anti-conformism.

Like Heliogabalus, Artaud never forgave the world for no longer believing in its myths.

Although he struggled against it and did his utmost to break away from it, Artaud still had a cultural experience. Jarry had none. Jarry is a meteorical phenomenon. After that it may involve the history of a text, because this text I wrote about Jarry and Artaud signaled my break with the College of Pataphysics. I had been involved with the College from the very beginning. My philosophy teacher, who founded it in Rheims in the late 40s, was also the one who started the *Cahiers du Collège*. I was rather young then, but it didn't take me long to realize that the pataphysical entourage was adopting the

same conformism, the same institutional infatuation that Ubu himself had. Ubu's "boodoe" had become the intellectual milieu. It didn't make any sense for me at that point to be involved with these people and I broke all contact with them. In a sense, the degradation of the movement itself was ironical. It was a proof of the spirit, of the pataphysical spirit, but against itself. On the other hand, I never broke with Artaud, or experienced any rejection, but my relation to him has changed. It changed into a secret life, and possibly a silence.

Is there still something that separates you from Artaud?

It is an indiscrete question to ask. I'm not separate from Artaud, Artaud was separated from himself. But we can't sublimate Artaud, or idealize him either. We can make a myth out of him, but certainly not a cultural ideology. This being said, what separates Artaud from us, from us all, is that he was lucky enough, so to speak, to be burnt at the stake. But we can say that about other people as well. What separates us from Andy Warhol, for instance, is that he was lucky enough to be a machine. And we are not.

Artaud was one too. In 1924 he wrote: "I am a walking automaton."

Notes

Introduction: The Piracy of Art

1. Jean Baudrillard, *Simulations*. Trans. Paul Foss, Paul Patton and Philip Beitchman. Edited by Sylvère Lotringer. New York: Semiotext(e) Foreign Agents series, 1983.

2. Corinna Ghaznavi and Felix Stalder, "Baudrillard: Contemporary Art is Worthless," in LOLA, Toronto. It didn't help much, of course, that they relied on a faulty translation, or simply misread his argument. Baudrillard 's claim that anyone *criticizing* contemporary art (as he does) is being dismissed as a "reactionary... even fascist mode of thinking" is turned around and presented as an attack on art. Cf. "A Conjuration of Imbeciles," *infra* in this volume.

3. Jean Baudrillard, *The Consumer Society* [1970]. Trans. Chris Turner. London: Sage publications, 1998.

4. Jean Baudrillard, *For a Critique of the Political Economy of the Sign* [1972]. Trans. Charles Levin. St. Louis: Telos Press, 1981.

5. Chris Kraus, *Video Green: Los Angeles, or the Triumph of Nothingness*. New York: Semiotext(e), 2004, p.17.

6. Jean Baudrillard, *Cool Memories II*. Trans. Chris Turner. Atlanta: Duke University Press, 1996, p. 83.

7. *Ibid*, p. 83.

In the Kingdom of the Blind...

1. Baudrillard continues to reference "Père Ubu," whose bulging gut was famously decorated with a spiral.

2. Another Jarry term, referring to the underlings who supported Père Ubu.

La Commedia dell'Arte

1. "The Danube peasant" in the *Fables of La Fontaine* (from Marcus Aurelius) comes to Rome to call Roman avarice to task. Book 11, fable 7 of the *Fables*.

Towards the Vanishing Point of Art

1. "Un coma dépassé" (which can be read as a "surpassed coma") is the French term for an irreversible coma or brain death.—Tr.N.

Aesthetic Illusion and Disillusion

1. Illusion, from *ludere*, play.—Ed.N.

2. In this passage, Baudrillard plays on the word "regard," both as viewing and as implication: "It no longer concerns you," "it's none of your business."—Tr.N.

3. In *Gestes et opinions du Docteur Faustroll, pataphysicien*, Jarry defines pataphysics as "the science of that which adds itself to metaphysics either in itself or outside itself, reaching as far away from metaphysics as metaphysics does from physics. Example: since the epiphenomenon is often the accident, pataphysics will above all be the science of the particular, although it is said that there is only science of the general. It will study the laws that rule exceptions. Definition: pataphysics is the science of imaginary solutions."

4. In English in the original.—Tr.N.

5. In English in the original.—Tr.N.

6. In *The Ecstacy of Communication* [Trans. Bernard and Caroline Schutze. Edited by Sylvère Lotringer. New York: Semiotext(e), 1988], Baudrillard writes, "There is

a state particular to fascination and giddiness. It is a singular form of pleasure, perhaps, but it is aleatory and dizzying. If one goes along with Roger Caillois' classification of games—mimiking, agôn, alea, ilinx: games of expression, games of competition, games of chance, games of giddiness—then the movement of our entire culture will lead from a disappearance of the forms of expression and competition towards an extension of the forms of chance (alea) and giddiness."—Ed.N.

7. 11th century author of the *Rubaiyat.*

Art between Utopia and Anticipation

1. See above "Aesthetic Illusion and Disillusion."

The Violence of Indifference

1. CIP (Contrat d'Insertion Professionnelle). Contract offered by the French Government to unemployed youth guaranteeing them a job for an inferior salary.—Ed.N.

2. The banlieues are often impoverished suburbs around many of the large cities in France.—Tr.N.

Radical Thought

1. In Robert Louis Stevenson, "A Humble Remonstrance," *Longman's Magazine,* 5 (November 1884), 139–47. "The novel, which is a work of art, exists, not by its resemblances to life, which are forced and material, as a shoe most still consist of leather, but by its immeasurable difference from life, which is designed and significant, and is both the method and the meaning of the work."—Tr.N.

2. A reference to Sartre's response calls for him to condemn Soviet totalitarianism: "Il ne faut pas désespérer Billancourt." Billancourt was the location of the Renault auto factory.—Tr.N.

Dust Breeding

1. Catherine Millet, *The Sexual Life of Catherine M.* Trans. Adriana Hunter. New York: Grove/Atlantic, 2002.

2. From the epilogue of *The Work of Art in the Age of Mechanical Reproduction.*—Tr.N.

3. In English in the original.—Tr.N.

4. Writer Jacques Henric is Catherine Millet's husband.

War Porn

1. Jean Baudrillard. *The Gulf War Did Not Take Place* (c1991). Bloomington: Indiana University Press, 1995:84-85. This quotation has been added to this article by the editors of the IJBS.—Ed.N.

Pataphysics

1. *Gidouille* is the term Alfred Jarry coined for Ubu's gut with its spiral vortex.—Tr.N.

2. The *Palotin* are the subalterns, the acolytes of Ubu.—Tr.N.

3. Baudrillard plays here on the expression "prendre des vessies pour des lanternes": to be deceived, literally, to mistake bladders for lanterns.—Tr.N.

Forget Artaud

1. This discussion was held at the Drawing Center in New York on November 16, 1996 as part of a series of events organized in conjunction with the "Antonin Artaud: Works on Paper" exhibit at the Museum of Modern Art (October 3, 1996–January 7, 1997).—Ed.N.

2. An early volume of texts by Artaud (1925). All other texts by Artaud quoted are in: *Antonin Artaud, Selected Writings.* Edited bySusan Sontag. University of Berkeley Press, 1976.—Ed.N.

3. *Simulations* is volume made of two parts, one lifted from *Simulations and Simulacrum*, the other from *Symbolic Exchange and Death*, was published in the Semiotext(e) imprint in 1983; *Forget Foucault* was published by Semiotext(e) in1987.

4. The "Chance Event" was produced by writer Chris Kraus at Whiskey Pete's on November 8–10, 1996

Sources

Interviews with Jean Baudrillard

First published in Jean Baudrillard, *Entrevues a propos du "Complot de l'Art"* (Paris: Sens & Tonka, 1997):

"Starting from Andy Warhol" (May 1990) Françoise Gaillard, in *Canal*

"Art Between Utopia and Anticipation" (February 1996) Ruth Scheps, in *Les Sciences de la prevision*, coll. Points/Sciences, Ed. du Seuil/France Culture, October 1996.

"No Nostalgia for Old Aesthetic Values" (June 1996) Geneviève Breerette, in *Le Monde*, June 9/10, 1996

"Commedia dell'Arte" (September 1996) Catherine Francblin, in *Art Press*, 216, September 1996.

"Too Much is Too Much" (2000-2001) Sylvère Lotringer, unpublished

Articles, Pamphlets & Lectures

"The Conspiracy of Art" (*Libération*, May 20, 1996; *Le Complot de l'Art*. Paris: Sens & Tonka, 1997)

"The Conjuration of Imbeciles" (*Libération*, May 7, 1997; *De la Conjuration des Imbeciles*. Paris: Sens & Tonka, 1997)

"In the Kingdom of the Blind..." (*Libération*, May 13, 2002; *Au Royaume des aveugles...* Paris: Sens & Tonka, 2002)

"Art Contemporary... to Itself" (Lecture at the Venice Biennale, 2003)

"Towards the vanishing Point of Art" (Lecture at the Whitney Museum, 1987)

"Aesthetic Illusion and Disillusion" (*Illusion, Desillusion esthétique*. Paris: Sens & Tonka, 1997)

"The Implosion of Beaubourg" (*Libération*, January 31, 1978)

"The Violence of Indifference" (*Magazine littéraire*, July-August, 1994. Trans. Brent Edwards)

"Radical Thinking" (*La Pensée radicale*. Paris: Sens & Tonka, 1994)

"Breeding Dust " (*Télémorphose*. Paris: Sens & Tonka, 2001)

"Telemorphosis" (*Télémorphose*. Paris: Sens & Tonka, 2001)

"War Porn" (*Libération*, May 19, 2004)

"Pataphysics" (New York, 1996; *Pataphysique*. Paris: Sens & Tonka, 2002)

"Forget Artaud" (1996) a dialogue between Jean Baudrillard and Sylvère Lotringer, unpublished

"The Matrix revisited" was first translated by Gary Genesco and Adam Bryx as "The Matrix Decoded" in International Journal of Baudrillard Studies (IJBS) Volume 1, Number 2, July 2004. "War Porn" by Paul A. Taylor in IJBS Volume 2, Number 2, January 2005. Both were reviewed by Jonathan Eugene Skonda Brilliant.

Index

Othe Semiotexte Titles Jean Baudrillard

Simulations

In the Shadow of the Silent Majorities

Forget Foucault

Looking Back on the End of the World

Ecstasy of Communication

Fatal Strategies